Put any picture you want on any state book cover. Makes a great gift. Go to www.america24-7.com/customcover

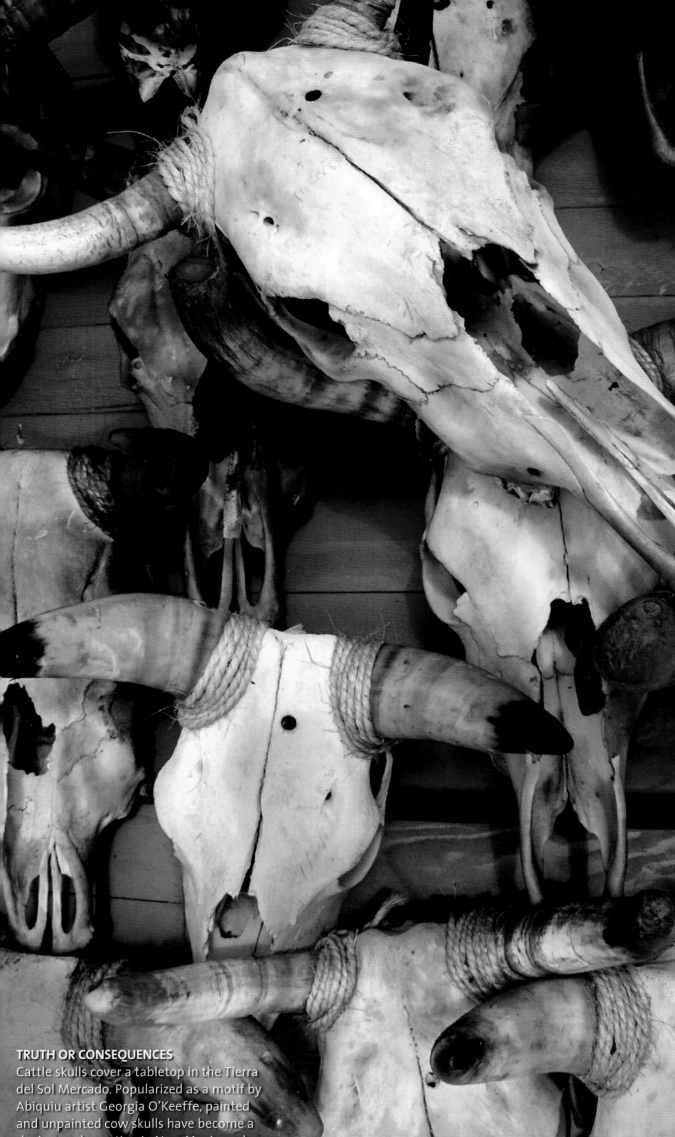

TRUTH OR CONSEQUENCES
Cattle skulls cover a tabletop in the Tierra del Sol Mercado. Popularized as a motif by Abiquiu artist Georgia O'Keeffe, painted and unpainted cow skulls have become a *de rigueur* decoration in New Mexico, adorning walls, fireplaces, and rock gardens.
Photo by Steve Northup

New Mexico 24/7 is the sequel to *The New York Times* bestseller *America 24/7* shot by tens of thousands of digital photographers across America over the course of a single week. We would like to thank the following sponsors, the wonderful people of New Mexico, and the talented photojournalists who made this book possible.

A® Adobe

OLYMPUS

LEXAR *Media*™

snapfish

jetBlue AIRWAYS

WEBWARE™

Google™

DIGITAL **POND**

ebaY

LONDON, NEW YORK, MUNICH, MELBOURNE, and DELHI

Created by Rick Smolan and David Elliot Cohen

24/7 Media, LLC
PO Box 1189
Sausalito, CA 94966-1189
www.america24-7.com

First Edition, 2004
04 05 06 07 08 10 9 8 7 6 5 4 3 2 1

Published in the United States by
DK Publishing, Inc.
375 Hudson Street
New York, NY 10014

DK Publishing, Inc. offers special discounts for bulk purchases for sales promo-
tions or premiums. Specific, large-quantity needs can be met with special edi-
tions, personalized covers, excerpts of existing guides, and corporate imprints.
For more information, contact:

Special Markets Department
DK Publishing, Inc.
375 Hudson Street
New York, NY 10014
Fax: 212-689-5254

Cataloging-in-Publication data is available
from the Library of Congress
ISBN 0-7566-0071-5

Printed in the UK by Butler & Tanner Limited

First printing, October 2004

SAN JOSE
The mission church of San Jose dates back to
the 1820s. Father Francis Malley of the San
Miguel parish holds services in the historic
chapel once a month and presides over an
occasional funeral.
Photo by Phillippe Diederich

NEW MEXICO 24/7

24 Hours. 7 Days.
Extraordinary Images of
One Week in New Mexico.

Created by Rick Smolan and David Elliot Cohen

DK Publishing

About the America 24/7 Project

A hundred years hence, historians may pose questions such as: What was America like at the beginning of the third millennium? How did life change after 9/11 and the ensuing war on terrorism? How was America affected by its corporate scandals and the high-tech boom and bust? Could Americans still express themselves freely?

To address these questions, we created *America 24/7*, the largest collaborative photography event in history. We invited Americans to tell their stories with digital pictures. We asked them to shoot a visual memoir of their lives, families, and communities.

During one week in May 2003, more than 25,000 professionals and amateurs shot more than a million pictures. These images, sent to us via the Internet, compose a panoramic yet highly intimate view of Americans in celebration and sadness; in action and contemplation; at work, home, and school. The best of these photographs, more than 6,000, are collected in 51 volumes that make up the *America 24/7* series: the landmark national volume *America 24/7*, published to critical acclaim in 2003, and the 50 state books published in 2004.

Our decision to make *America 24/7* an all-digital project was prompted by the fact that in 2003 digital camera sales overtook film camera sales. This techno-logical evolution allowed us to extend the project to a huge pool of photographers. We were thrilled by the response to our challenge and moved by the insight offered into American life. Sometimes, the amateurs outshot the pros—even the Pulitzer Prize winners.

The exuberant democracy of images visible throughout these books is a revela-tion. The message that emerges is that now, more than ever, America is a supersized idea. A dreamspace, where individuals and families from around the world are free to govern themselves, worship, read, and speak as they wish. Within its wide margins, the polyglot American nation manages to encompass an inexplicably complex yet workable whole. The pictures in this book are dedicated to that idea.

—*Rick Smolan and David Elliot Cohen*

American nightlight: More than a quarter of a billion people trace a nation with incandescence in this composite satellite photograph.
Photo by Craig Mayhew & Robert Simmon, NASA Goddard Flight Center/Visions of Tomorrow

The Persistence of Space

By Jim Belshaw

New Mexico casts a wary eye on lists. Too often at the top of the wrong ones and at the bottom of the right ones, New Mexicans find themselves defined by the framework of list makers far removed from the high desert.

Some lists tally too many New Mexico residents living in poverty, too many accidental deaths in the home, high teen pregnancy rates, low average teacher salaries, and so on. That said, others report that New Mexico ranks first among states in Hispanic-owned businesses, and that it's in the top 10 for female-owned businesses. In his book *The Rise of the Creative Class*, Carnegie Mellon professor Richard Florida ranked Albuquerque's creative community No. 1 among medium-sized cities and Santa Fe's No. 1 among cities with fewer than 250,000 people.

Good or bad, New Mexico cannot be summed up by computing its place on a list. Any portrait requires a subjectivity not found in the framework of lists.

A Pueblo Indian emergence myth comes to mind: When people came up from the underworld into what is now New Mexico and found a holy man of no little fierceness awaiting them, they asked if they could stay in his territory. He did not object but warned them that the land had little to offer in the way of material benefit. If they were looking for such things, he advised them, they might look elsewhere. They stayed, as did others. Now 19 Pueblo Indian tribes live here; Apache and Navajo, too. The Hispanic history of the state predates anything that happened on Plymouth Rock. Albuquerque is home to the National Hispanic Cultural Center, a splendid repository of cul-

ture and history. Ethnic minorities account for more than 50 percent of the state's population, making it a "minority majority" state.

New Mexico has long been a magnet for artists and writers, drawn by the mysteries of a place that at one moment might appear to be a foreign land and the next moment a dream—a fragment of light that caught Ansel Adams's eye, a color or shape that intrigued Georgia O'Keeffe.

D.H. Lawrence wrote: "I think New Mexico was the greatest experience from the outside world that I have ever had. It certainly changed me forever."

The novelist Tony Hillerman said of our place: "As for me, I can only say that New Mexico seems to make me want to write."

One constant is the idea of space, a vast openness that quietly insinuates itself into the subconscious if not the soul. Edward Abbey wrote of the desert: "Walk one half-mile away from the town, away from the road, and you find yourself absolutely alone, under the sun, under the moon, under the stars, within the sweet aching loneliness of the desert."

The persistence of space, sometimes cloaked in the demands and stresses of modernity, pops up in odd places to remind us of its presence. Stuck in traffic during Albuquerque's rush hour, the commuter might look west and be surprised to see Mount Taylor—Tsoodzil, the Navajo Nation's Sacred Mountain of the South. From the commuter's viewpoint on the freeway, the mountain may be 80 miles away, shimmering in the high-altitude thinness of New Mexico's air, telling us that the sweet aching loneliness of the desert is not so far away after all.

JIM BELSHAW, *a Chicago native, adopted New Mexico in 1967 while serving in the Air Force. He has written a column for the* Albuquerque Journal *for 24 years.*

CARLSBAD
From the banks of the Pecos River, sunset over Carlsbad.
Photo by Pat Vasquez-Cunningham

ROSWELL

The truth is out there: No one knows for sure what actually crashed on a ranch 20 miles north of Roswell in early July 1947. Some say it was a UFO; others say a weather balloon. Obviously, the former is more interesting, and so the town is overflowing with aliens, like this mannequin at Zone 2, an alien memorabilia store on Main Street.
Photo by Pat Vasquez-Cunningham

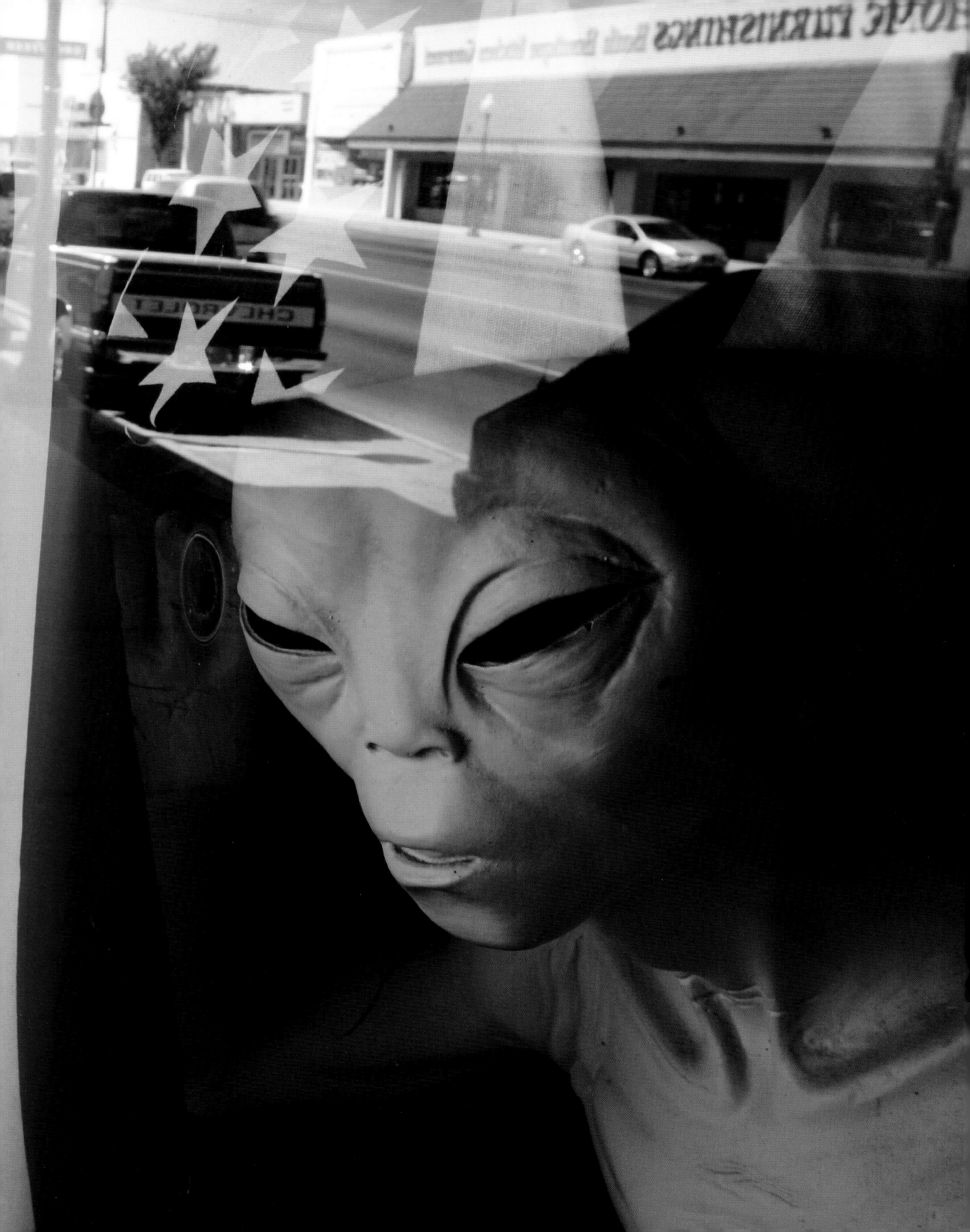

SOCORRO COUNTY

Key scenes in the movie *Contact* were filmed at the National Science Foundation's Very Large Array site west of Magdalena. The 27 antennae, each weighing 230 tons, attract scientists from around the world, who use them to detect and analyze radio emissions from our solar system and distant galaxies.

Photo by Jake Schoellkopf

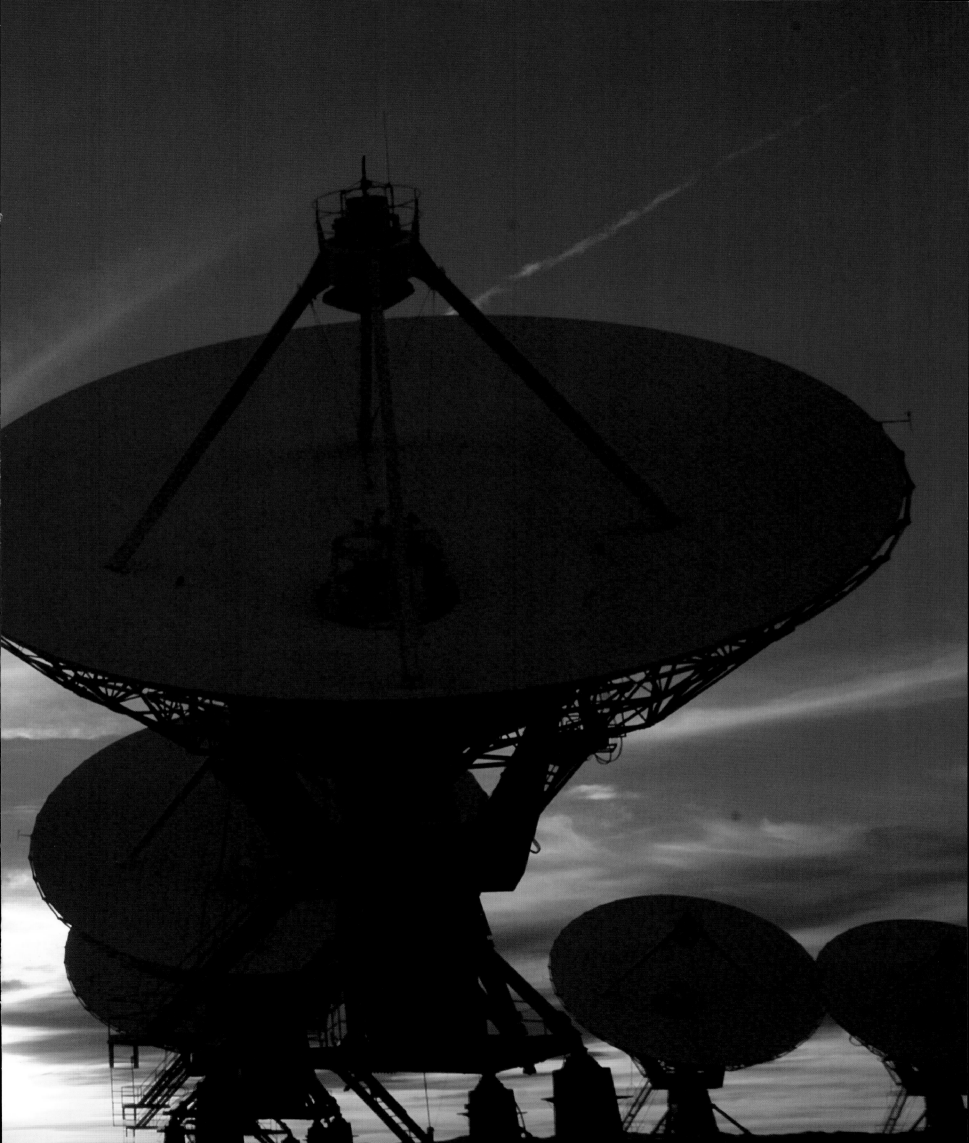

ALBUQUERQUE
On a scorching Albuquerque afternoon,
Louise Shank shades herself while selling
radishes, mint, lambs' quarters, and flower-
ing plants at the South Valley Farmers'
Market. Shank has lived in the rural South
Valley since 1969.
Photo by Richard Scibelli, Jr.

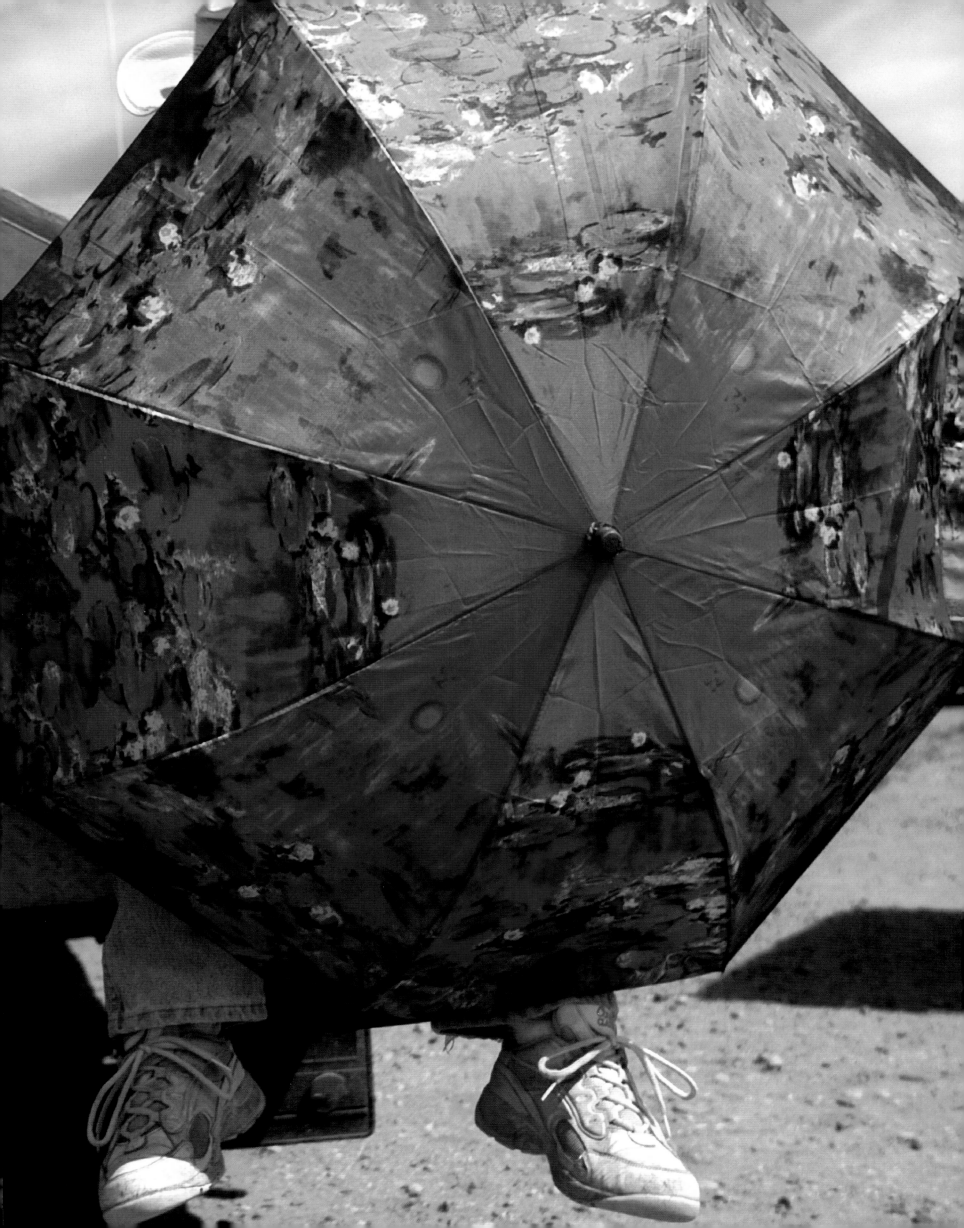

SANTA FE
Carolyn Salazar, with Baile Español, gets into the spirit of the "La Negra" during the 10th annual CommUNITY Days celebration, sponsored by the Parks & Recreation Department to entice locals to Santa Fe Plaza.
Photo by Carole Devillers

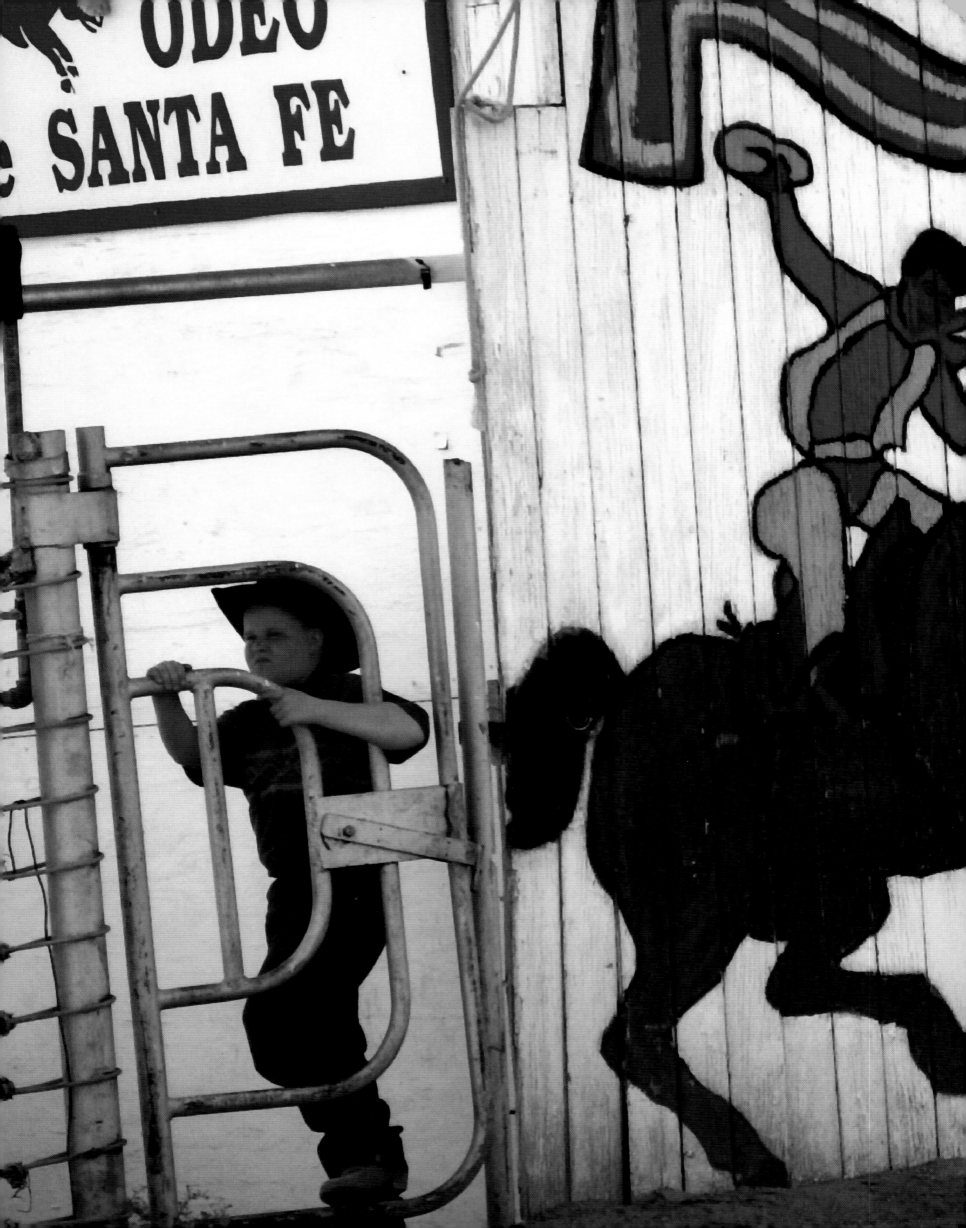

SANTE FE
Rodeo de Santa Fe is usually home to Professional Rodeo Cowboys Association events. Today, it has been turned over to the Sante Fe County 4-H and its cowboys in training.
Photo by Preston Gannaway

EMBUDO

Isaac Velasquez is the Campos family's "right and left hand." For 15 years, Velasquez has been the sole employee of the small organic farm started by Analisa Campos's grandmother, Eremita Campos.

Photo by Jamey Stillings

Hearth & Home

VILLANUEVA

After retiring from teaching in 2000, Marvel Lanstra left Washington State and moved to Villanueva, drawn by its beauty and wildlife. One night, a bear killed her chickens, ducks, and one of her goats. The other goat, Cookie, was injured and spent 10 days recuperating in the bathroom. Lanstra says she still loves the area but has purchased a gun to scare away future marauders.
Photo by Phillippe Diederich

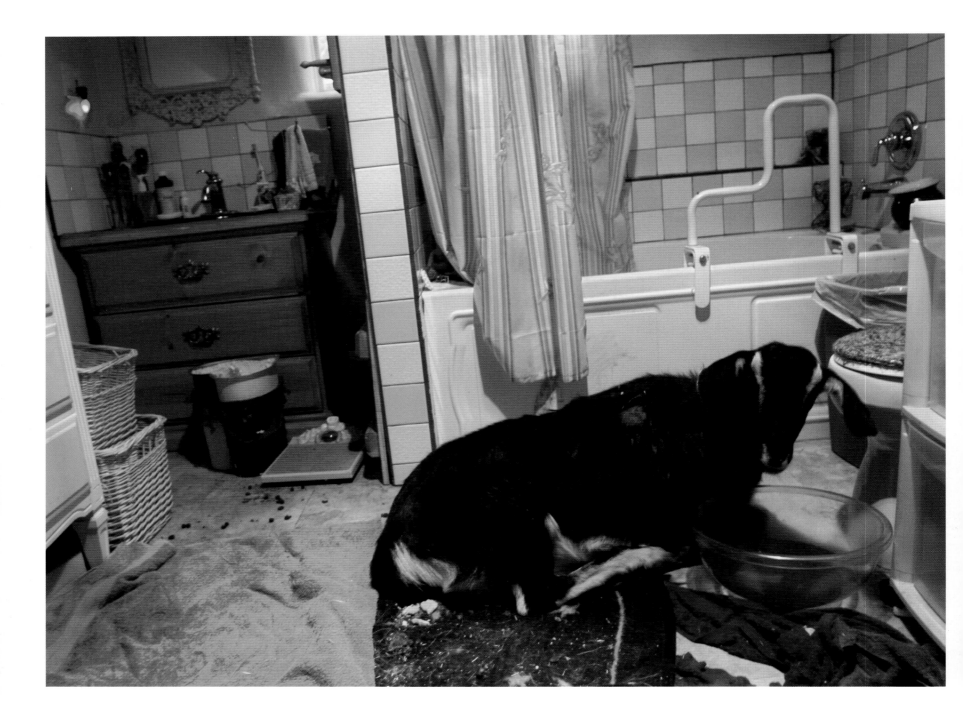

EMBUDO

A sleepy Analisa Campos awaits the watermelon breakfast her mom Margaret is slicing. The family, which runs a chemical-free farm on the banks of the Rio Grande River north of Santa Fe, grows most of their own food.
Photo by Jamey Stillings

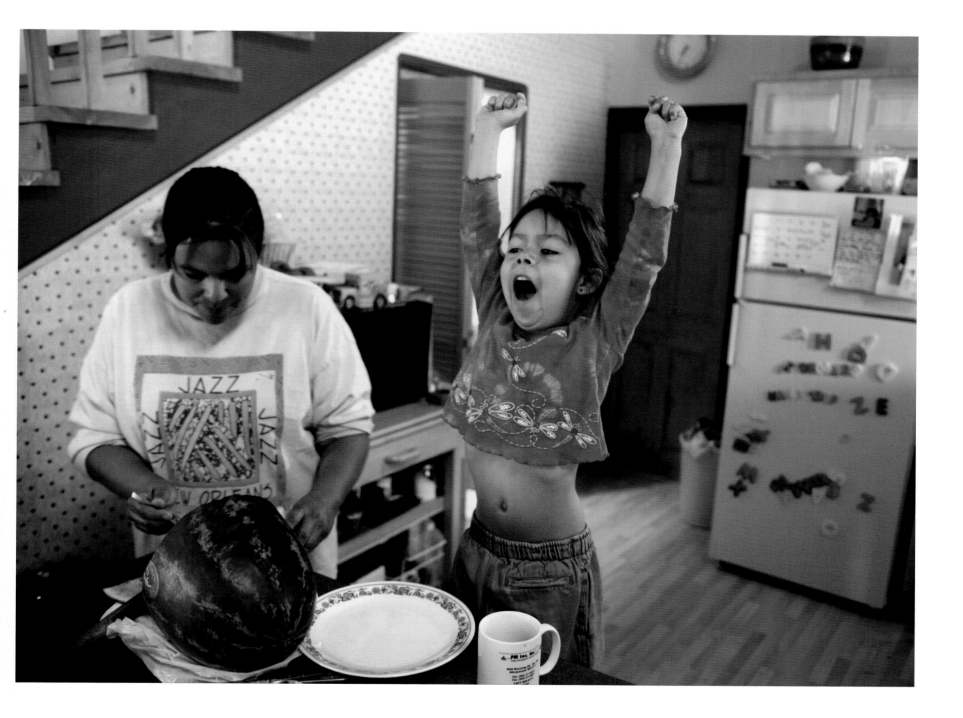

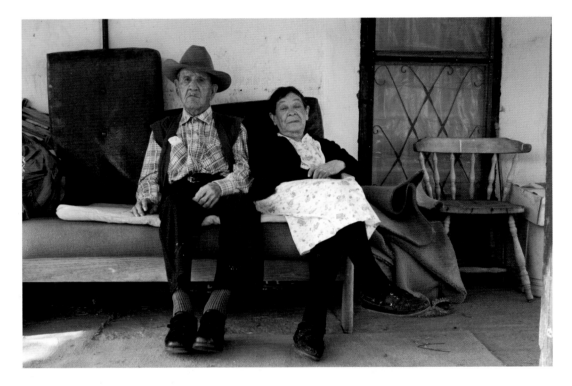

SENA

Don Pablo Aguilar and his wife Grace are known as the grand couple of Sena. In addition to raising six children of their own, they helped raise many others whose parents needed support. Pablo started out as a farmer but eventually turned to politics. Before retiring, he spent time on the school board and was a commissioner and deputy sheriff for San Miguel County.

Photo by Phillippe Diederich

SABINAL

Alvara Loughman began dating Bud Schmidt in junior high school. They married during World War II in the middle of a Nebraska blizzard, raised five children in suburban New York, and then moved to Albuquerque in 1970. Two years ago, the couple moved into a trailer near daughter Beth Crowder's farm. "We're still very much in love," Bud says.

Photo by Jake Schoellkopf

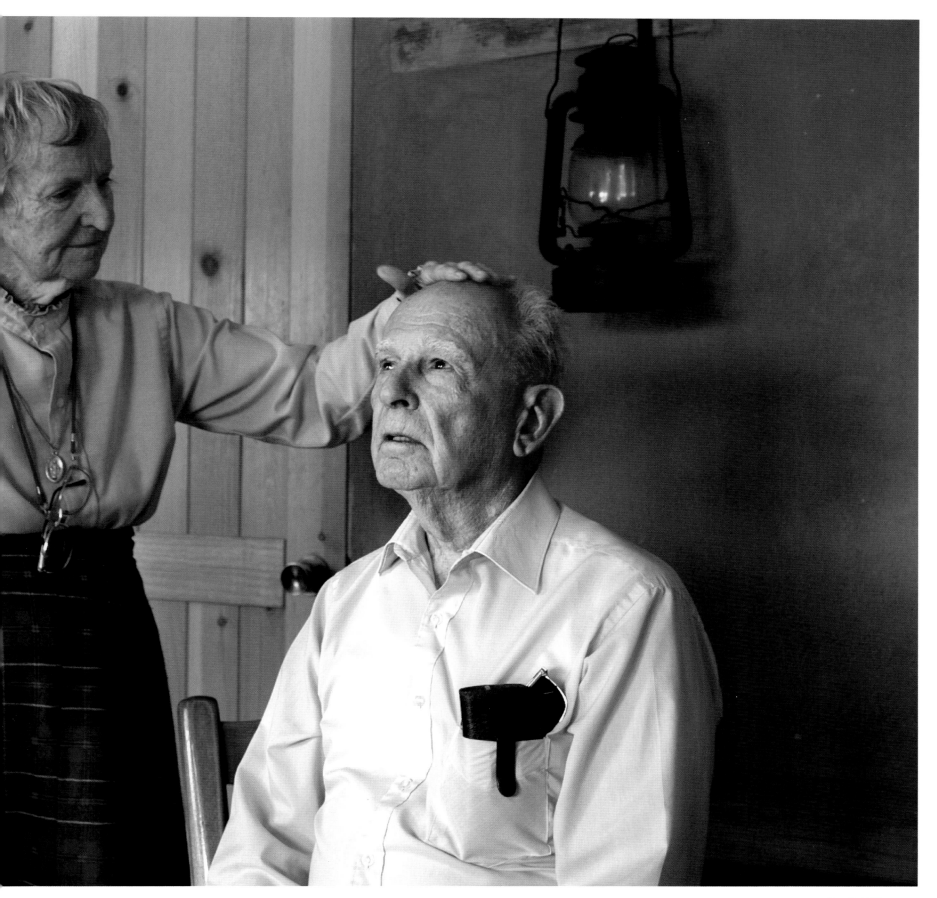

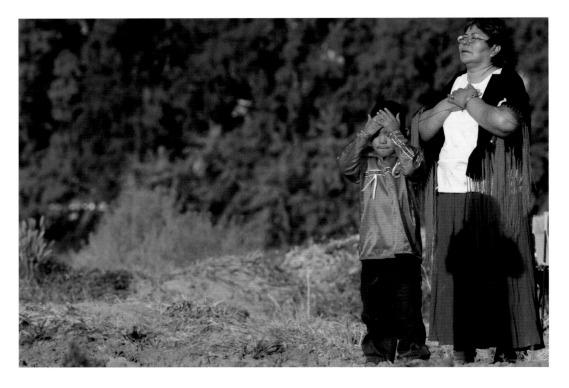

SHIPROCK

For his 6th birthday, Landius Bahe asked his mother for a prayer meeting in his honor, an all-night ceremony usually reserved for older Navajo. She honored her son's wish, and on the eve of his big day, 30 friends and relatives gave blessings for Landius's spiritual well-being.
Photos by Brett Butterstein

Landius admires his birthday gift, a feather fan presented to him by a friend who had once received it from his father as a gift.

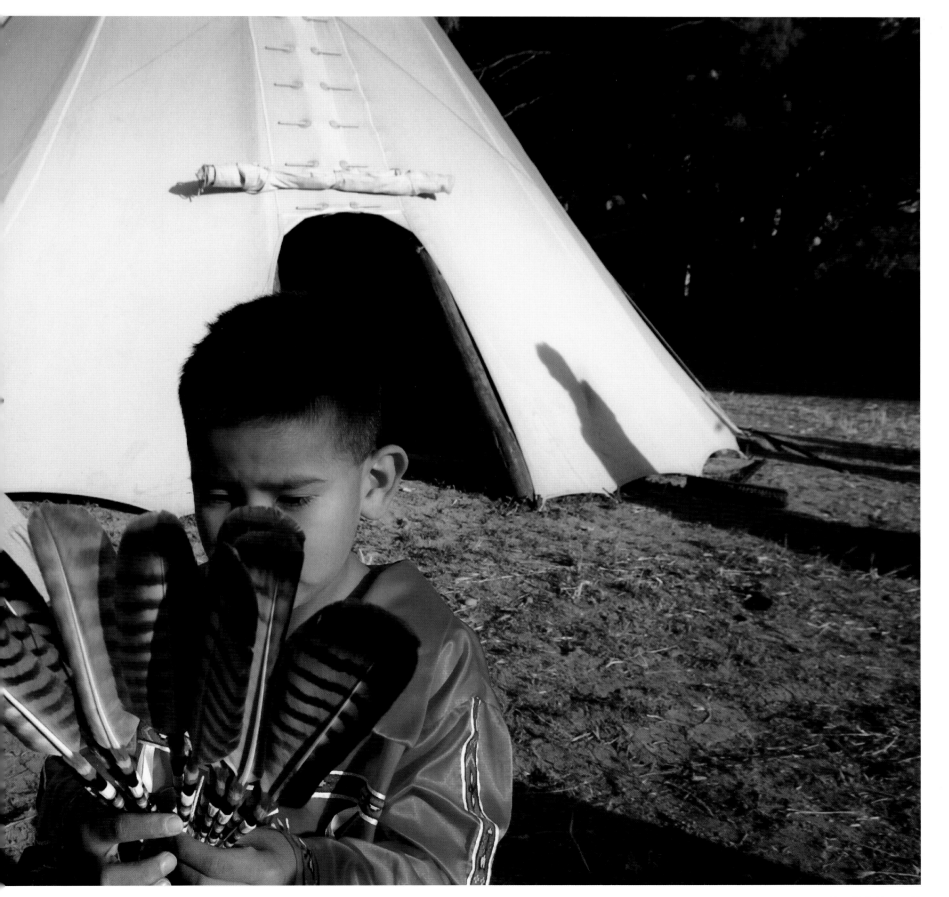

SAPELLO

It's unassuming, but the house that Betty and John Wayne bought 24 years ago is steeped in history. Formerly the Sapello Stage Station, the home was a stage coach stop on the Santa Fe Trail. Merchant traders making their way from Missouri to Santa Fe used to spend the night here.
Photos by Barbara Van Cleve

CIMARRON

"I sleep in the room I was born in," says Gretchen Sammis. Her restoration of the 130-year-old adobe homestead earned Sammis a place in the Cowgirl Museum and Hall of Fame's Western Heritage division. The retired gym teacher works her family's 11,000-acre Chase Ranch full time.

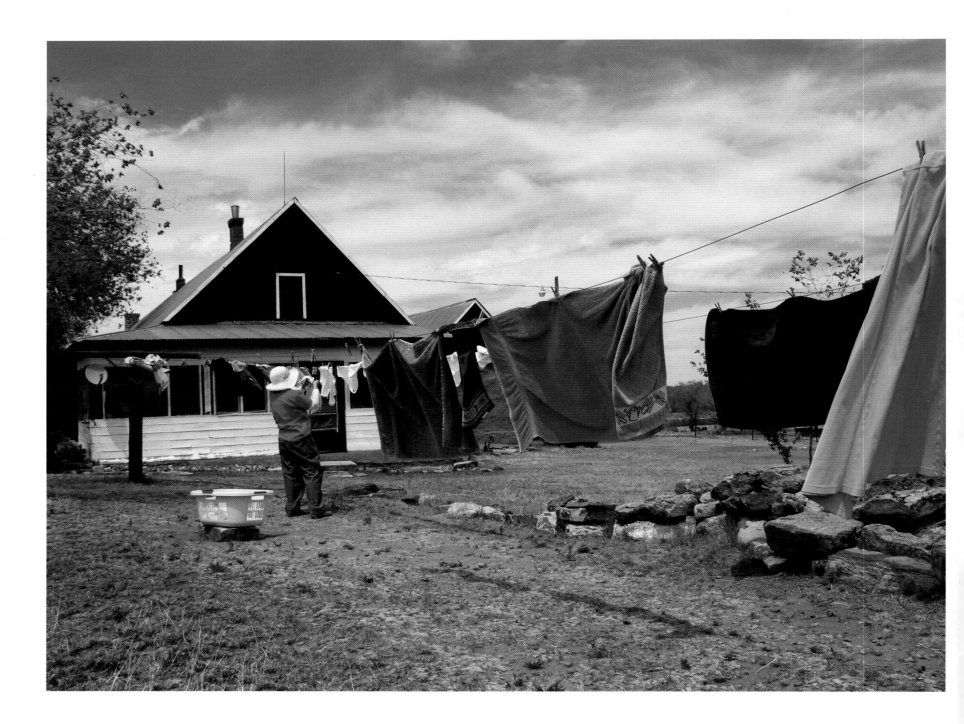

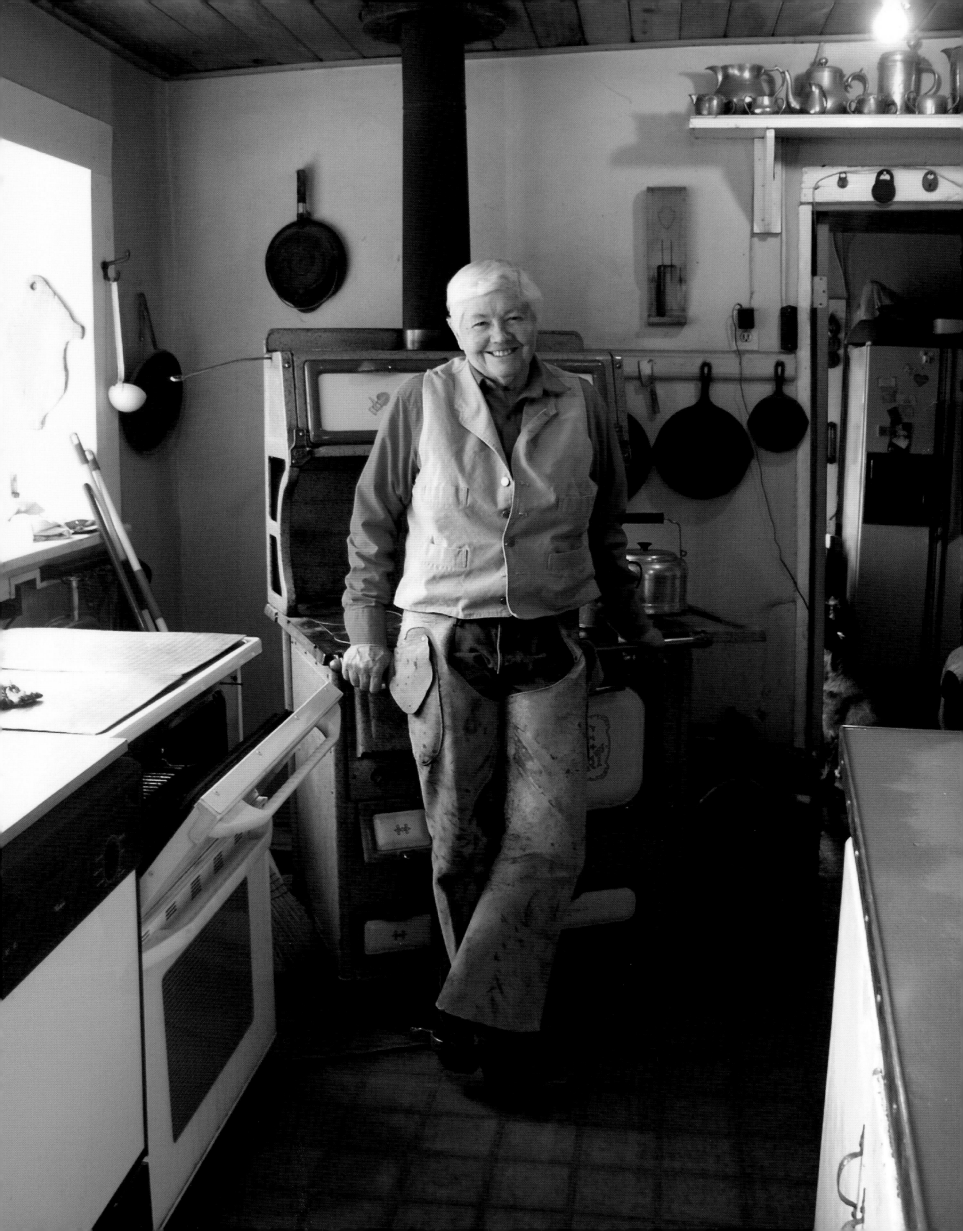

CAÑONES

Patti and Dana Foy met when they were software engineers in California's Silicon Valley. They married in 1992 and, wanting to live someplace less crowded, relocated to Cañones in the Jemez Mountains. "The change was more extreme than we'd imagined," admits Dana. Their new place is on 6 acres, surrounded by the Santa Fe National Forest.
Photos by Carole Devillers

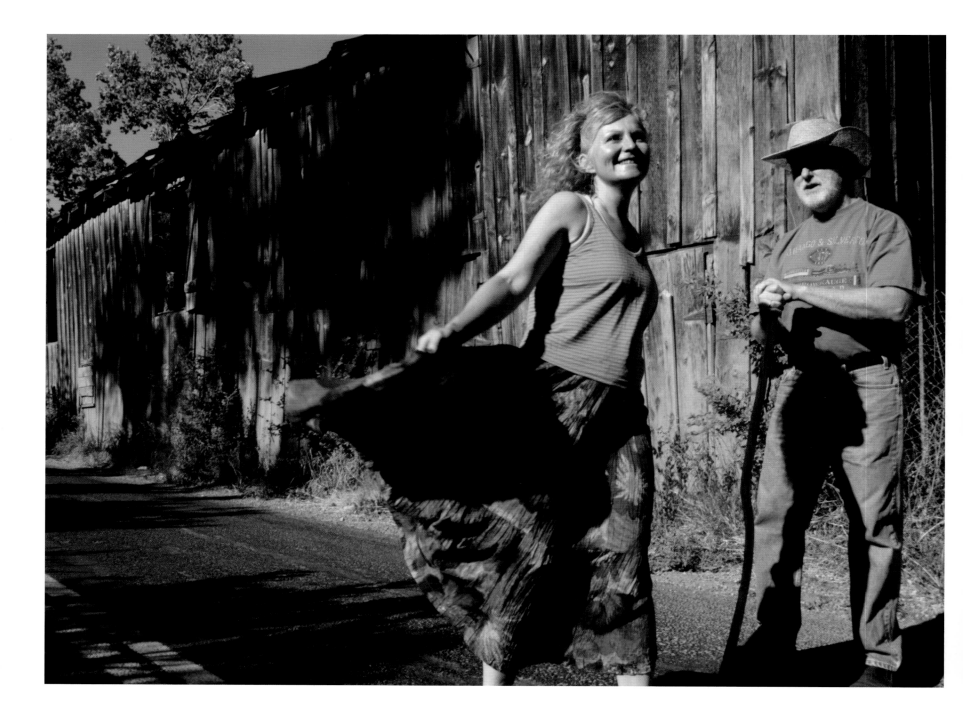

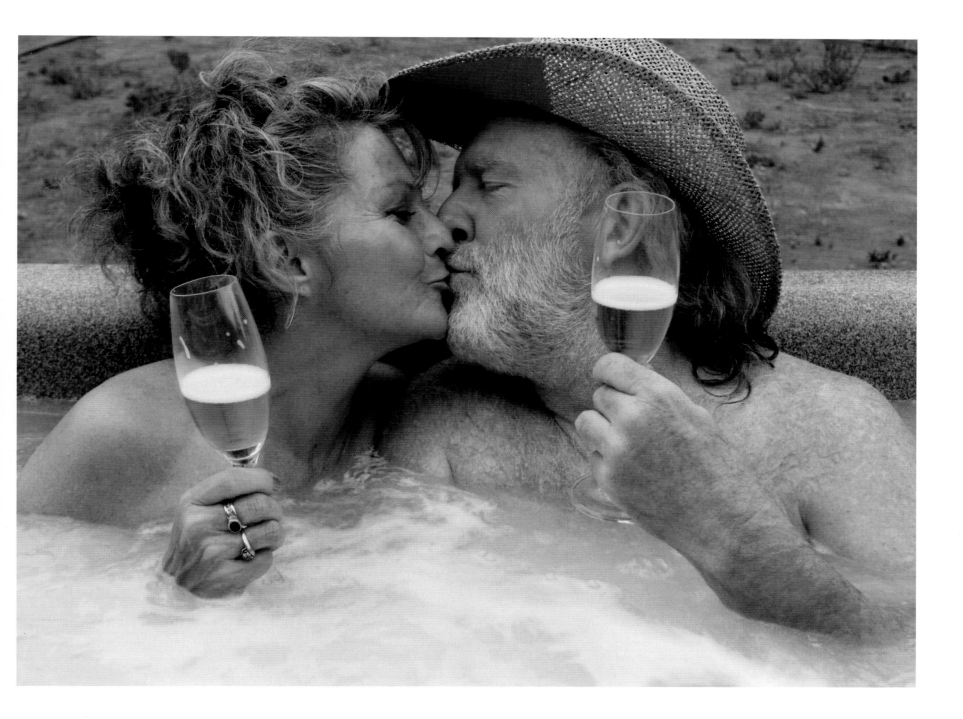

CAÑONES

After the Foys moved to rural New Mexico, Dana found he missed the intellectual stimulation of the San Francisco Bay Area. So he signed up to teach night photography at the University of New Mexico in Albuquerque, an hour away. "Patti is okay with the quiet and isolation," he muses. "I guess I need more human contact."

ALBUQUERQUE

After participating in her first—and last—sweat lodge ceremony, a dehydrated Cara Scibelli stays home sick from work for the second day in a row. Scibelli, a newspaper designer who was camping at the Navajo-run Spider Rock Campground in northeastern Arizona, accepted an invitation to participate in the two-hour cleansing ceremony in an outdoor sauna, but she failed to bring enough water.
Photo by Richard Scibelli, Jr.

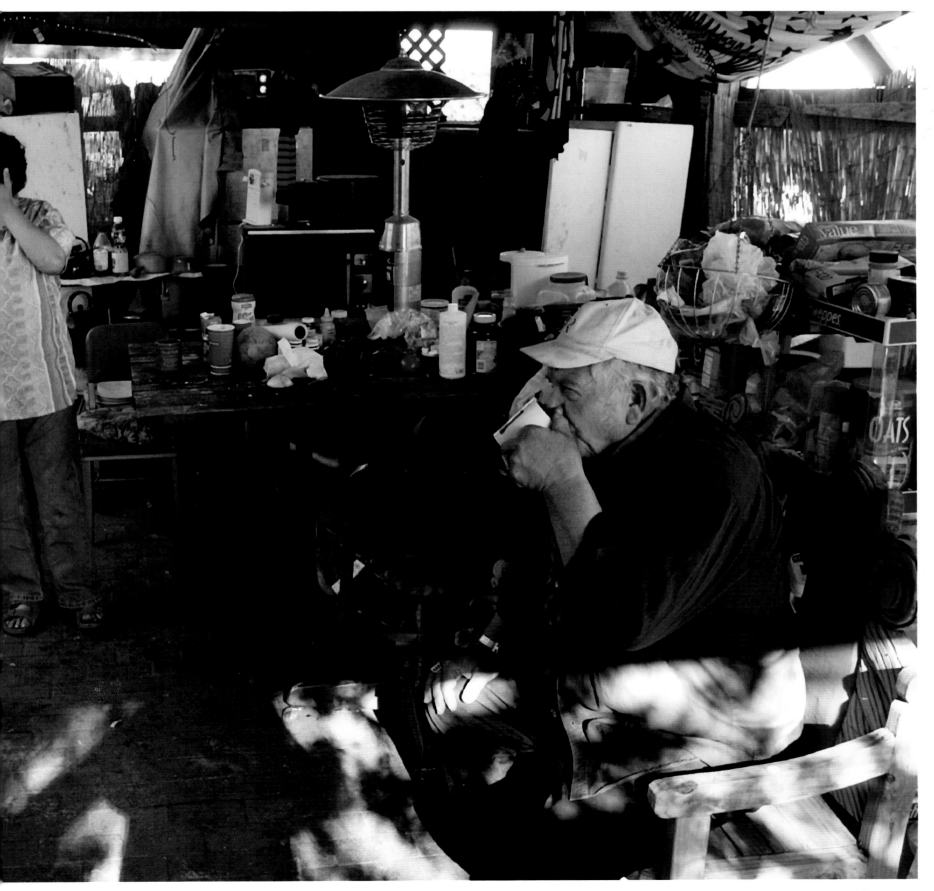

ALBUQUERQUE

Even though county officials recently closed down the Volcano Springs RV Campground, citing 30 safety violations, owner Joe Williams and his companion Cynthia Valdez have stayed on. Along with several other residents who have nowhere else to go, Williams and Valdez now live without running water or electricity.

Photo by Steven St. John

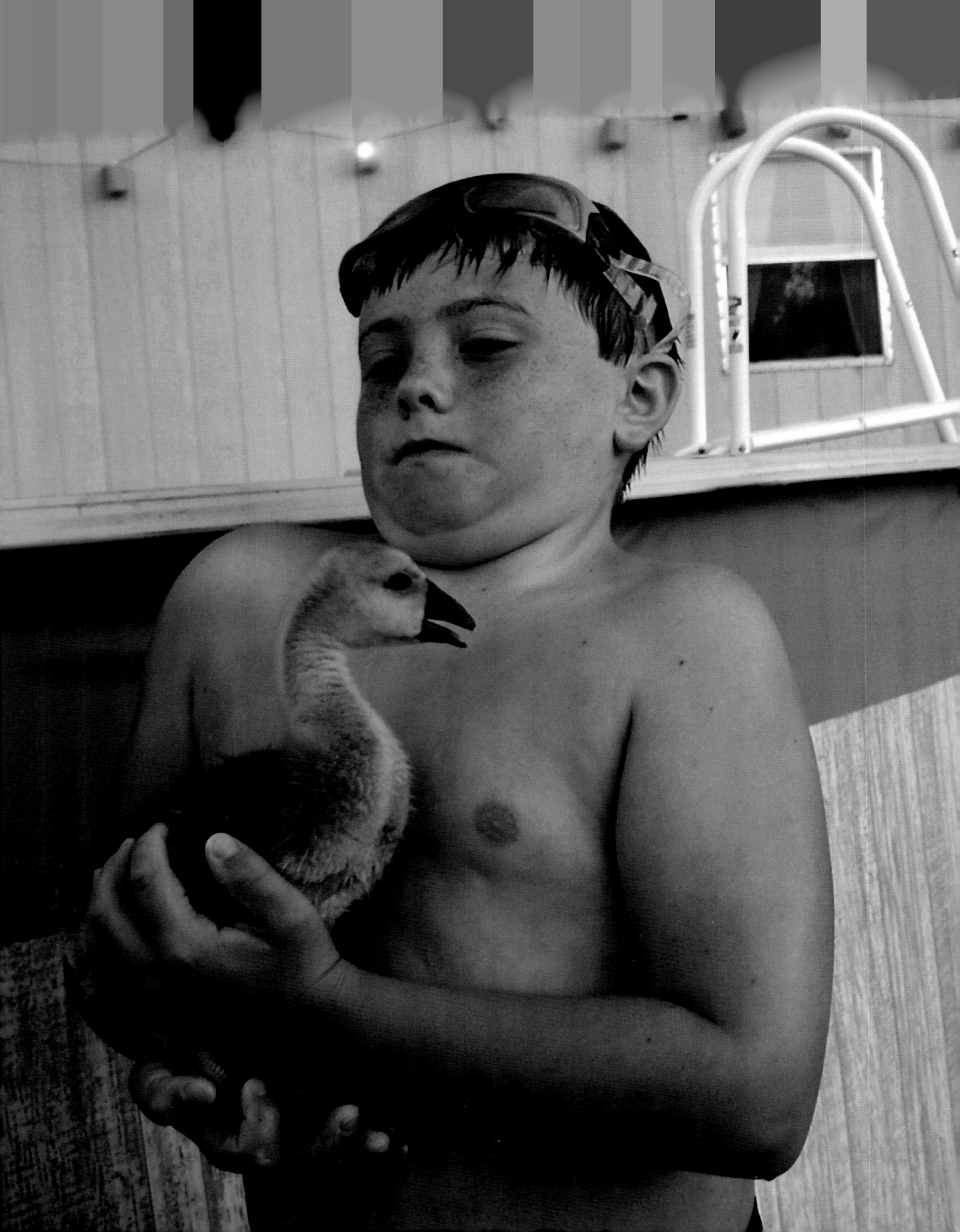

PERALTA
Several neighborhood kids, including Amiel Leiblein, came to their friend Emmett McConnell's house to take a dip in his pool. Cheese, Emmett's baby African goose, took to the water too. In addition to Cheese, Emmett has another goose...named Quackers.
Photo by Karen Kuehn

SANTA FE

Four generations of Mendozas—Manuel, Carlos, Isaiah, and Salomon—catch up on family and world affairs. A native of Mexico, Salomon came to New Mexico at the age of 17 and worked in the Ortiz Mountain coal mines until he was 35. He then learned the art of making and building with adobe. Now 94, he passed the trade onto Manuel, who built the four-plex residence in the background.

Photos by Carole Devillers

PECOS

After learning bricklaying from his dad, Manuel taught his son Carlos. Now, they're teaching Carlos's son Isaiah. The family is working on Manuel's retirement home near the town of Pecos, southeast of Santa Fe. The 4-year-old seems eager, but Manuel says most of the kids prefer computers and video games.

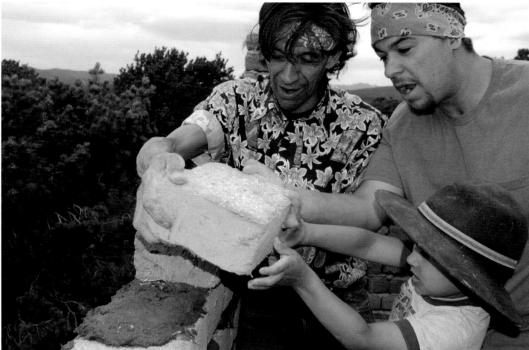

SANTA CRUZ
Anani Frost and Kahlil, 22 months, make their way home through a strawberry patch on a neighbor's organic farm. A part-time massage therapist, Frost gave birth to her son at home with the help of a midwife.
Photo by Esha Chiocchio

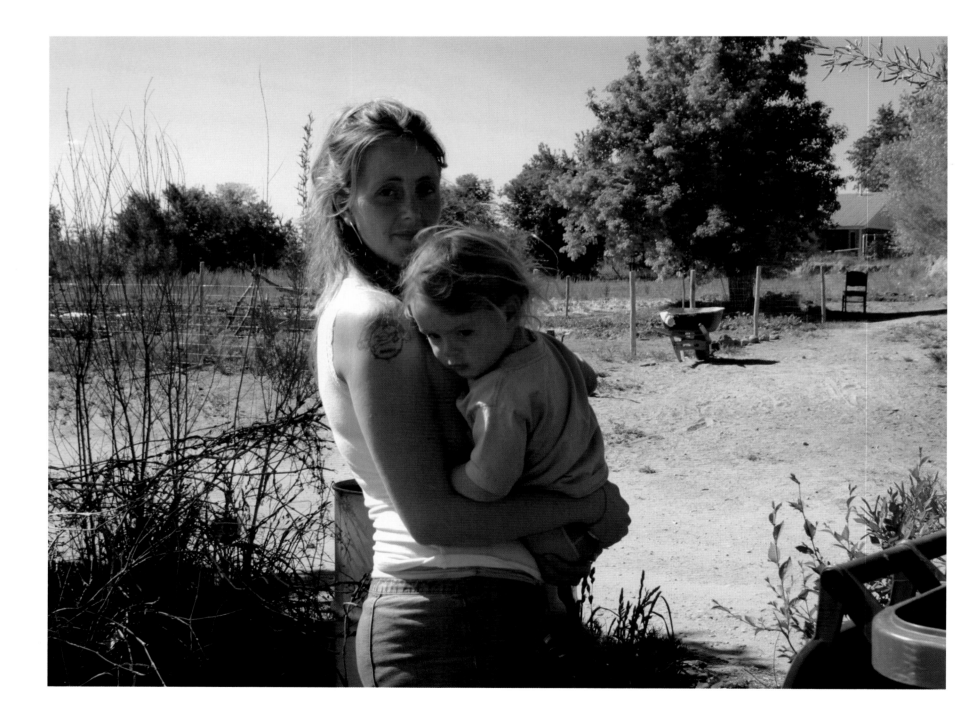

CUBA

Anna Schulte and her son Jacob share a love of horses. She's an accomplished equestrian who specializes in vaulting (gymnastics on horseback), and he's learning saddle tricks. The two often ride together through a nearby 360-acre wilderness preserve where her grandmother's old house still stands.

Photo by Eli Reed, Magnum Photos, Inc.

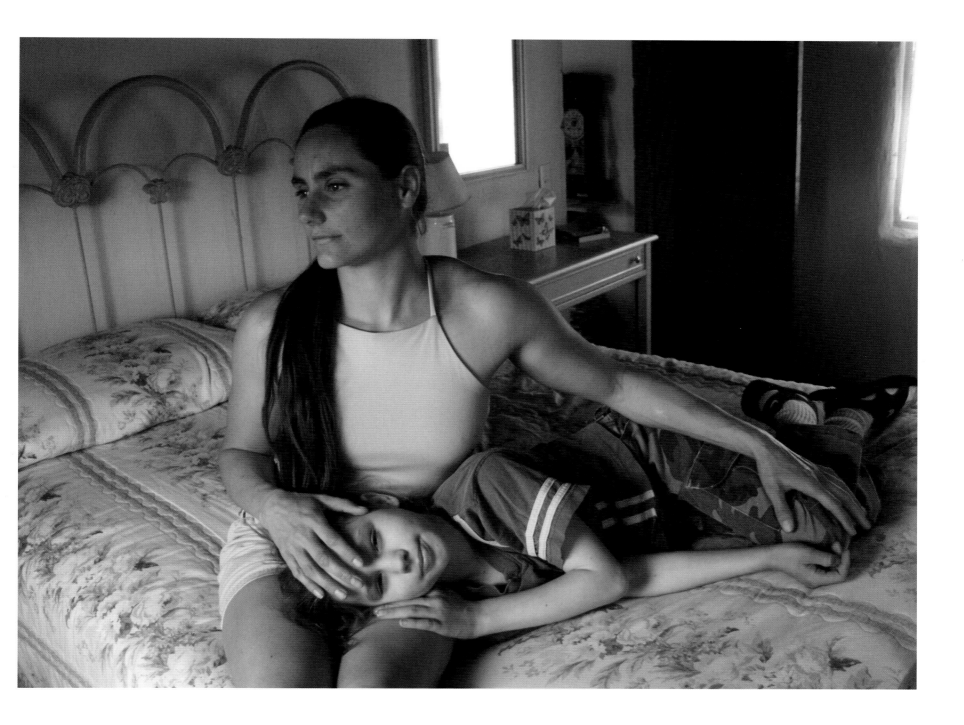

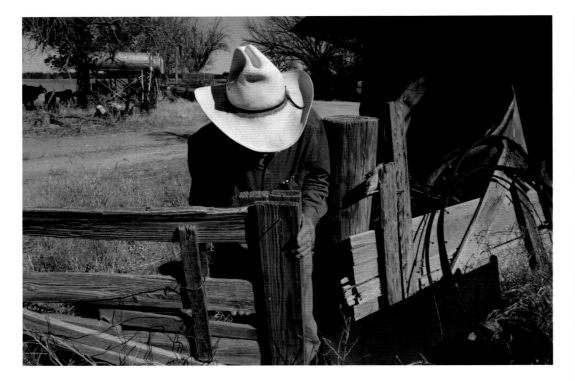

CARLSBAD

Eighty-year-old cowboy Jesse Rayroux continues to work on his 150-acre ranch in La Huerta, a section of Carlsbad. Rayroux raises feed cattle and irrigates his wheat and alfalfa crops every day. His Swiss father came to Carlsbad as a boy in 1895.
Photo by Pat Vasquez-Cunningham

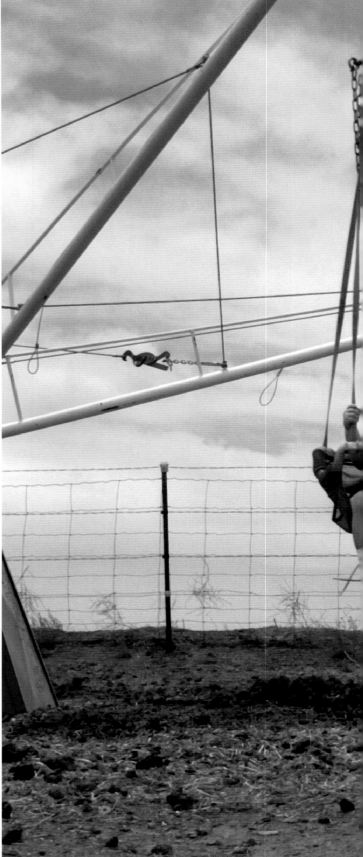

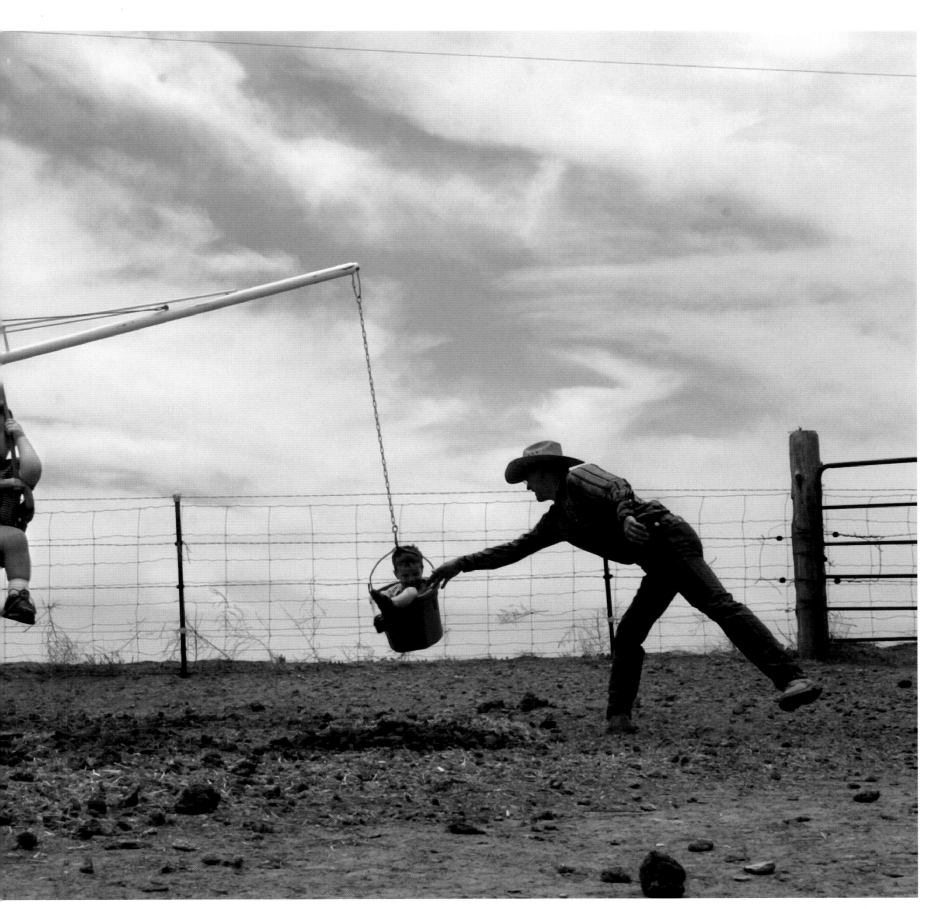

STANLEY

Normally, Earl Brayman uses the horse walker for the paint horses he and his wife Jennifer raise. Today, it serves as a carnival ride for grandchildren Tyler Ortiz and Jacob Schmit.
Photo by Jennah Ward

MORIARTY

Bill Rogers and his wife Mary have lived and worked on their 40-acre farm since 1956. In those 47 years, a lot of stuff has accumulated. Rogers wends his way through some of it en route to feed the dogs.

Photos by Jennah Ward

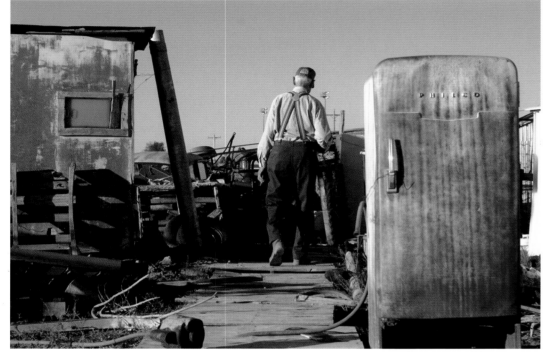

MORIARTY
Born in Oklahoma, 87-year-old Bill Rogers, who naps while his wife reads the newspaper, traveled to New Mexico in a covered wagon with his parents when he was a year old.

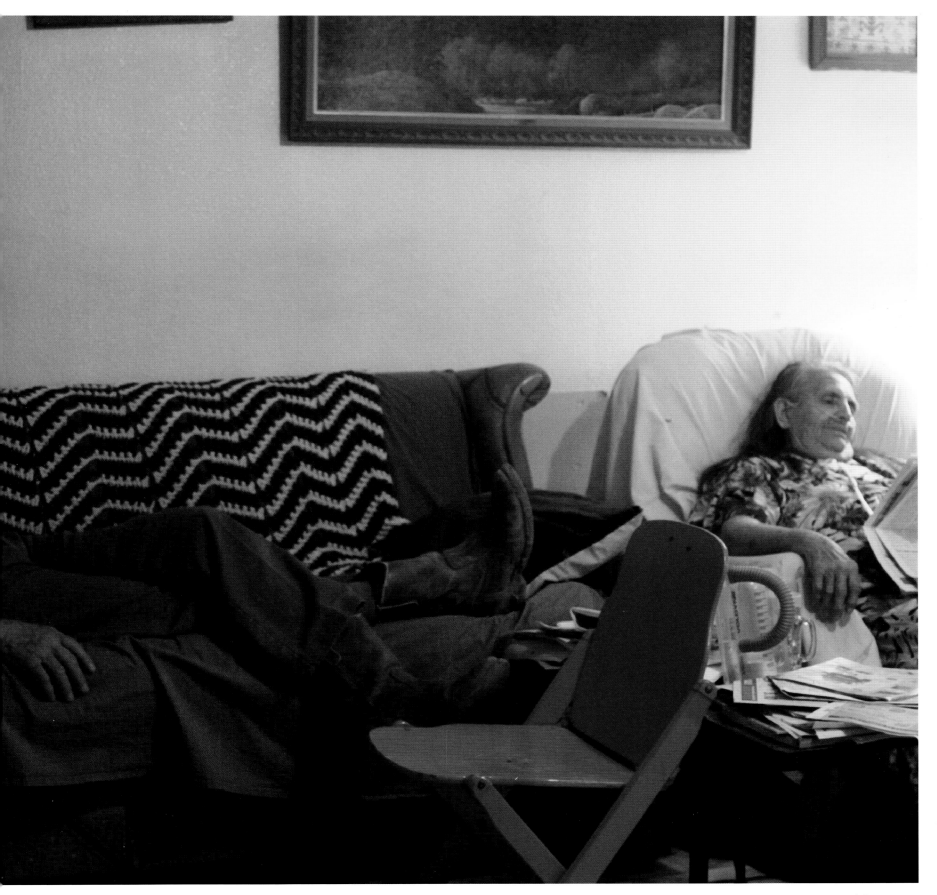

The year 2003 marked a turning point in the history of photography: It was the first year that digital cameras outsold film cameras. To celebrate this unprecedented sea change, the *America 24/7* project invited amateur photographers—along with students and professionals—to shoot and, via the Internet, submit digital images. Think of it as audience participation. Their visions of community are interspersed with the professional frames throughout this book. On the following four pages, however, we present a gallery produced exclusively by amateur photographers.

WHITE SANDS NATIONAL MONUMENT Making sand angels helps Moriah Lockhart cool off in the dunes.
Photo by Kellie Lockhart

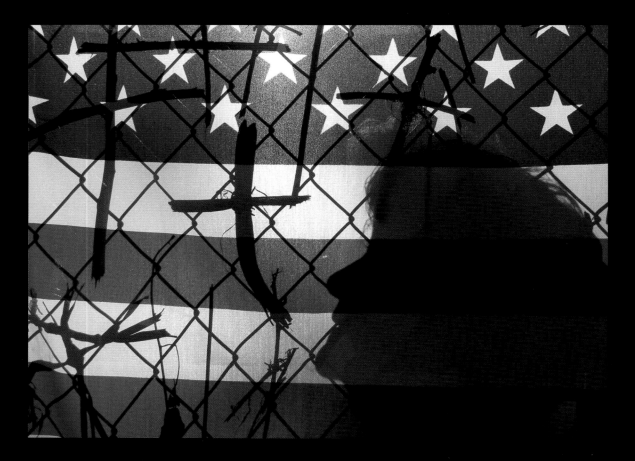

CHIMAYO After praying at Santuario de Chimayo, a church renowned for its holy soil, Mary Turner stands by the fence decorated with a flag and twig crosses. *Photo by Taralyn Quigley*

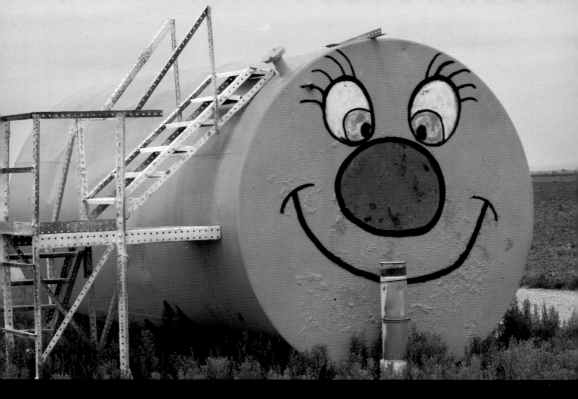

MORIARTY This cheerful fuel storage tank offers some distraction for travelers driving the lonesome 30-mile stretch of Route 41 between Moriarty and Willard. *Photo by Paul Jaeger*

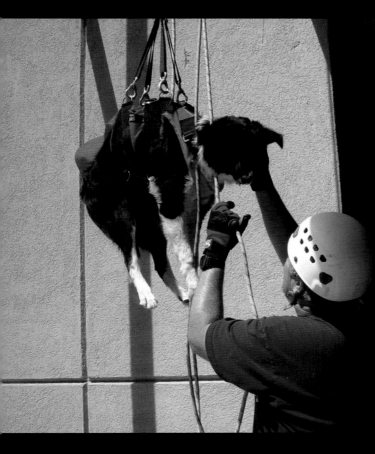

CARLSBAD Rick Wiedenmann, a volunteer with Search Dog Southwest, teaches border collie Tess to ride in a

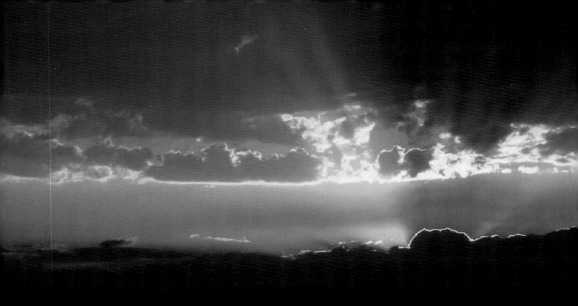

SANTA FE Viewed from I-25, the sun drops beneath the horizon and paints the clouds with molten gold.
Photo by Adam Conner

ACONITA After she survived grueling chemotherapy treatments for non-Hodgkins lymphoma, Carolyn Young's family bought her a horse. She and Terbay have been best friends ever since.

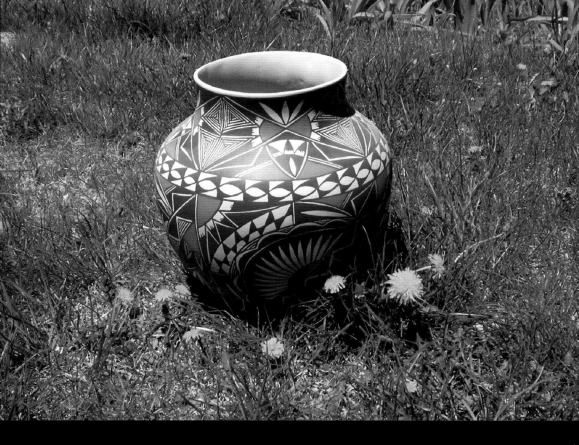

CEDAR CREST New Mexico has 19 Indian pueblos, each distinguished by their social order, religious practices, and art. This piece of pottery is from the pueblo of Laguna.
Photo by Teresa Espindola

TENT ROCKS A greenleaf manzanita ekes out its existence in the sandstone formations at Kasha-Katuwe Tent Rocks National Monument. *Photo by Roger Levien*

STANLEY
Earl Brayman, right, and his buddy Bob Contreras get into roping competition shape on Brayman's 8.5-acre farm, 50 miles east of Albuquerque.
Photo by Jennah Ward

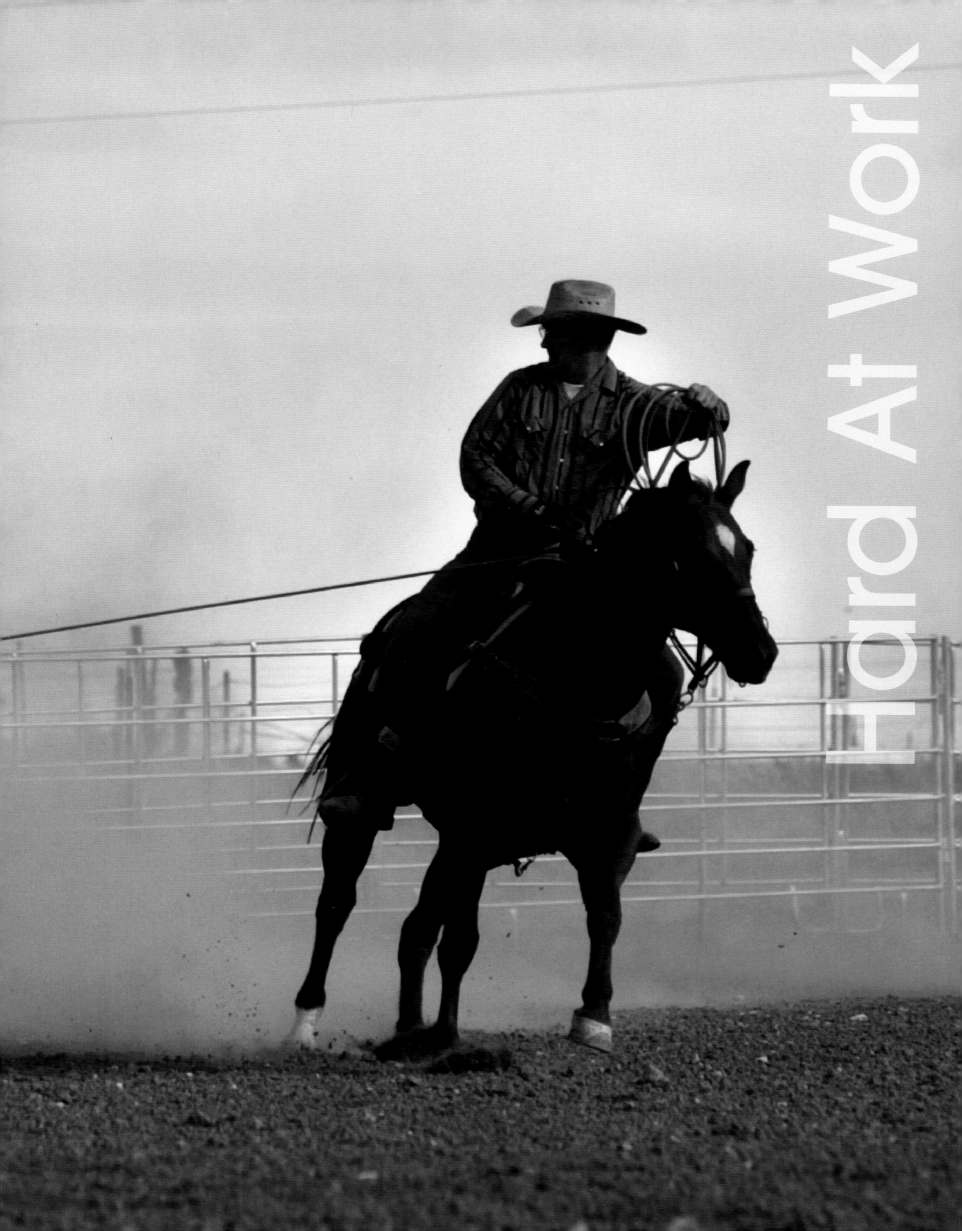

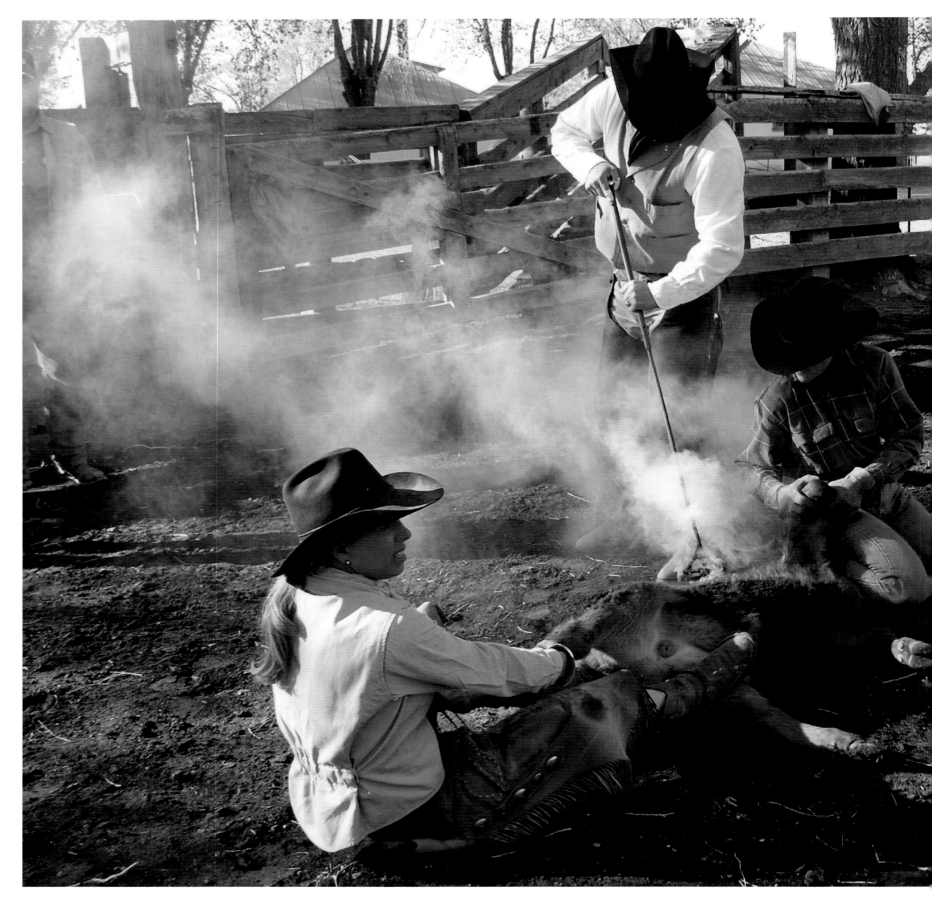

CIMARRON

All in the family: Six Davis siblings and their spouses pitch in to run the sprawling CS Ranch. While his sisters-in-law Mary (left) and Trina hold down a calf, Randy Davis does the flanking. Each family member is responsible for some part of the 180,000-acre operation, including ranch management, marketing, and leading hunting expeditions.

Photos by Barbara Van Cleve

CIMARRON

In the late 1800s, cowboys drove huge herds of cattle across the country in pursuit of grazing lands. As they moved about, different herds got mixed up, making identification marks critical. Brands were originally painted on, but the long drives and rustlers forced ranchers to adopt a more permanent type of marking—burned into the animals' hide with hot irons.

CIMARRON

Randy Davis wears a cowboy's essential equipment—chaps, boots, and spurs. Spurs date back to the first century when Romans developed them to steer their horses, leaving their hands free to fight. The original spurs had a single, sharp point; rowels like these were developed in France in the 10th century.

SANTA FE
Born to be shorn: Alpacas chow down on
hay after losing their coats. Alpacas de Santa
Fe ranch imports the animals from Peru and
Chile and breeds them. Nearly 3,000 alpaca
farms exist in America. Known as the "fiber
of kings," alpaca wool is used for clothes,
scarves, and blankets and comes in 22 hues.
Photo by Carole Devillers

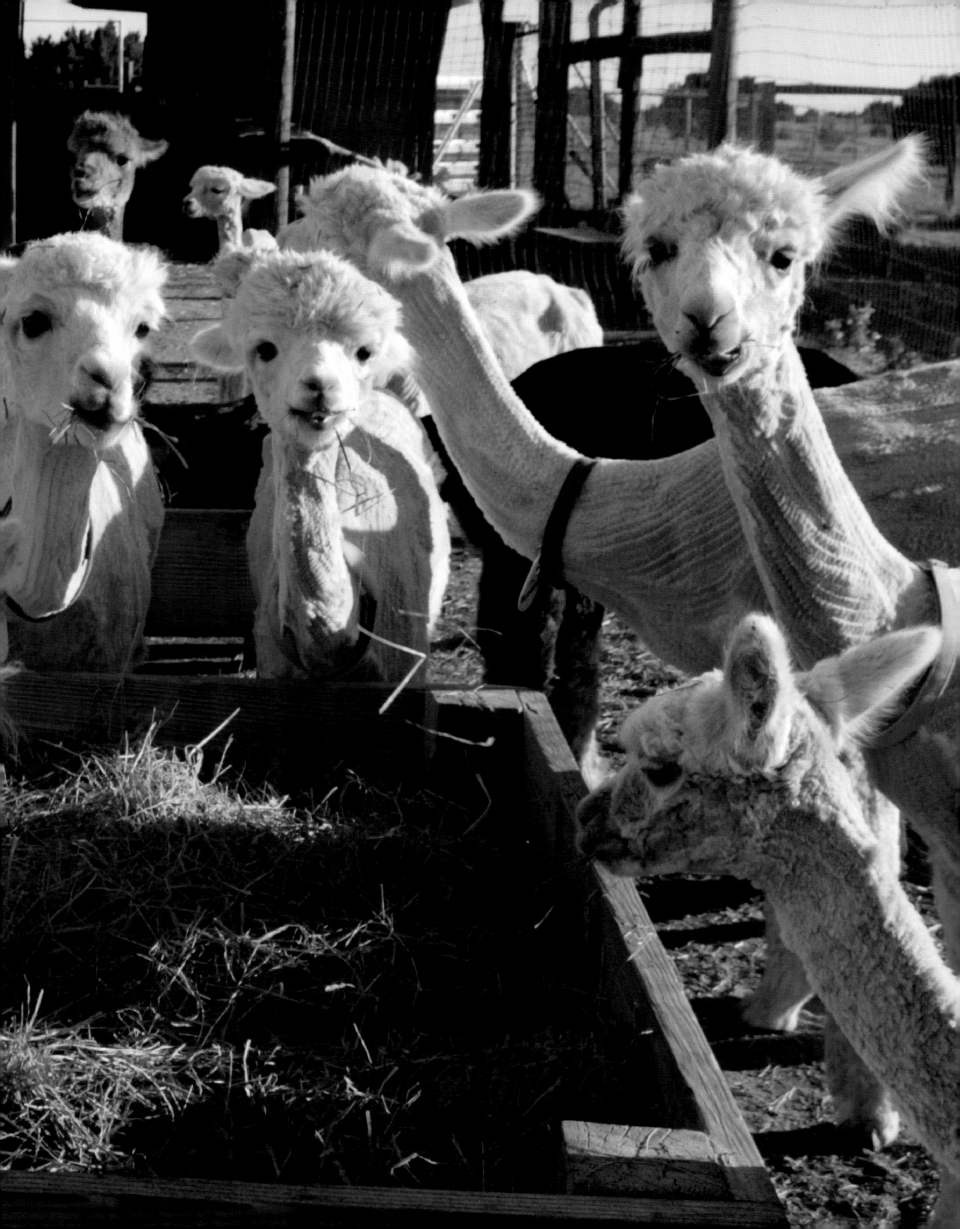

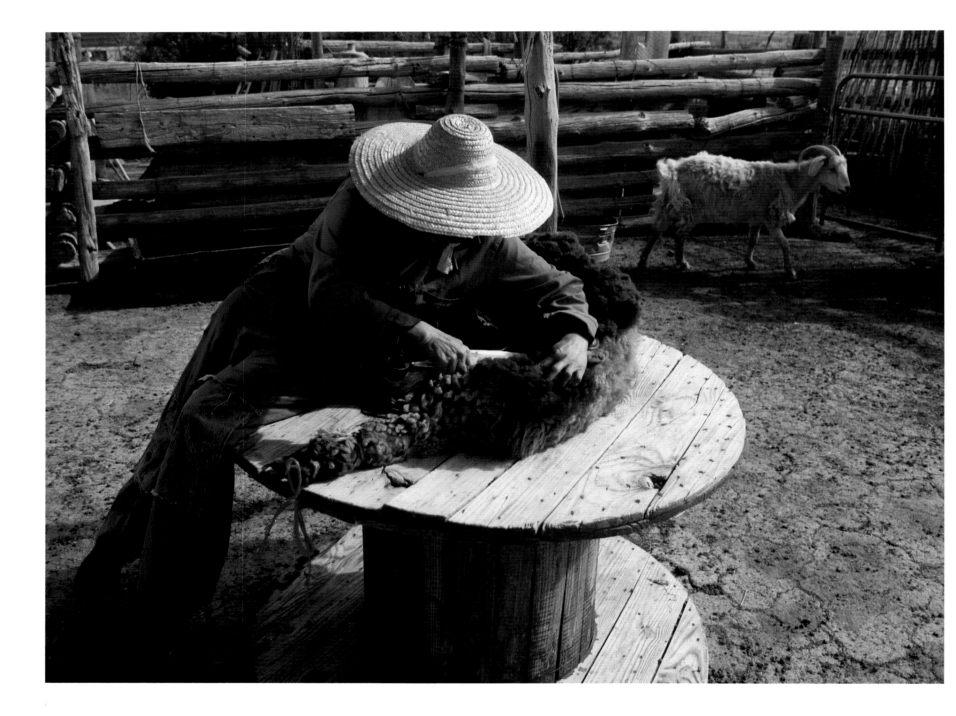

TWO GREY HILLS

At the Two Grey Hills Trading Post, Navajo social worker Irma Henderson spends her evenings and weekends shearing her 24 Churro sheep. She also spins and weaves their wool. The first breed of sheep in the New World, the Churro is sacred to the Navajo and was listed as a federal Endangered Species in the 1970s, but it has recently made a comeback.

Photo by Stacia Spragg, The Albuquerque Tribune

ALBUQUERQUE

Since 1945, The Man's Hat Shop on Route 66 has been selling fedoras, yachting caps, pith helmets, Greek fishermen's hats, and, of course, cowboy hats. Here, owner C. Stuart Dunlap, who inherited the business from his father, uses steam to shape a cowboy hat.

Photo by Steven St. John

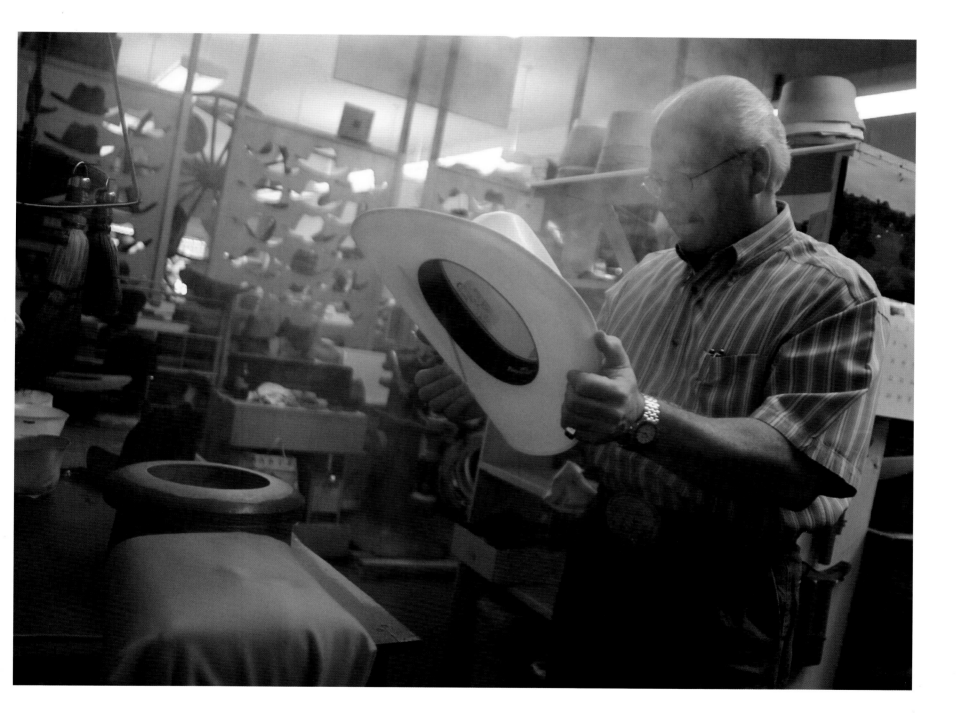

Eventually these eggs at Privett Hatchery, one of the country's largest mail-order hatcheries, will produce chickens, ducks, geese, turkeys, and pheasant. Within 48 hours, the chicks are boxed and shipped, reaching customers in 50 states and Puerto Rico.
Photos by Karen Kuehn

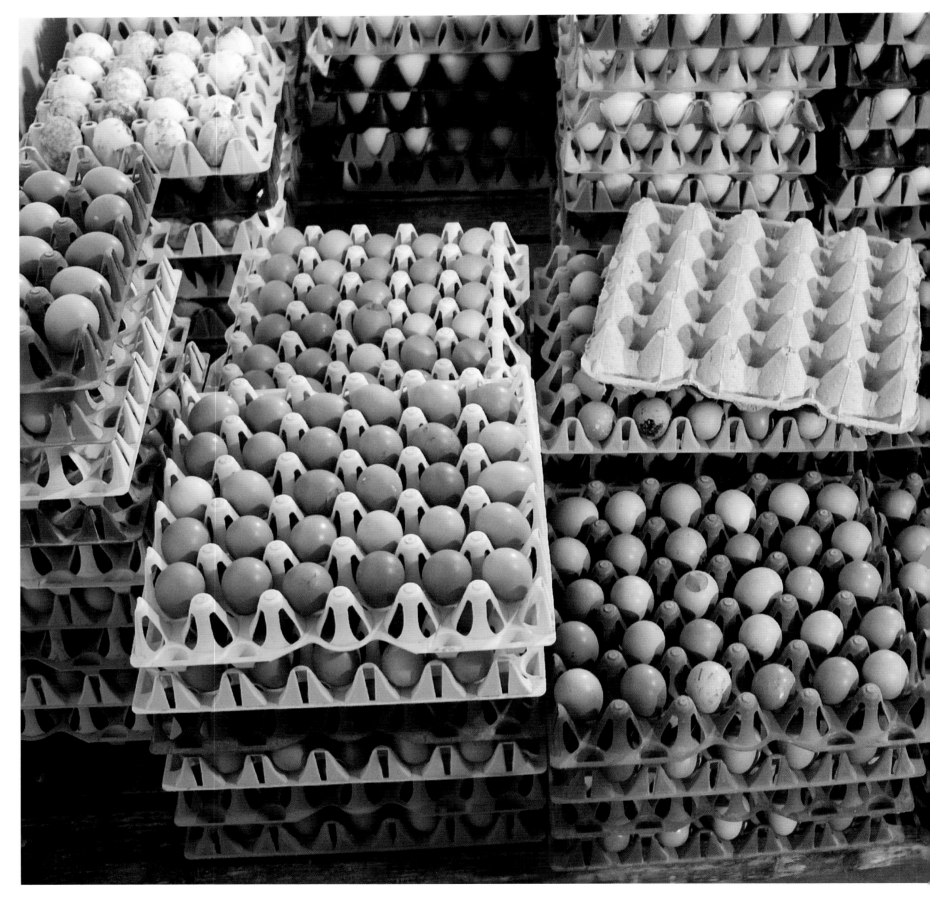

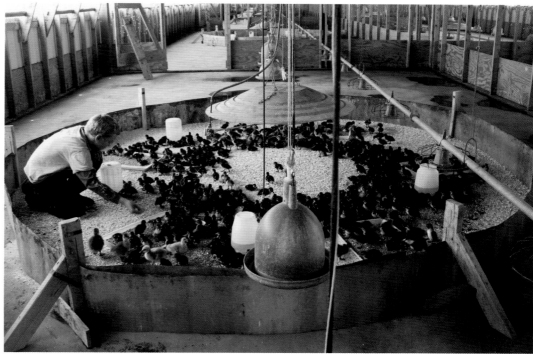

PORTALES
Jimmy Privett checks on some newly hatched baby ducks in the brooder ring. The brooder is the heater that hangs above the center of the ring. Privett has been in the mail-order hatchery business since 1959.

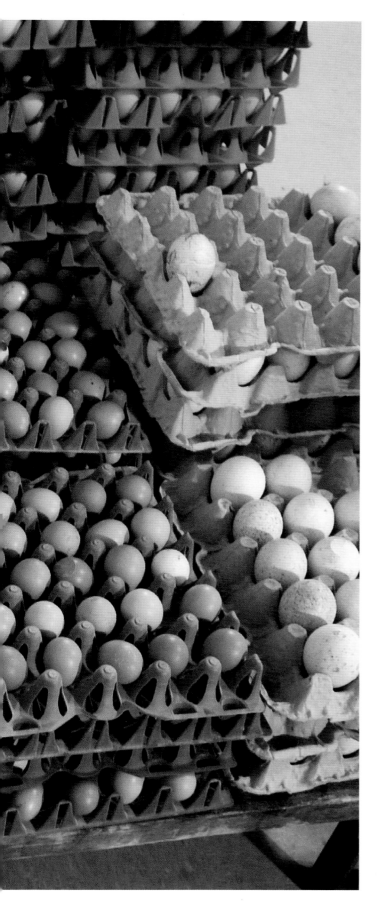

Coyotes are weaned on regurgitated food, so they greet their pack leaders with licks across the mouth. In this case, love is also at play. Renee Rice-McClure, a volunteer at Wildlife West Nature Park, has a special relationship with Carrie, a 5-year-old coyote orphan. They even practice howling together.
Photos by Carole Devillers

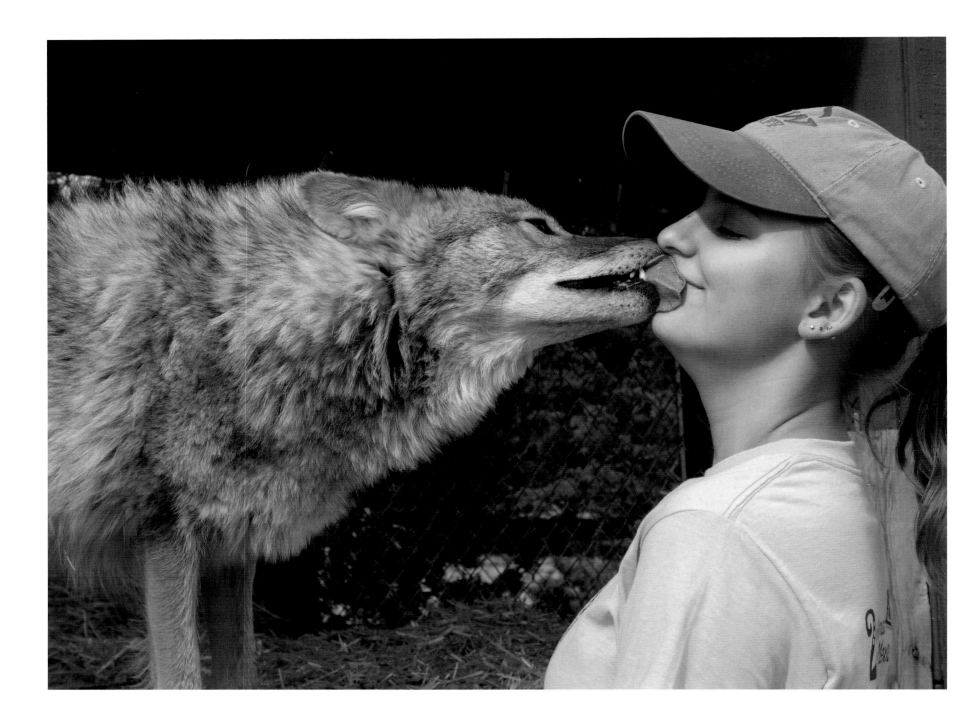

EDGEWOOD

After retiring from the Houston Fire Department, Bill Brown and his wife moved to New Mexico, and he became a volunteer at Wildlife West. When Moon Shadow arrived, Brown helped raise him and took him to visit schools. Now, the mountain lion weighs 120 pounds—too big to leave the park—and Brown is the only person he allows in his cage.

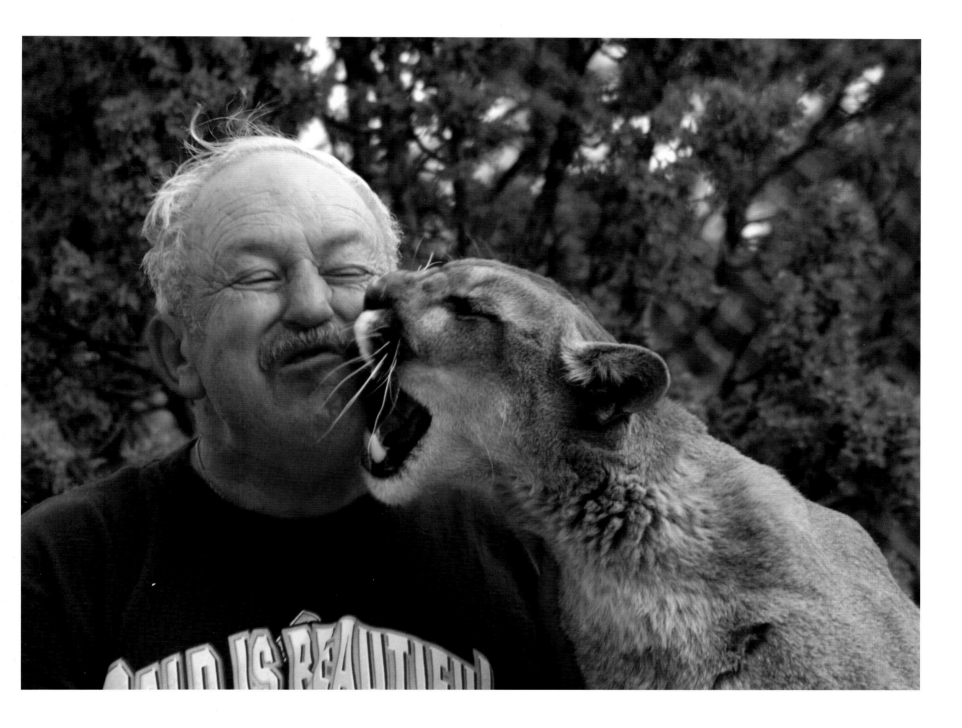

SENA
Arturo Gallegos grows corn, cucumbers, and five kinds of chiles on land his family acquired more than 100 years ago as part of the San Miguel del Bado grant for people of Pueblo or Hispanic ancestry. The crops are sold at local farmers' markets. The un-married 63-year-old is training three neph-ews to take over when he retires.
Photo by Phillippe Diederich

ALBUQUERQUE

Once used just in sporting complexes, artificial grass is growing in popularity throughout New Mexico, as residents realize that the driest state in the union can no longer support lush lawns. Richard Sandoval, Nick Whitson, and Richard Montoya of Real Turf and Putting Greens roll out turf for a yard on Crested Butte N.E.
Photo by Michael J. Gallegos,
The Albuquerque Tribune

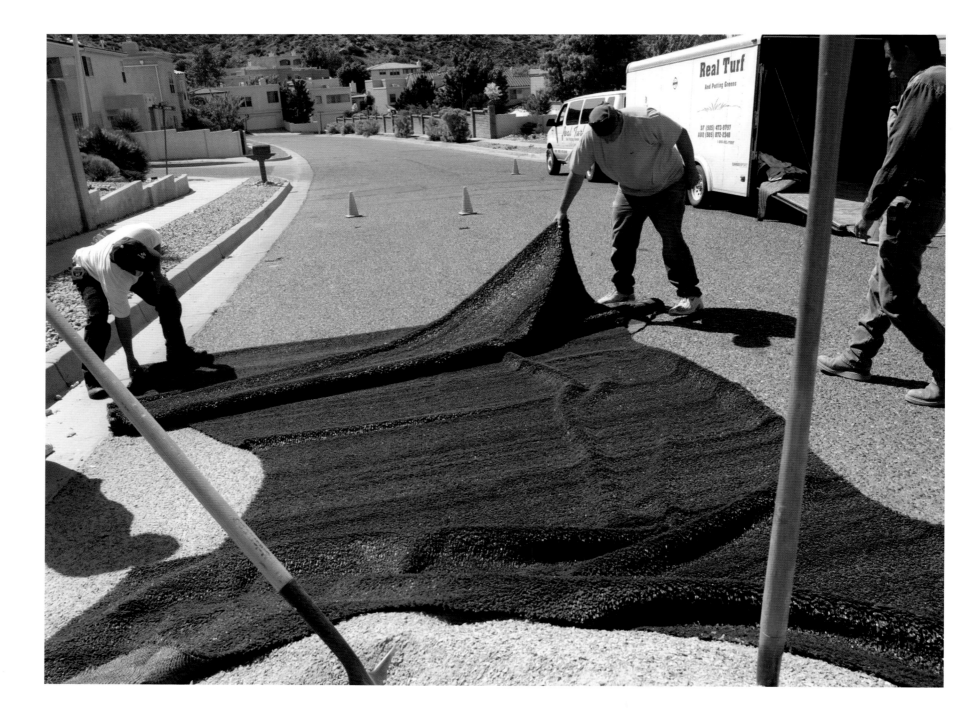

CARLSBAD

Located in the remote Chihuahuan Desert, the Waste Isolation Pilot Plant facilities include disposal rooms located 2,150 feet underground in a 2,000-foot-thick salt formation that's been stable for more than 200 million years. Waste handling technician Marcus Ingram enters inventory information after containers of radioactive waste were moved into their final resting place.
Photo by Pat Vasquez-Cunningham

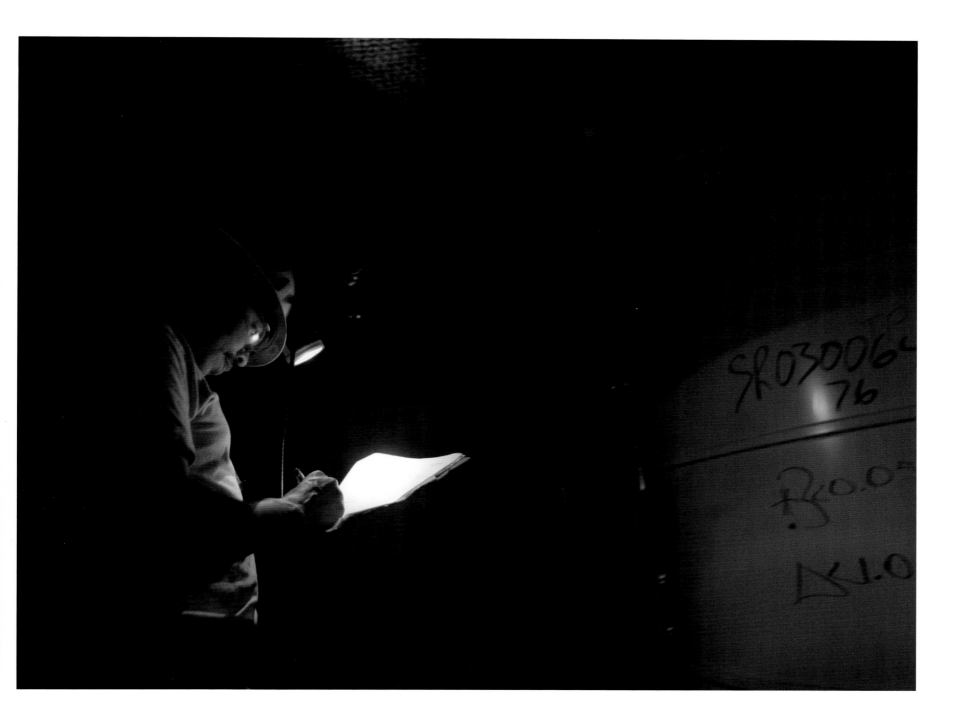

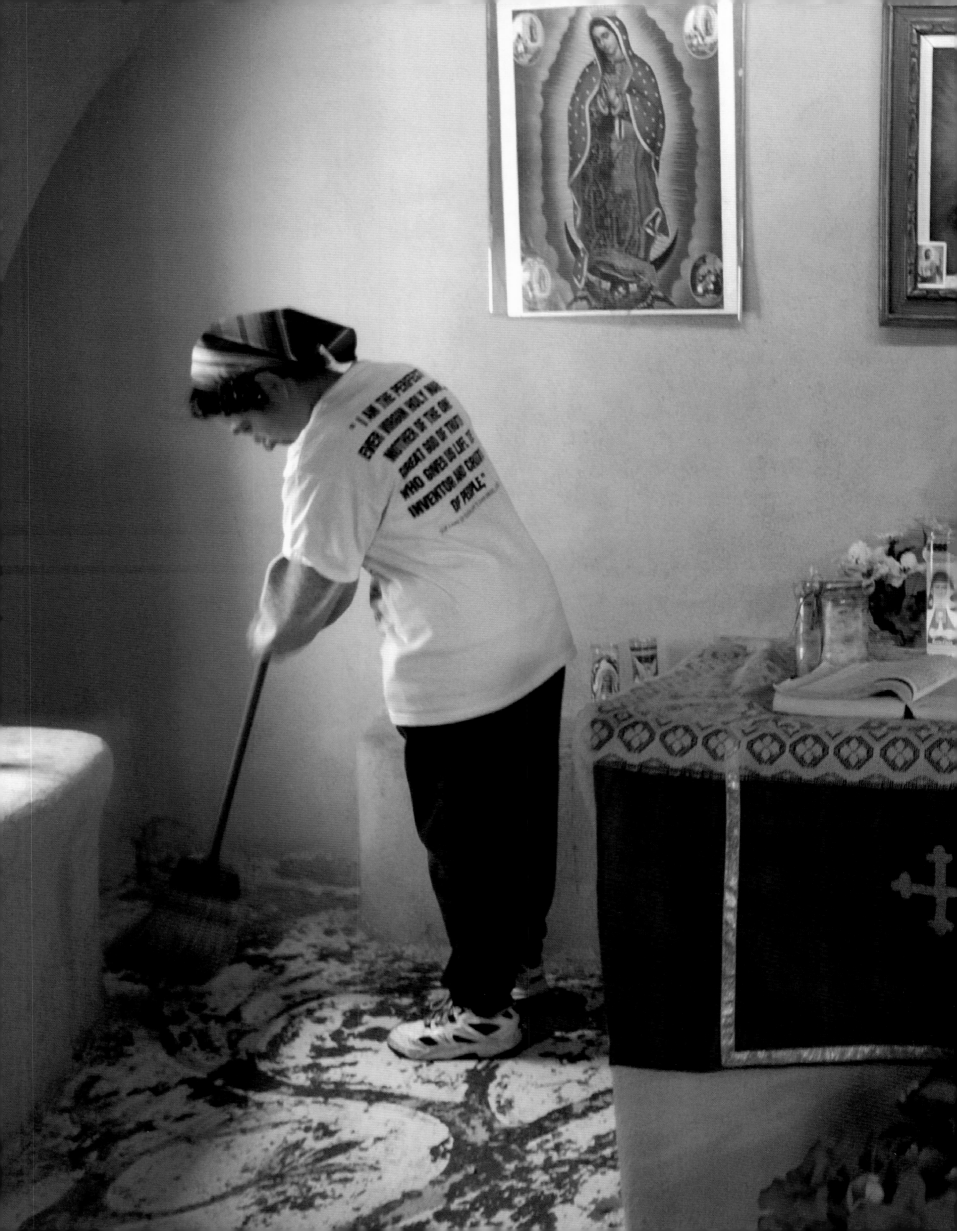

ALBUQUERQUE
Capilla de Nuestra Señora de Guadalupe, aka
The Hidden Chapel, was built in the 1970s on
San Felipe Street behind Albuquerque's Old
Town Plaza. It's maintained by locals includ-
ing Rita Montoño, who for 20 years has de-
voted three days each week to praying in and
cleaning the unaffiliated, one-room chapel.
Photo by Michael J. Gallegos,
The Albuquerque Tribune

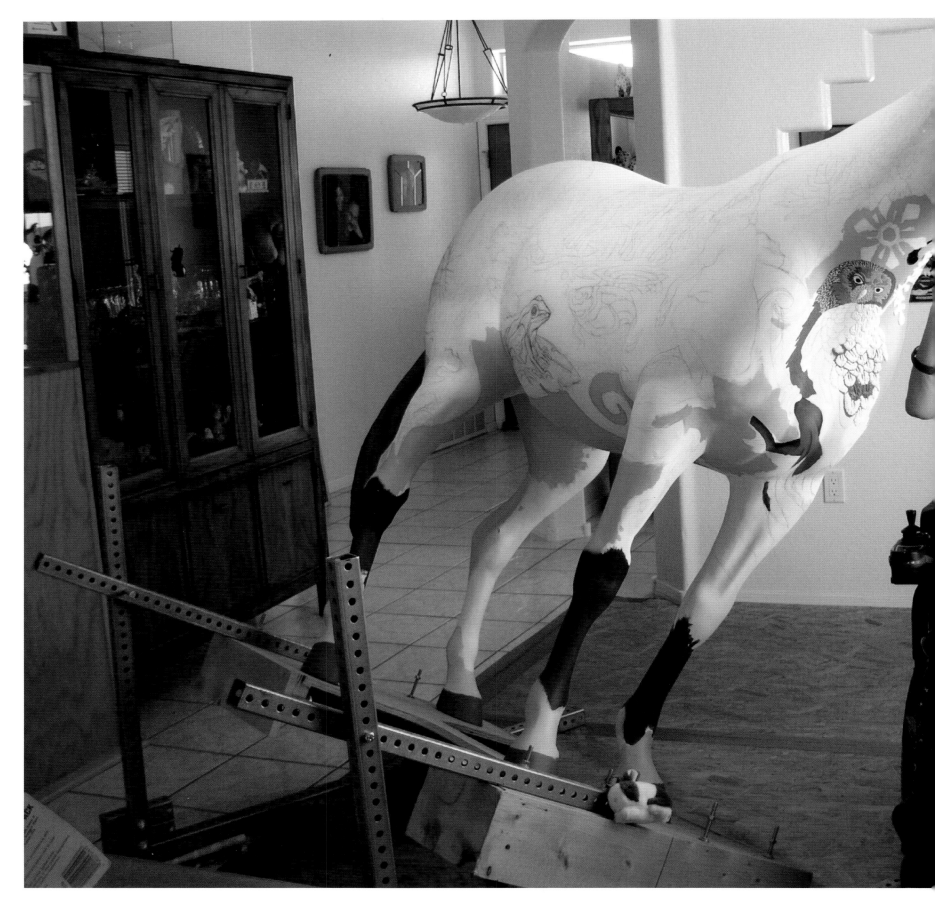

ALBUQUERQUE

Mitzie Bower, paralyzed in a gymnastics accident in 1975, works her magic on one of New Mexico's painted ponies. A computer illustrator at Sandia Labs by day, Bower is painting the statue for "The Trail of the Painted Ponies." Similar to the painted cow project in Chicago, the Trail supports local artists and raises money for nonprofits.
Photo by Carole Devillers

ALBUQUERQUE

Artist Emily Trovillion, whose magical realist works are inspired by Greek and Celtic myths as well as gender and environmental issues, stands in her studio in front of her painting *1945*. Based on the 1945 detonation of the first atomic bomb in New Mexico, Trovillion's painting depicts her mother (background), herself, and an oversized bird in a dematerialized world.
Photo by Douglas Kent Hall

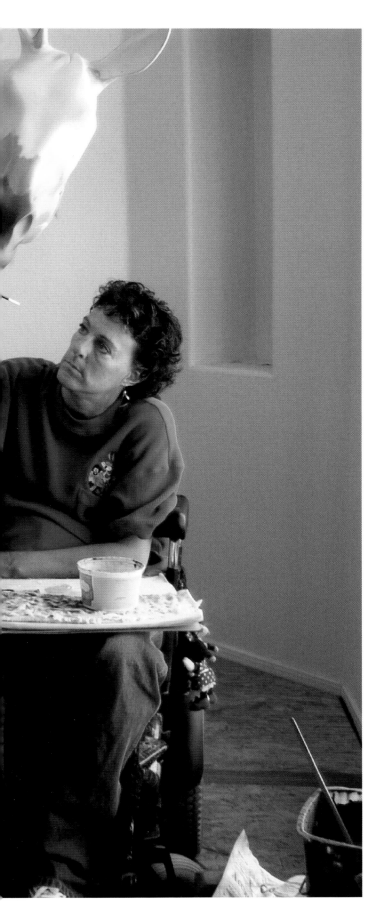

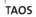

TAOS

Seven years ago, multimedia artist Larry Bell was ripping up rejects from a work made of mylar and laminate film when he discovered that the discards were art in themselves. He cooked them to near liquefaction, cut them into 10-inch squares, and framed them. Ten thousand pieces later, Bell stands in his studio in front of his *Fractions* series.
Photo by Douglas Kent Hall

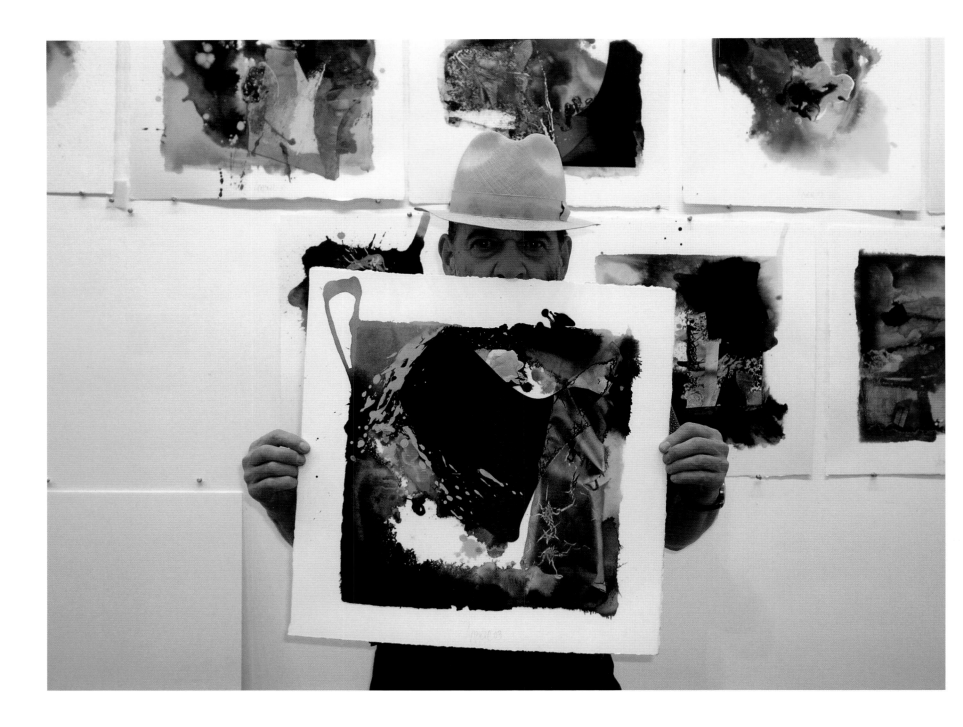

STANLEY

In 1973, California native Alan Ebnother moved to Germany at the age of 20 to study ballet, took up painting 12 years later, and then moved to Stanley in 2000 and built this studio. The artist, who frequently travels to Germany for showings of his monochromatic work, likes his new home. "The land is cheap and it's beautiful—the opposite of Germany," he says.

Photo by Jennah Ward

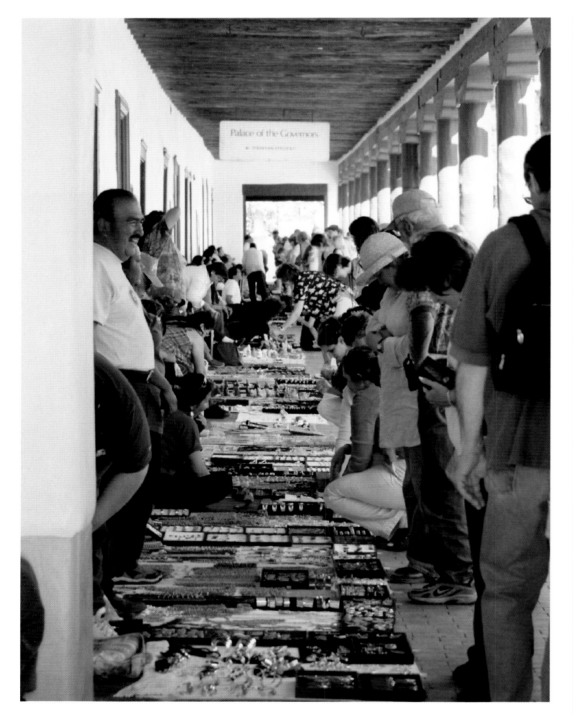

SANTA FE
The Palace of the Governors daily market on Santa Fe Plaza began in the 1940s. Today, its array of Native American pottery and jewelry attracts 2.4 million visitors a year.
Photo by Paul Jaeger

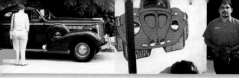

SANTA FE

Sheldon Garcia of the Santo Domingo Pueblo has
been handcrafting jewelry since age 7. Now,
alongside other members of his Pueblo, Garcia
sells his silver and turquoise necklaces, bracelets,
and earrings every Thursday through Sunday at
The Palace of the Governors.
Photo by S. Ray Acevedo

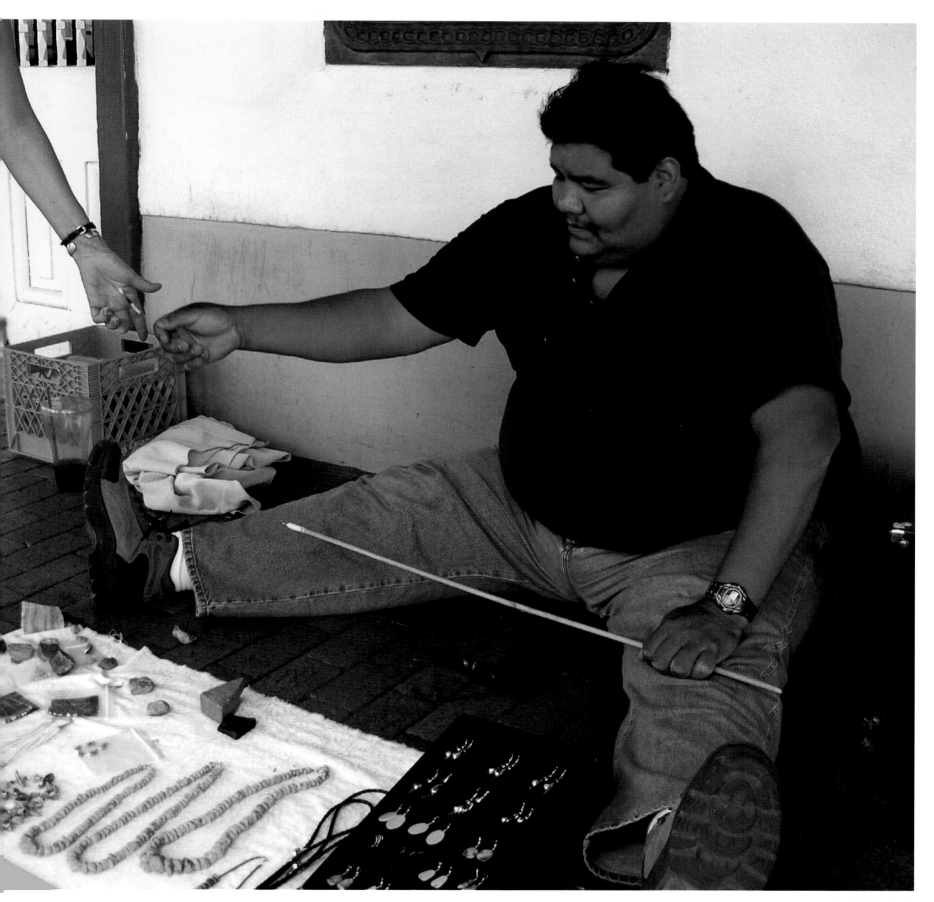

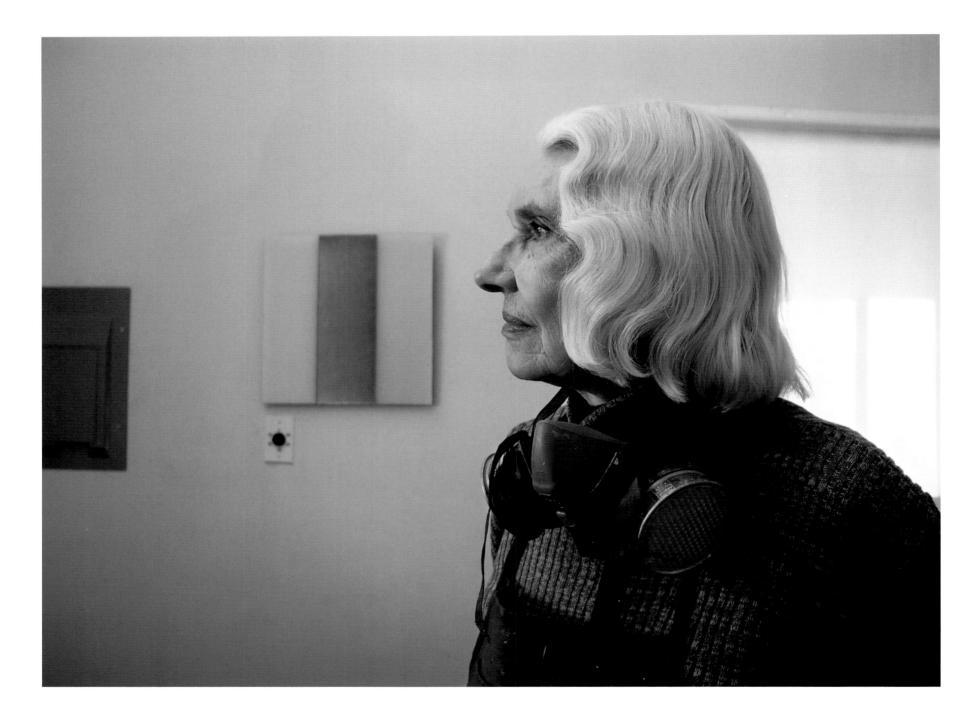

ALBUQUERQUE

At 19, Florence Pierce became the youngest member and one of only two women in the Taos Transcendental Painting Group, a collective of experimental artists concerned with form over content. Today, Pierce continues creating her minimalist, abstract art, but instead of paint she works with Plexiglas and resin and so wears a respirator.

Photos by Douglas Kent Hall

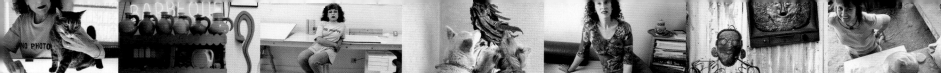

BELEN

Noted artist Judy Chicago in her studio in the old Belen Hotel. Since the 1960s, Chicago has made her name by dissecting female identity in both the domestic and worldly realms with mixed-media works such as *The Dinner Party*, *The Birth Project*, and *Womanhouse*.

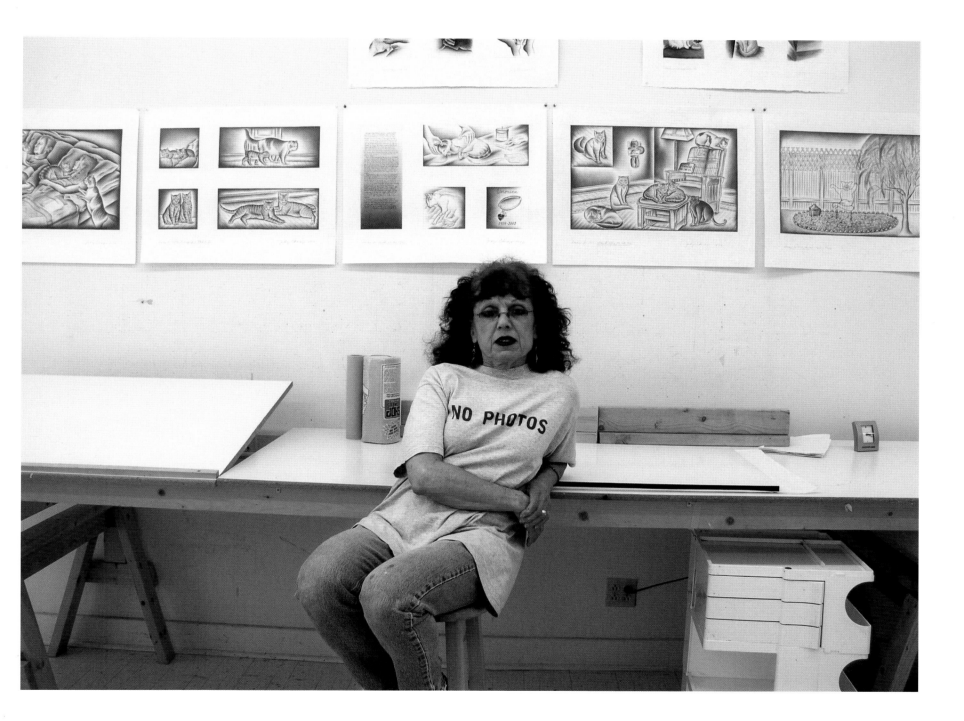

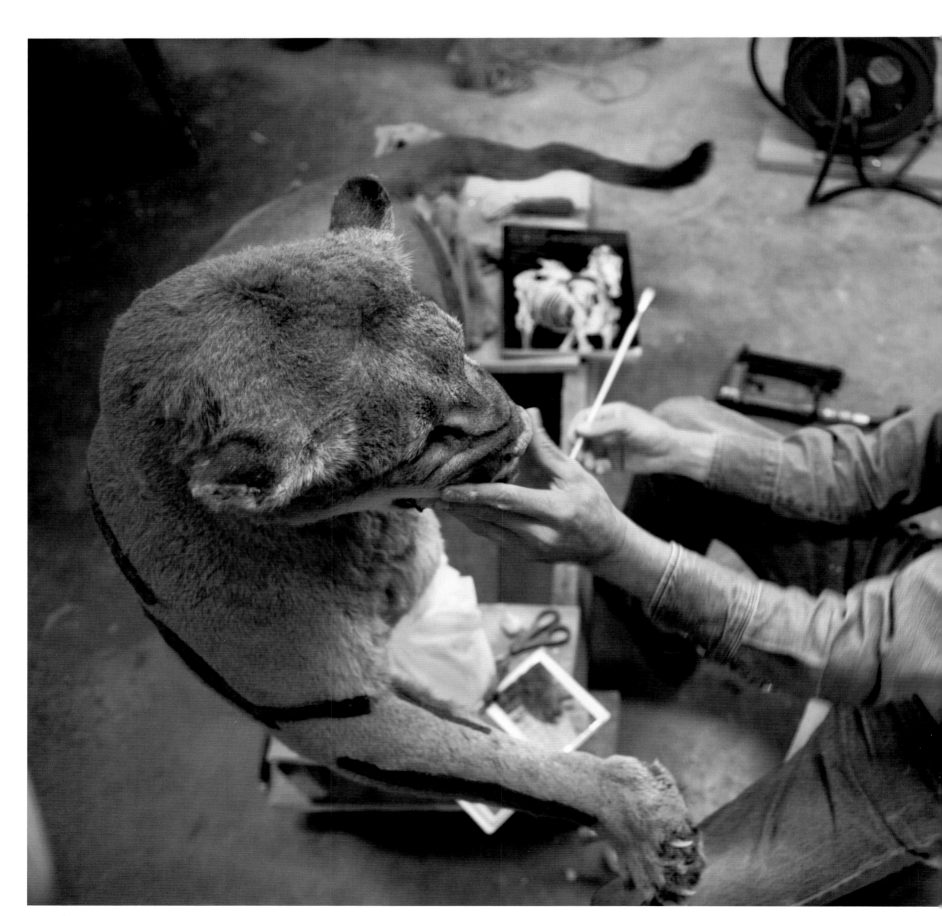

RINCONADA

When Mark Saxe is not creating sculpture, he is carving fireplaces, garden fixtures, and architectural elements for his retail business, Southwest Stoneworks. For two weeks every summer, he holds a stone carving workshop featuring sculptors from around the world. It's fitting he's in this line of work: *Sax* is Latin for stone.

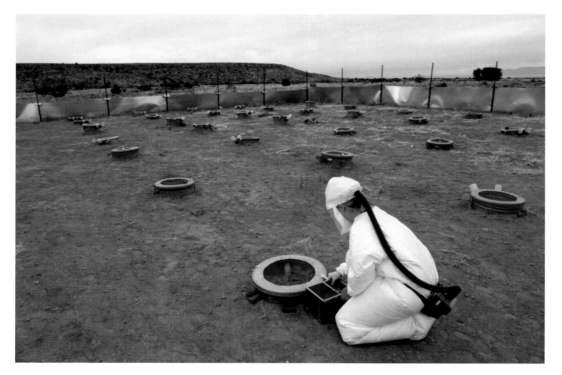

SEVILLETA

University of New Mexico research technician Rebecca Hamel puts deer mice back in underground cages, 5-gallon buckets inside 30-gallon metal cans covered with wire mesh. Researchers infected the mice with the hantavirus (also known as *sin nombre* virus) to study possible vaccines and treatments. Of the 336 hantavirus cases recorded in America, 60 have been fatal.

Photos by Toby Jorrin, The Albuquerque Tribune

SEVILLETA

Hantavirus researchers in Level 4 hazard suits (complete with air ventilators) search for a mouse that broke loose. Although determined to find him, they're not too worried. The outdoor lab is surrounded by steel plates that extend 3 feet above ground and 2 feet below, based on how high mice can jump and how deep they can dig.

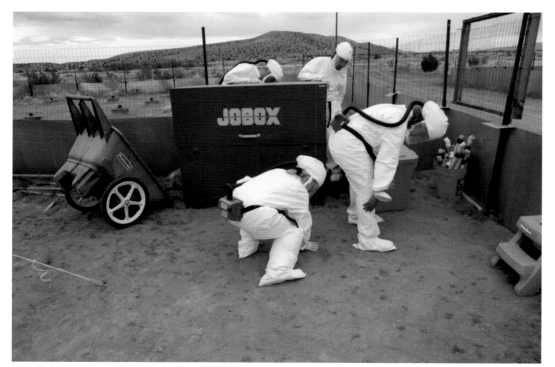

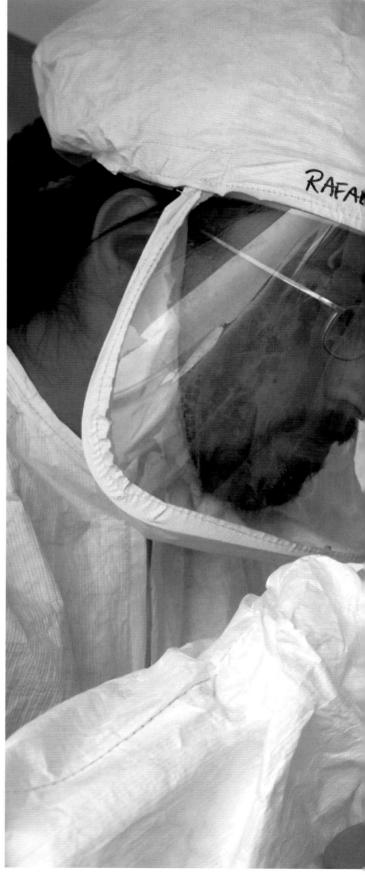

SEVILLETA

Rafael Medina and Rebecca Hamel inject drugs into a hantavirus-infected mouse. Deer mice are the carriers of the disease, but they do not become ill when infected. So researchers are studying them to try to discover protective antibodies and to test the effects of various drugs.

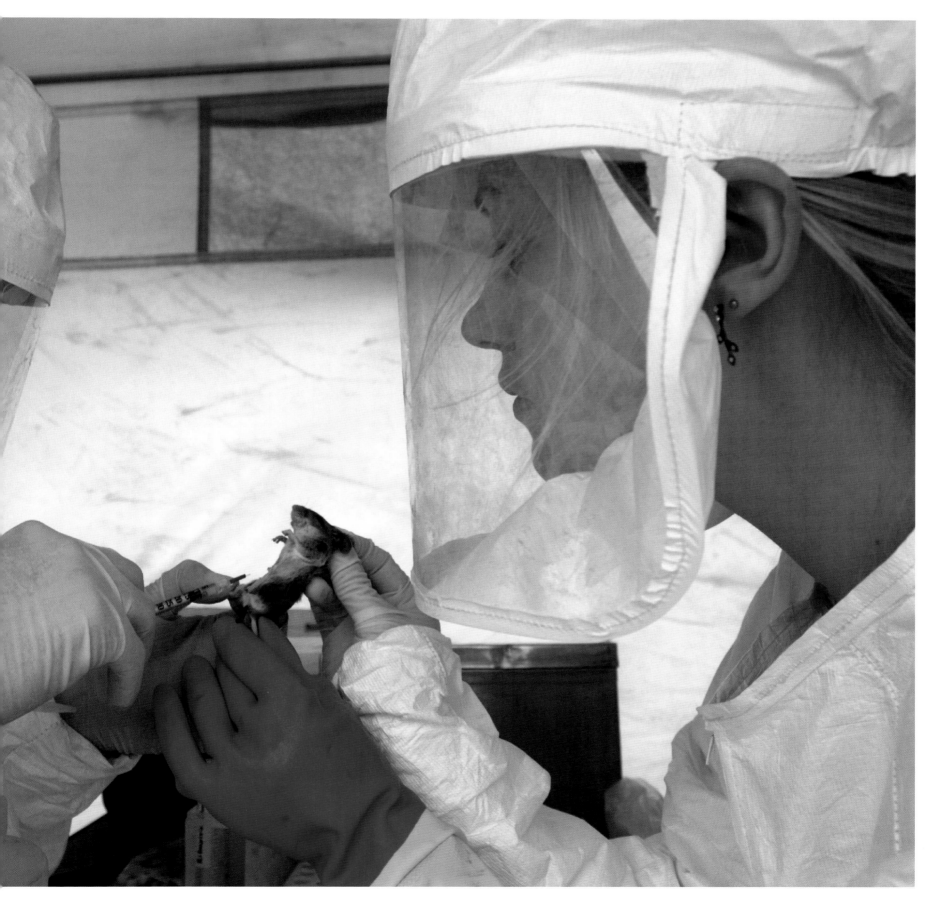

GHOST RANCH
Director Ron Howard, left, works out a shot on location for *The Missing*, an adventure drama set in late-19th-century New Mexico. The film, starring Tommy Lee Jones and Cate Blanchett, was in production for six months at a cost of $65 million.
Photo by Eli Reed, Magnum Photos, Inc.

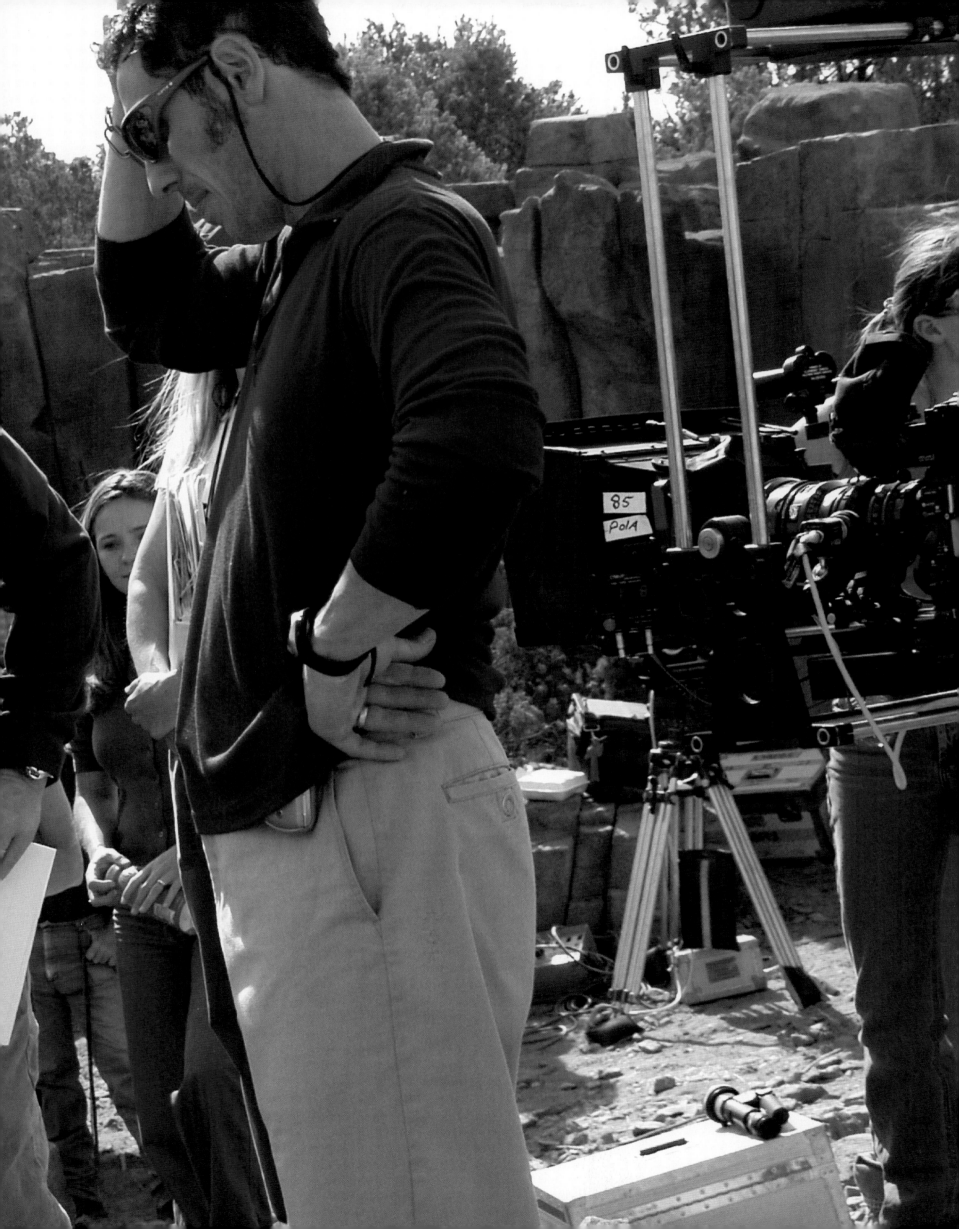

WHITE SANDS NATIONAL MONUMENT
Eighth-graders from Blue Ridge Junior High School in Lakeside, Arizona, spend the day at White Sands, 275 square miles of gypsum dunes left behind by the shallow sea that covered southern New Mexico 250 million years ago.
Photo by Craig Fritz

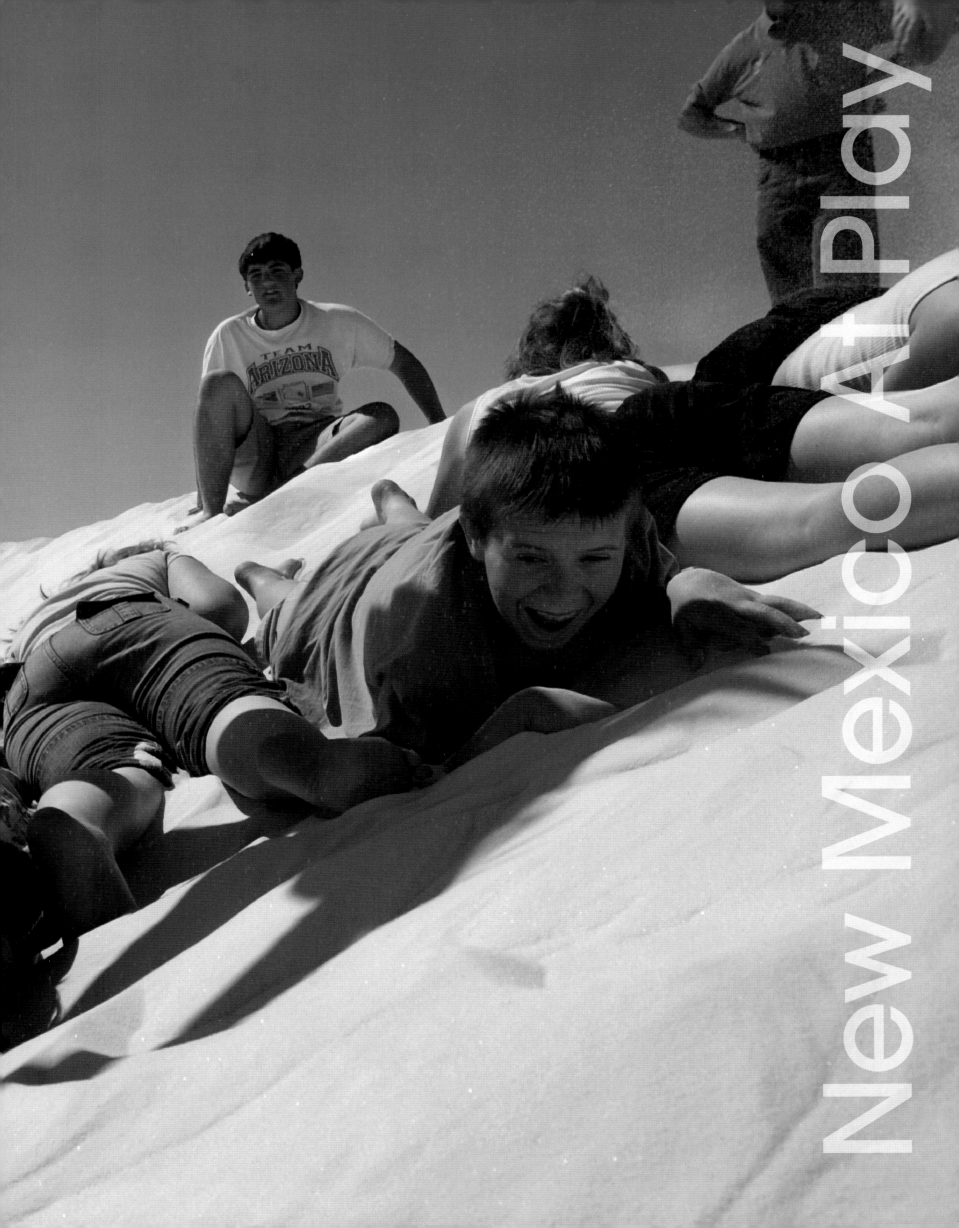

New Mexico At Play

GALISTEO

Weekend warrior: Eighty miles into the annual Santa Fe Century (a recreational bike event), Bernie Archuleta started getting cramps in his shoulder, which he dislocated a year earlier bull-riding in a local rodeo. The 41-year-old accounting student at Northern New Mexico Community College plans to slow down the rodeo action and do more biking.

Photos by Carole Devillers

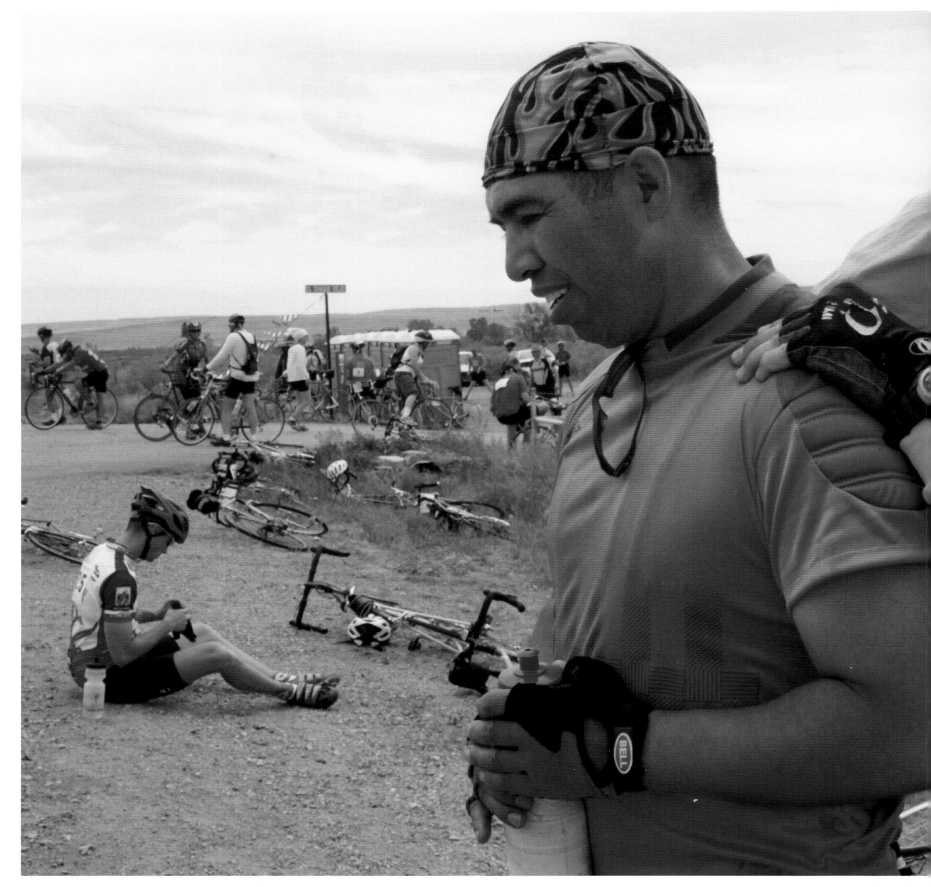

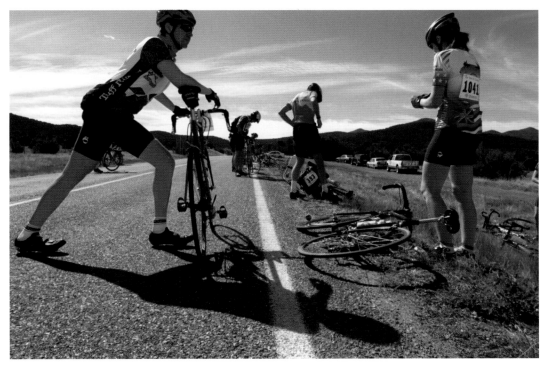

GOLDEN

Avid biker James Beldzik stretches before taking on the biggest climb of the century. Nicknamed Heartbreak Hill, the 17 percent incline is between the towns of Golden and Cedar Grove. Beldzik, a physical therapist at Española Hospital, biked the 100 miles in a little more than seven hours. He says his goal for 2004 is to complete it in six.

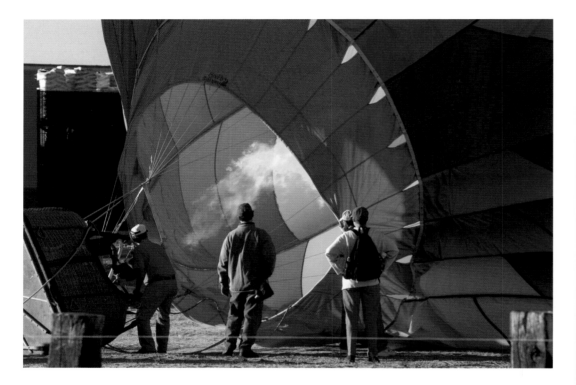

ALBUQUERQUE
Cooking with gas: A hot-air balloon pilot fires up
the propane at the annual Kodak Albuquerque
International Balloon Fiesta.
Photo by David Reffalt

SHIPROCK

Chinele Ahasteen misses a bar at the Diné College ropes course in the Navajo Nation. Established in 1976, Diné College was the first affiliated tribal community college in America. Ahasteen, who came here for the day with her Tse'Bit'ai Middle School classmates, says the ropes course allowed her to get over her fear of heights and falling.

Photo by Brett Butterstein

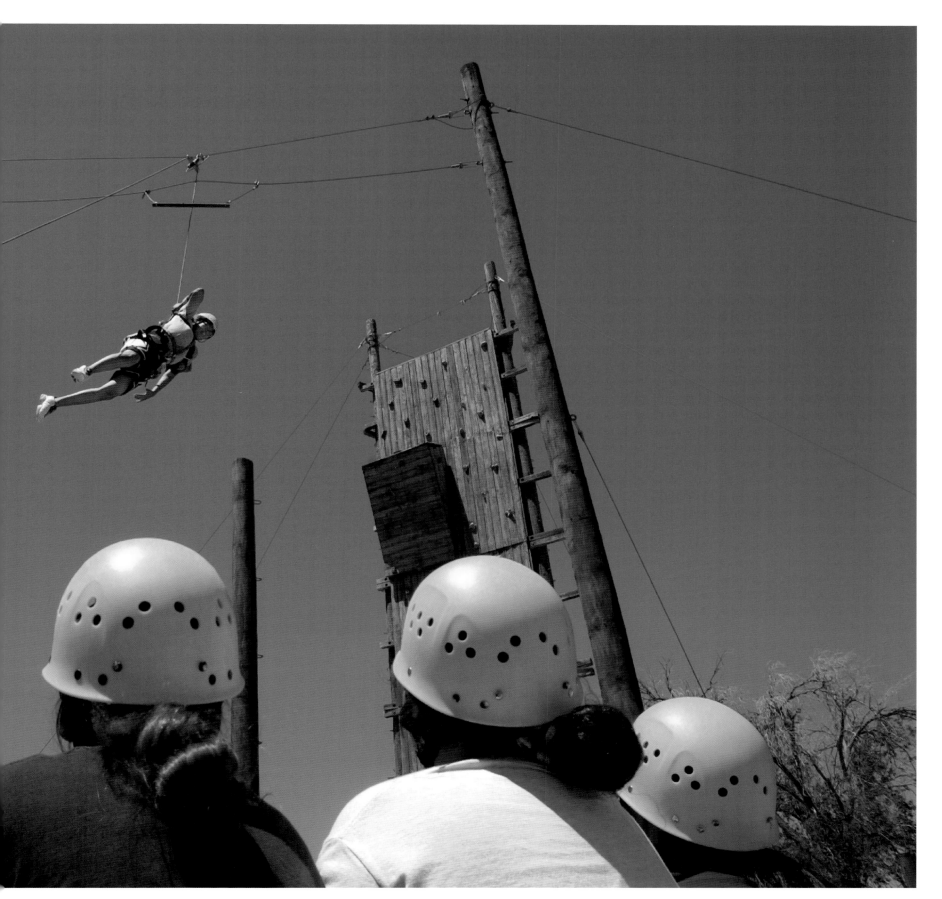

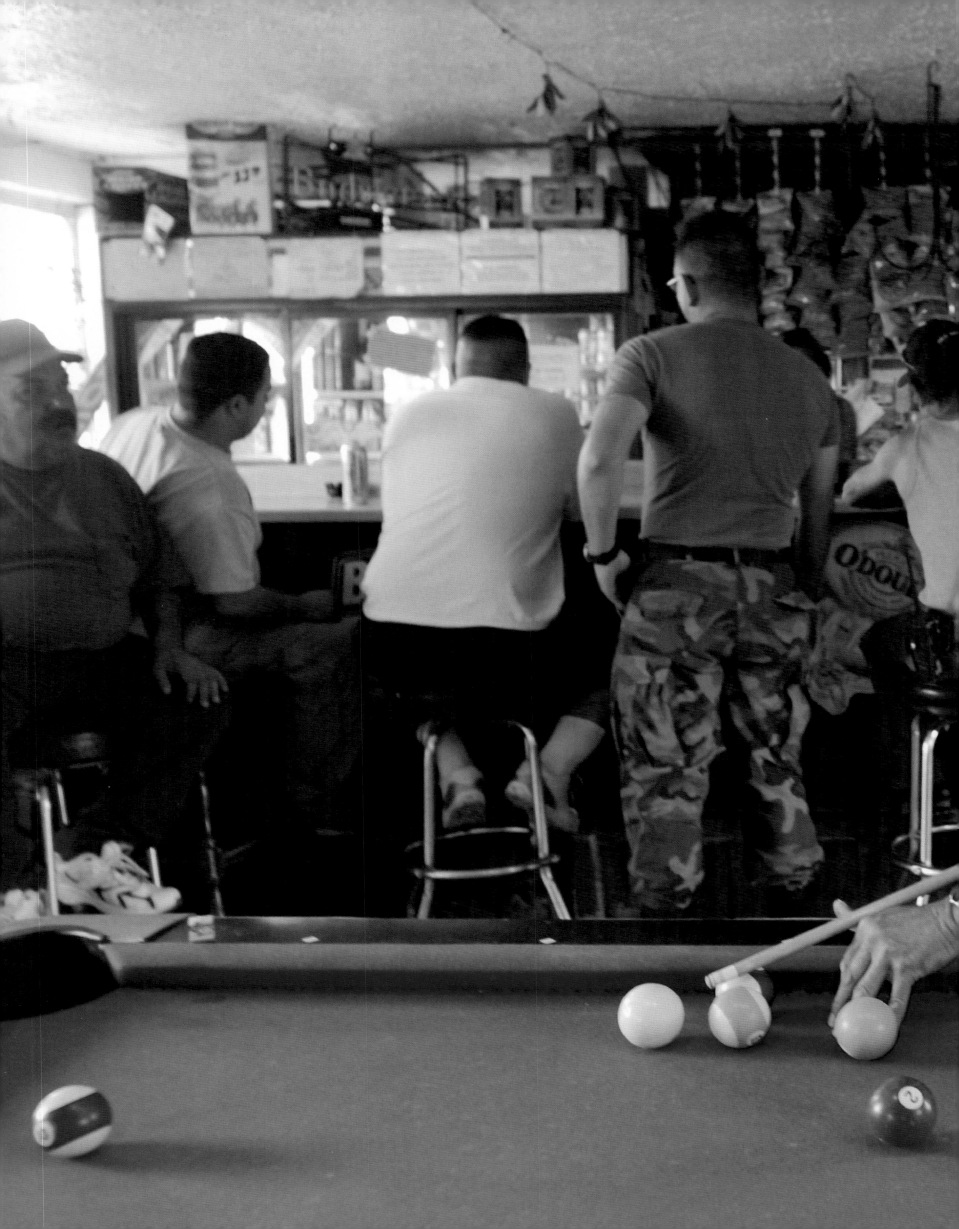

SAN JOSE
El Alto Bar on Highway 3 is a home away from home for its regulars. One of two bars in a 20-mile radius, the 70-year-old establishment, open from 8 a.m. to midnight, has two pool tables, video games, and a jukebox. "The only kind of music we don't have is opera," says owner Alex Perea.
Photo by Phillippe Diederich

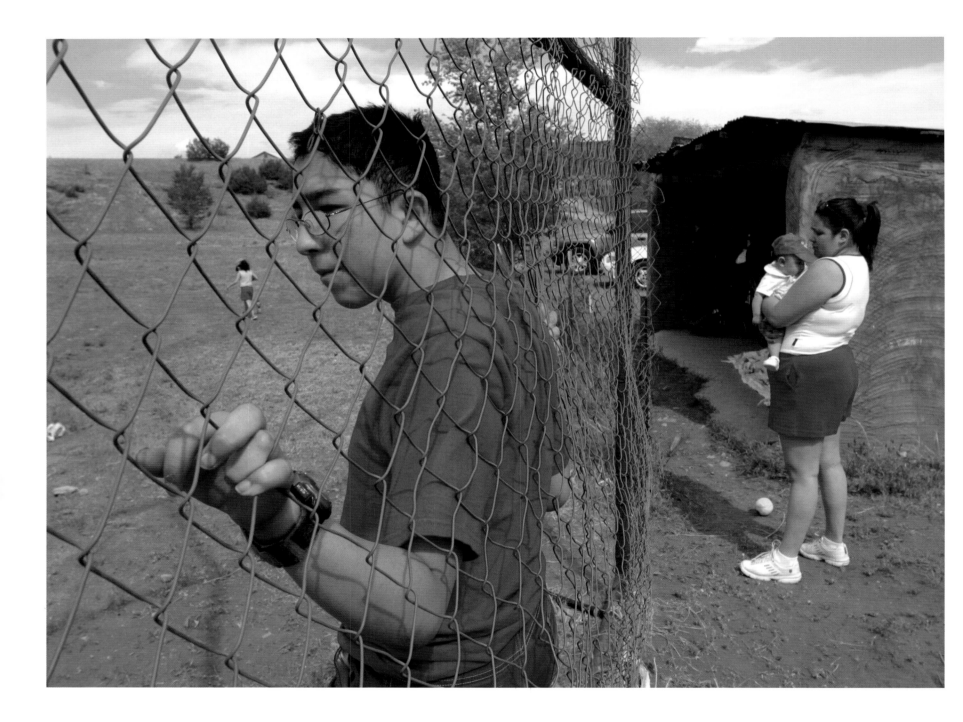

RIBERA

Thirteen-year-old Paul Bustamante watches a softball game at the community field. The town is one of 13 historic villages, minutes apart from one another, that make up the El Valle region of the Pecos River Valley.

Photo by Phillippe Diederich

ALBUQUERQUE

Positioned behind the right field fence, Darion Bird, 5, hopes to catch a home run ball at a game between the Albuquerque Isotopes and the Iowa Cubs. The Isotopes, whose name is a tribute to New Mexico's scientific heritage (and a *Simpson*'s episode) are the Triple-A affiliate of the Florida Marlins.

Photo by Wes Pope, The Santa Fe New Mexican

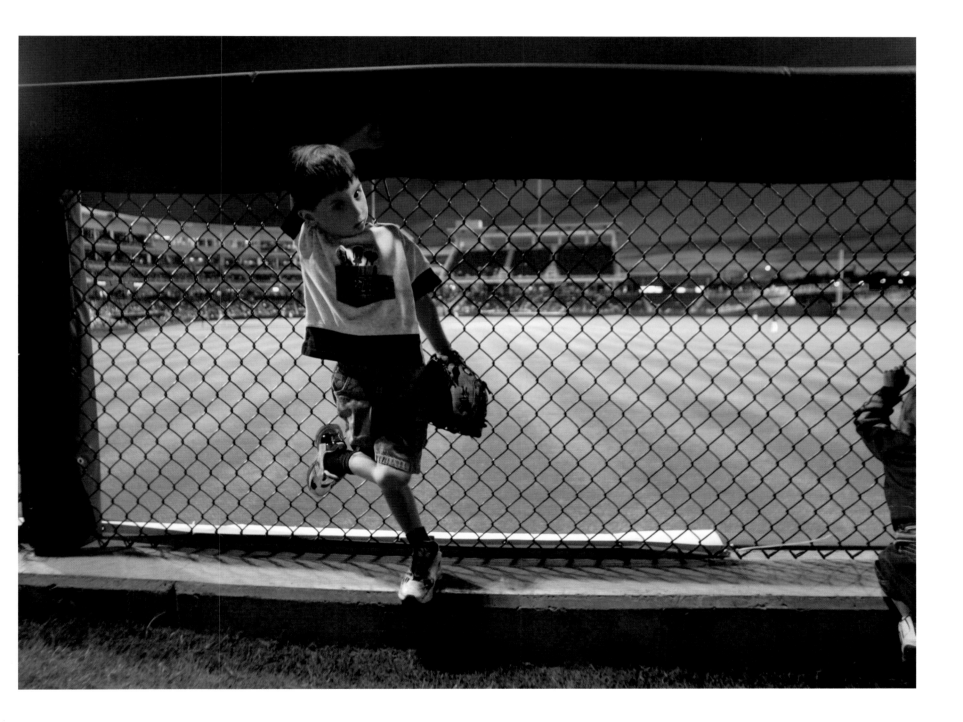

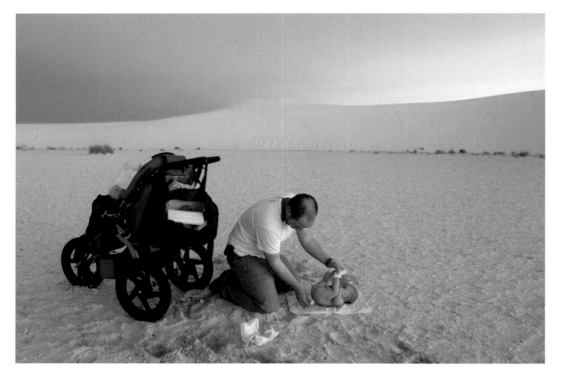

WHITE SANDS NATIONAL MONUMENT
Craig Fritz tends to business while strolling
through the White Sands dunes at dusk with
wife Kitty and 2-month-old daughter Maya.
Photo by Kitty Clark Fritz

PERALTA

Barrels of bruises: Matthew John Maez takes a spill and his little brother Isaiah stays upright during a round of "dirt barreling," an improvised something-to-do in which ATVs drag half-barrels and their passengers around in the dirt, faster and faster 'til all hell breaks loose.
Photo by Karen Kuehn

SHIPROCK
Just before sunset on the Navajo Nation, Michelle Johnson and her brothers Zachary and Quentin break through the horizon line on a neighbor's trampoline.
Photo by Brett Butterstein

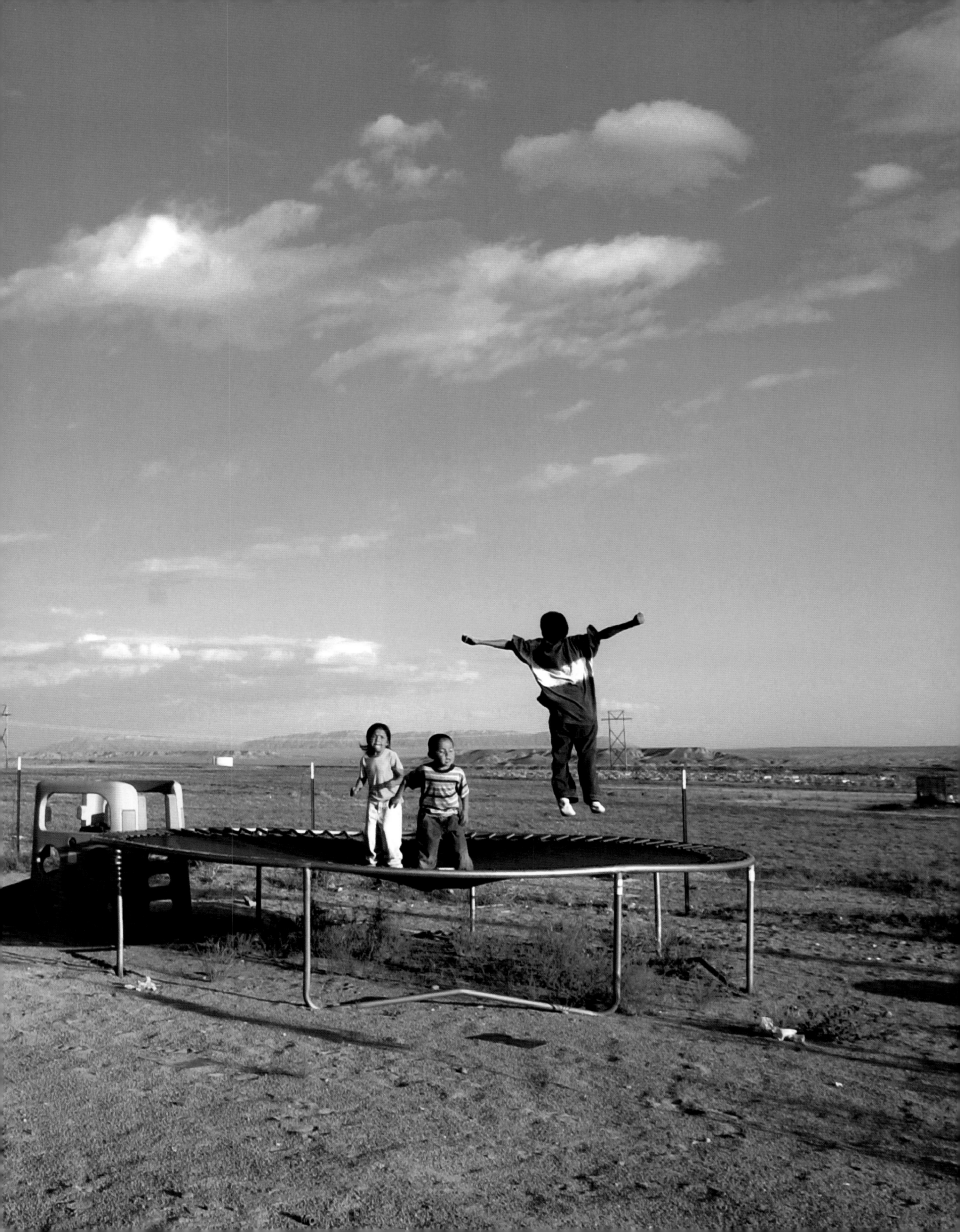

ALBUQUERQUE
Two Del Norte High School students get in extra gym time. Freshman Danielle Yonnie (background) is a defensive specialist on the girls' volleyball team. The team hopes to do better in 2004; it finished the 2003 season with 4 wins and 9 losses.
Photo by Craig Fritz

ALGODONES

Marisa and Franchesca Quintana demonstrate their dunking and hoop-hanging moves. In addition to participating in sports, the sisters are honor roll students. They attend the elementary and middle schools in the Rio Rancho district, a 20-minute drive from home, because its curriculum and graduation requirements exceed state standards.

Photo by Kitty Clark Fritz

ALBUQUERQUE

Kites made from plastic bags are a typical sight in the makeshift community of Pajarito Mesa. Parcels of land were sold in 1997, but without arrangements for basic services. There is no running water, electricity, or sewage system. Residents have set up generators, propane stoves, and water storage tanks to service their homes, most of them trailers.

Photo by Toby Jorrin,
The Albuquerque Tribune

LAS CRUCES

Different cultures blend effortlessly during the Feast of San Ysidro at the New Mexico Farm and Ranch Heritage Museum. A young boy holds a traditional shepherd's staff, a musician stands ready to play mariachi music, and Bishop Ricardo Ramirez—hip in his wireless mike and prayer shawl from Chile—sprinkles the fields with holy water.

Photo by Sterling Trantham,
New Mexico State University

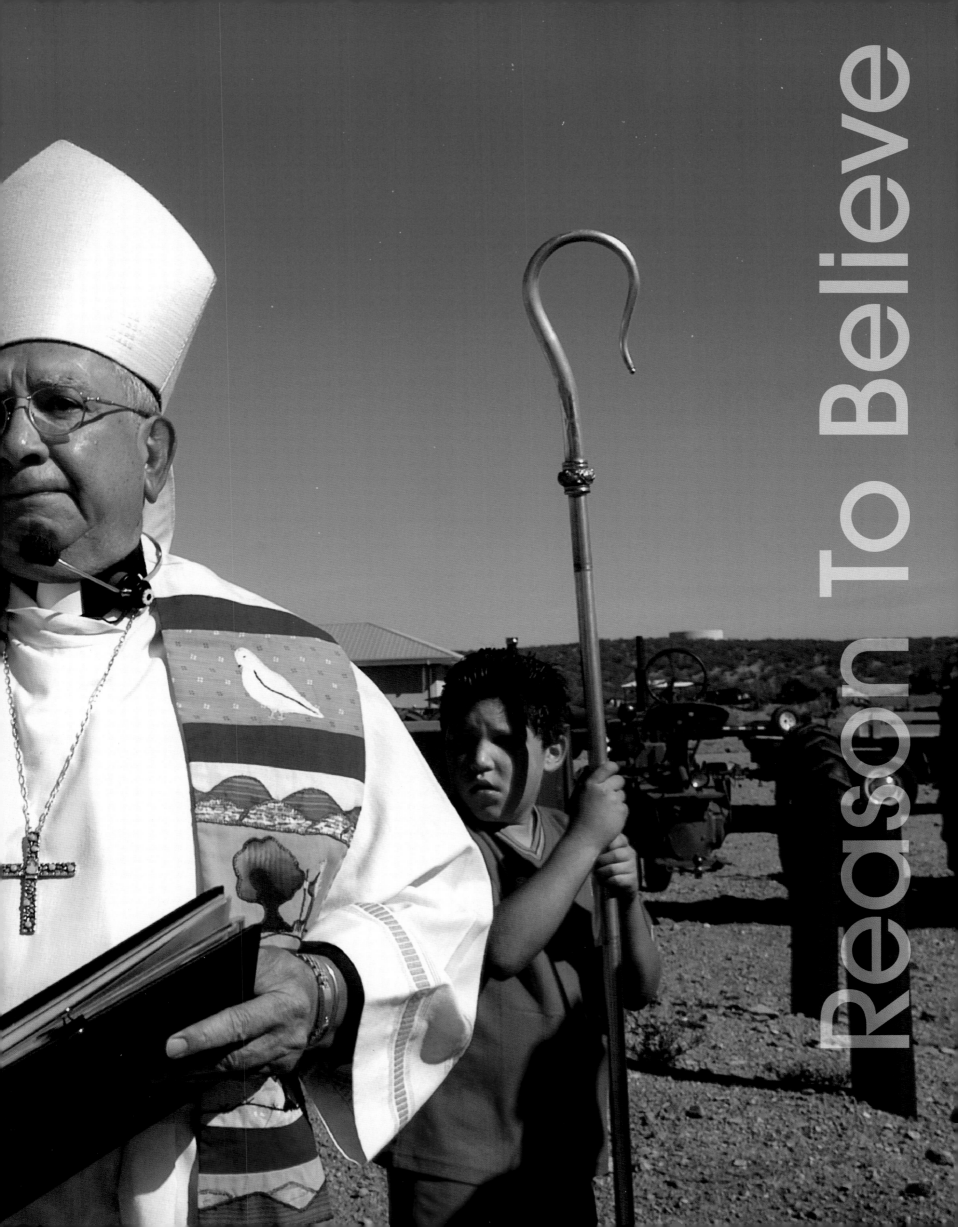

Reason To Believe

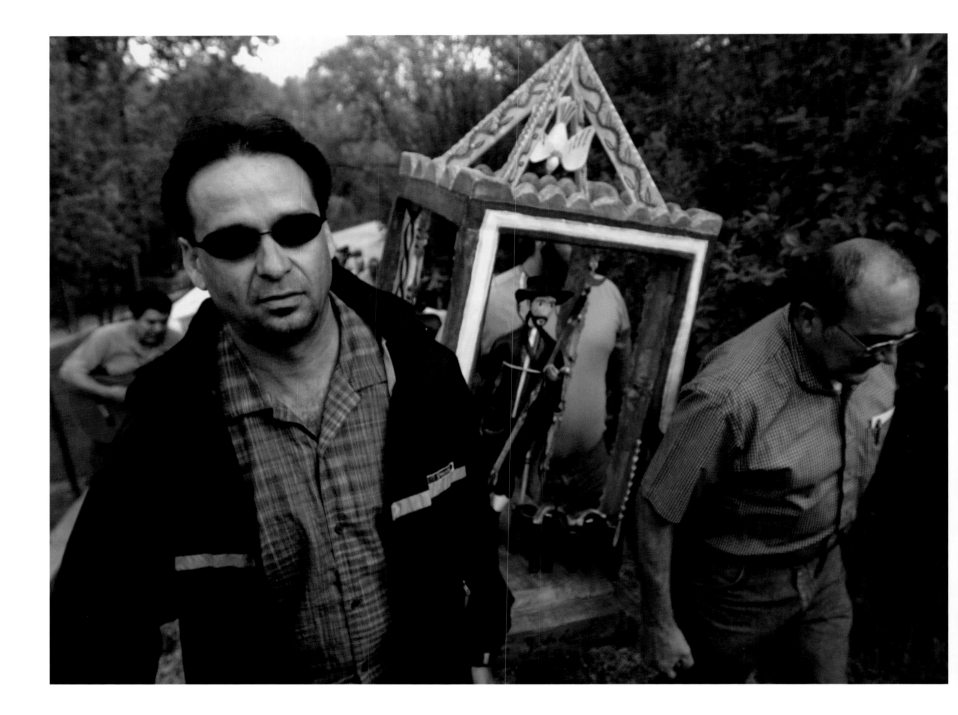

SANTA FE
The faithful fall in line to celebrate the Feast of San Ysidro, a 12th-century Spaniard honored as the patron saint of farmers. The *bulto* (carved image), like most other depictions of the saint, shows him with agricultural tools and an angel.
Photos by Toby Jorrin, The Albuquerque Tribune

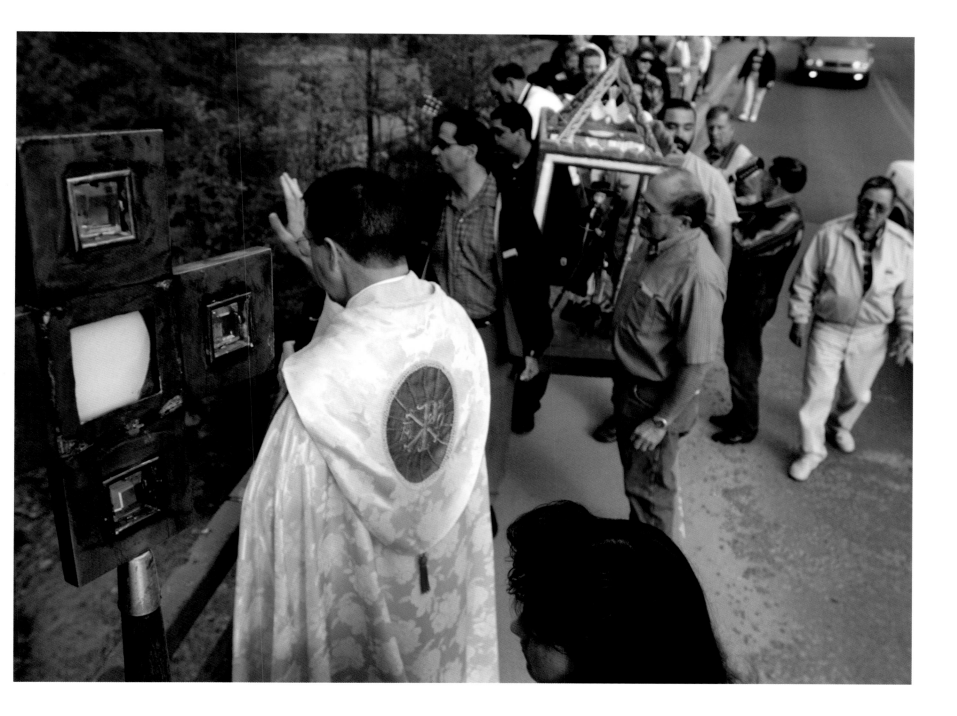

SANTA FE

Father Lambert Luna, pastor of the Cristo Rey Church, pauses to pray at the region's main water sources, the Santa Fe River and a parallel *acequia madre* (primary irrigation channel). San Ysidro is associated with rainfall and bountiful harvests, so he is the focus of prayer during dry spells. In 2003, New Mexico was in its fourth year of drought.

VADO

Ashanta Williams, 9, listens while her grand-
mother reads scripture at Valley Grove Baptist
Church. Her mom and three siblings reside in
El Paso, Texas, and Ashanta lives with her grand-
parents in Vado. The family has deep connections
to the Valley Grove congregation: Ashanta's
great-grandfather Bobby Bonds was the pastor
for 37 years.

Photos by Sterling Trantham,
New Mexico State University

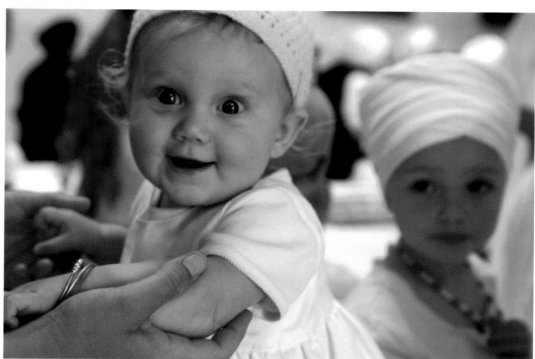

ESPAÑOLA

One of the tenets of Sikhism is that children are the future. As such, they are treated with reverence and encouraged to participate in Sunday prayers. Siri Atma Kaur Khalsa is a third-generation American Sikh.

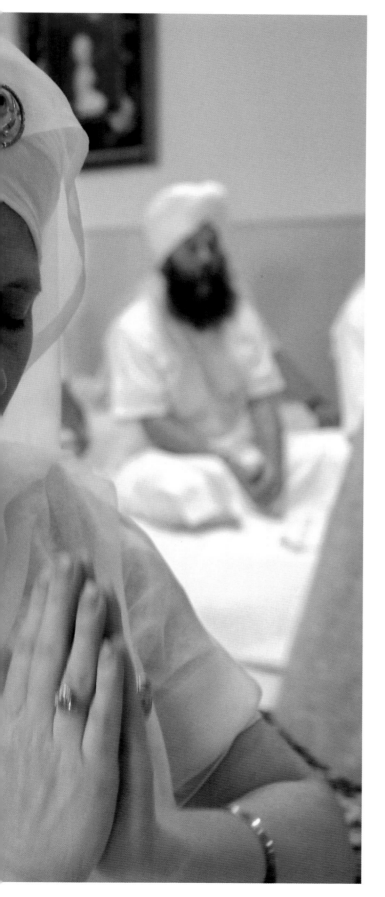

ALBUQUERQUE

At the Indian Pueblo Cultural Center, visiting Tibetan monks Jampa Gyaltsen and Tsering Phuntsok prepare for the Black Hat Dance. The Pueblo community invited the monks to perform the ancient dance to eliminate negative energies. It is one of several performances planned for the monks' Mystical Arts of Tibet cross-country tour.

Photos by Marcia Keegan

ALBUQUERQUE

At the Pueblo Center, Geshe Tsultrim Gyatso dismantles a sand mandala made for world peace and healing. Gyatso is one of 2,000 Tibetan monks living in India's Drepung Loseling Monastery, which was built after China invaded Tibet in 1959 and destroyed its 6,500 monasteries.

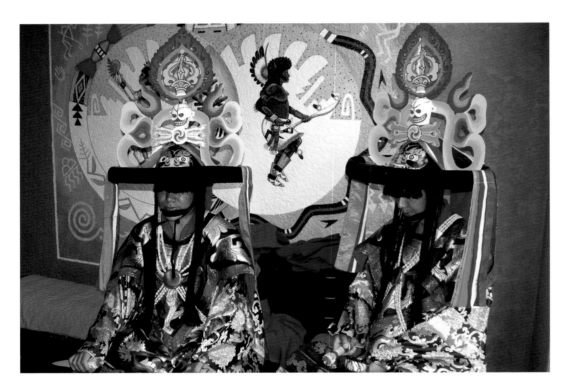

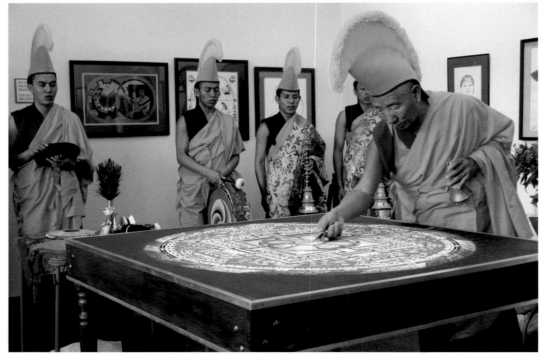

CHACO CANYON

Monks Kelsang Dorjee, Thupten Wangchuk, and Lobsang Samten pray at Chaco Canyon, the Pueblo Indians' ancestral home built in the 11th century. Among the linguistic cross-cultural connections the Pueblo people discussed with Tibetans are that *nyima* means sun in Tibetan and moon in Hopi, and *dawa* means moon in Tibetan and sun in Hopi.

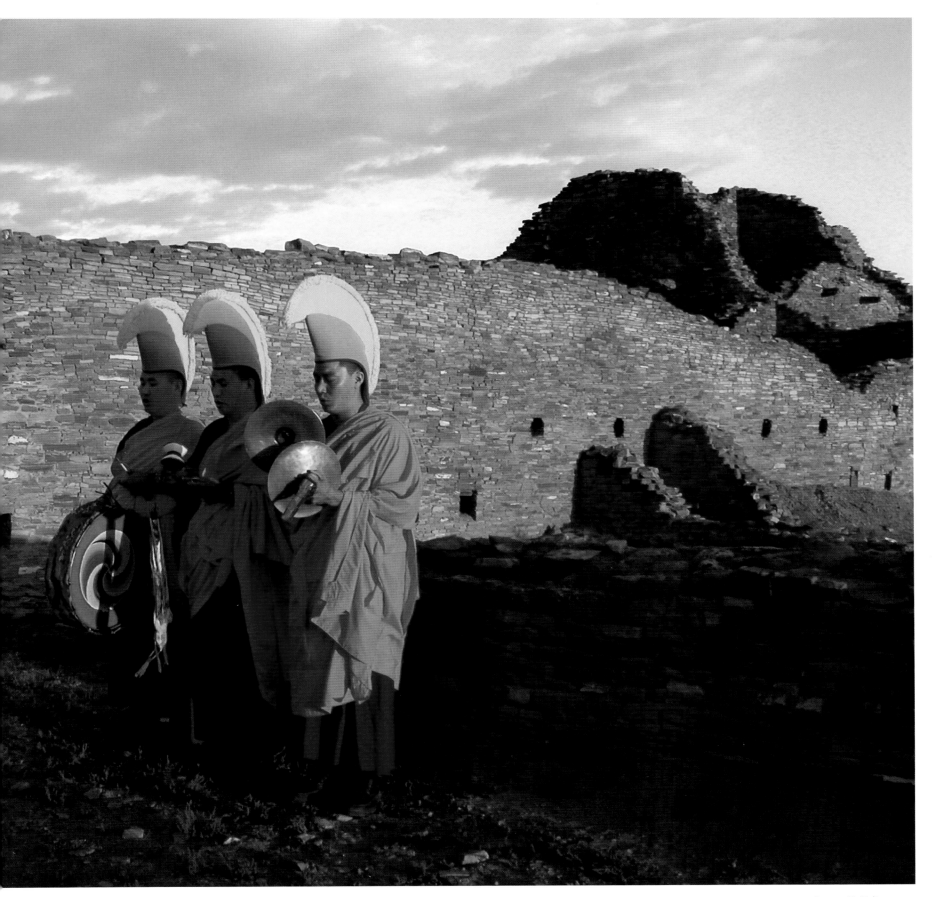

ALBUQUERQUE

Outside the Capilla de Nuestra Señora de Guadalupe, visitors leave their prayers and presents for the Virgin. According to legend, the mother of Jesus appeared in 1531 to Juan Diego, an Aztec who had recently converted to Christianity, and asked him to build a church to honor her.
Photo by Michael J. Gallegos,
The Albuquerque Tribune

ALBUQUERQUE

In 1980, a Korean War veteran named Toby Avila took his kitchen knife to an 80-year-old cottonwood tree and spent a year carving this statue, *La Virgen de Guadalupe*. A week after completing his homage, Avila died, his hands still speckled with blue paint. Today, locals and tourists visit Old Town Plaza to honor the Virgin.
Photo by Douglas Kent Hall

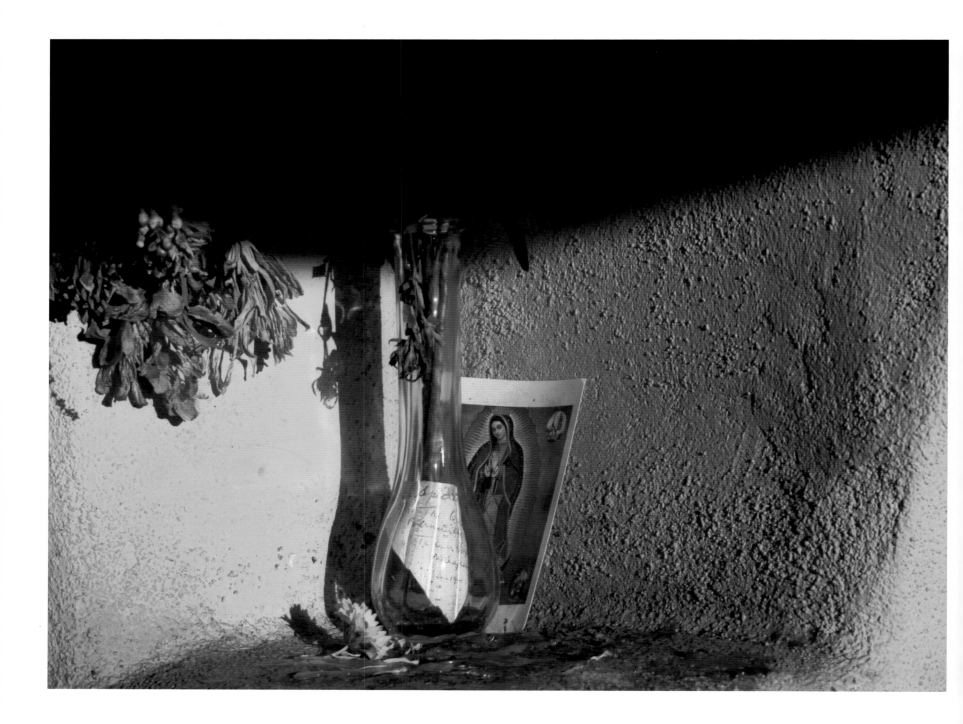

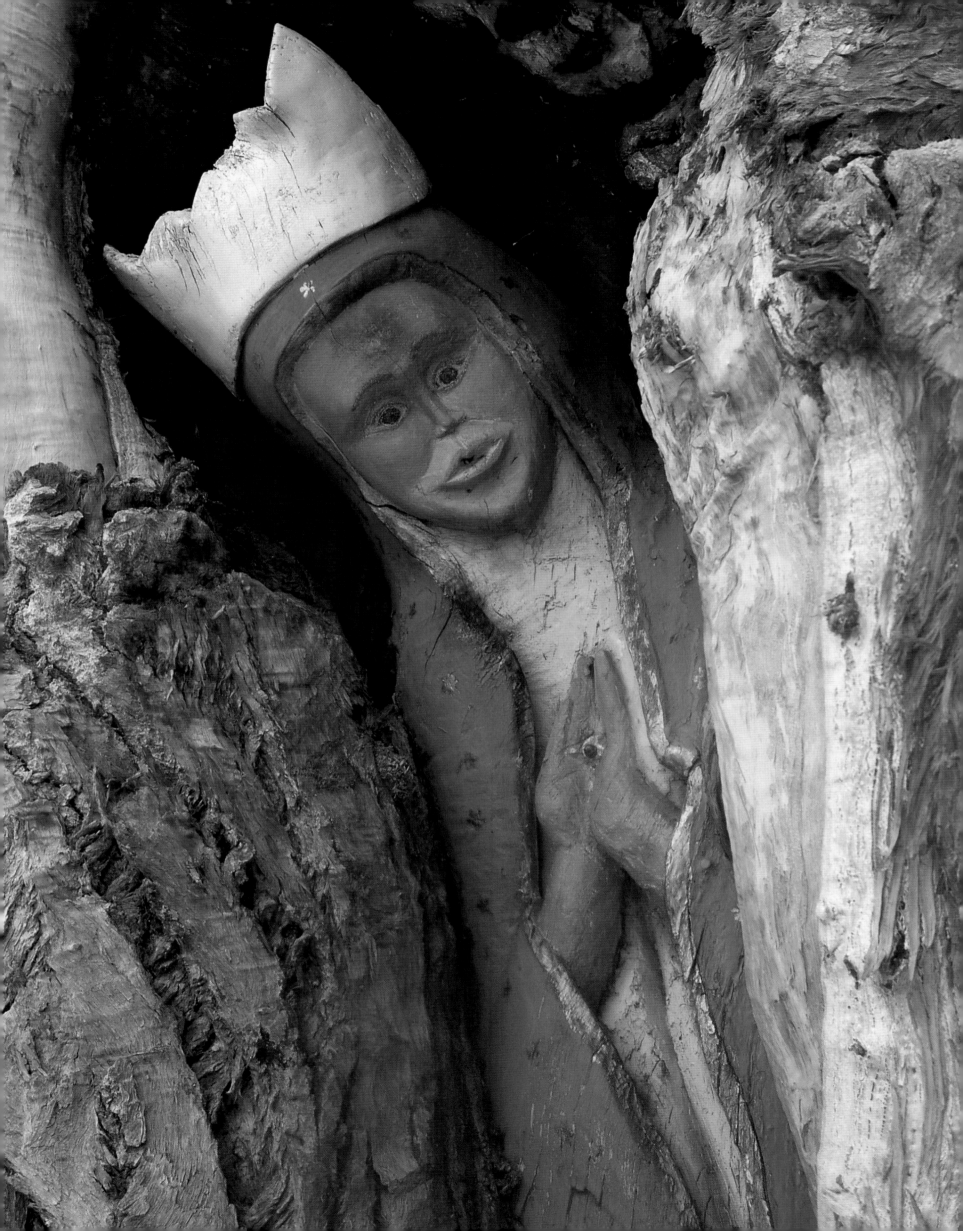

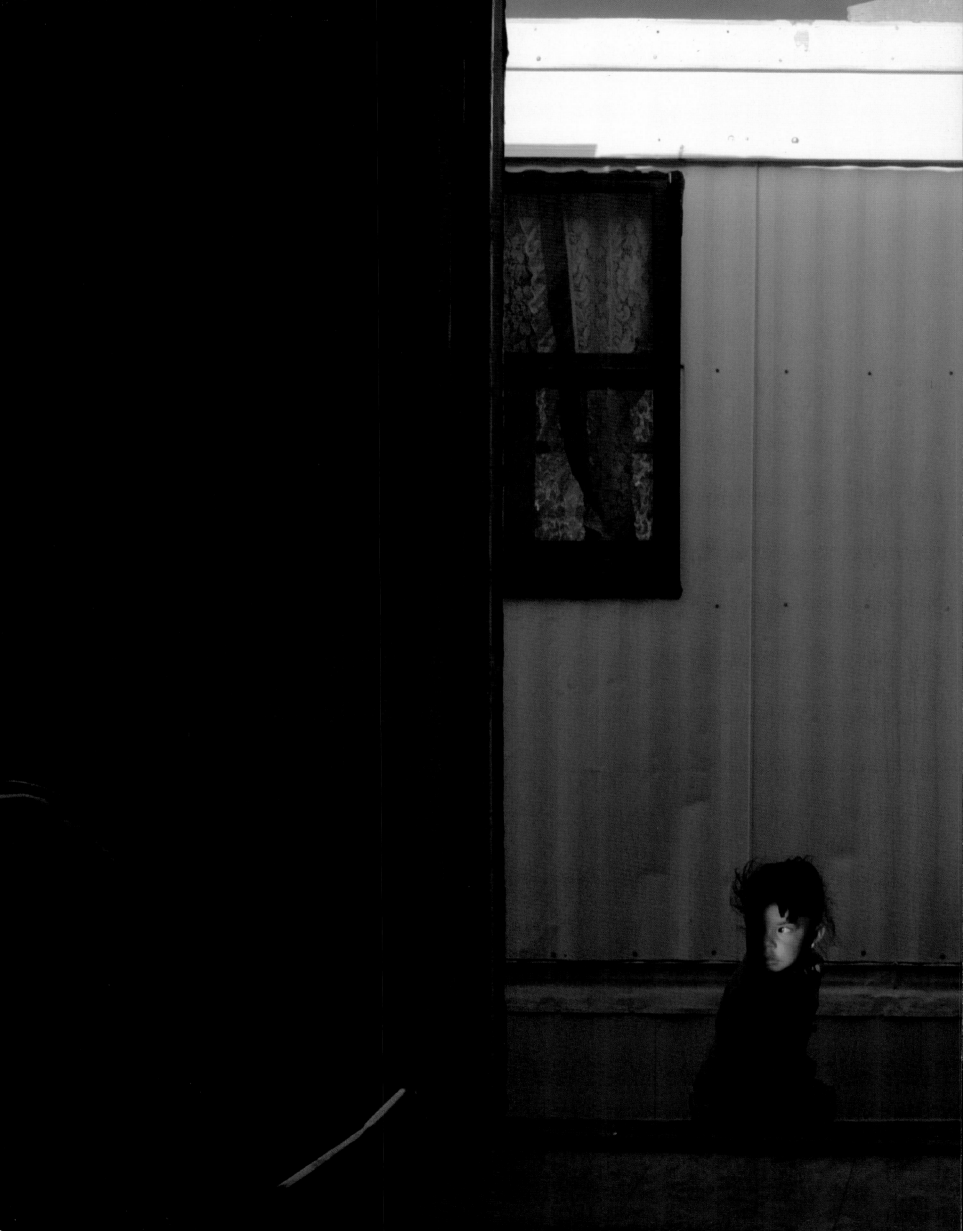

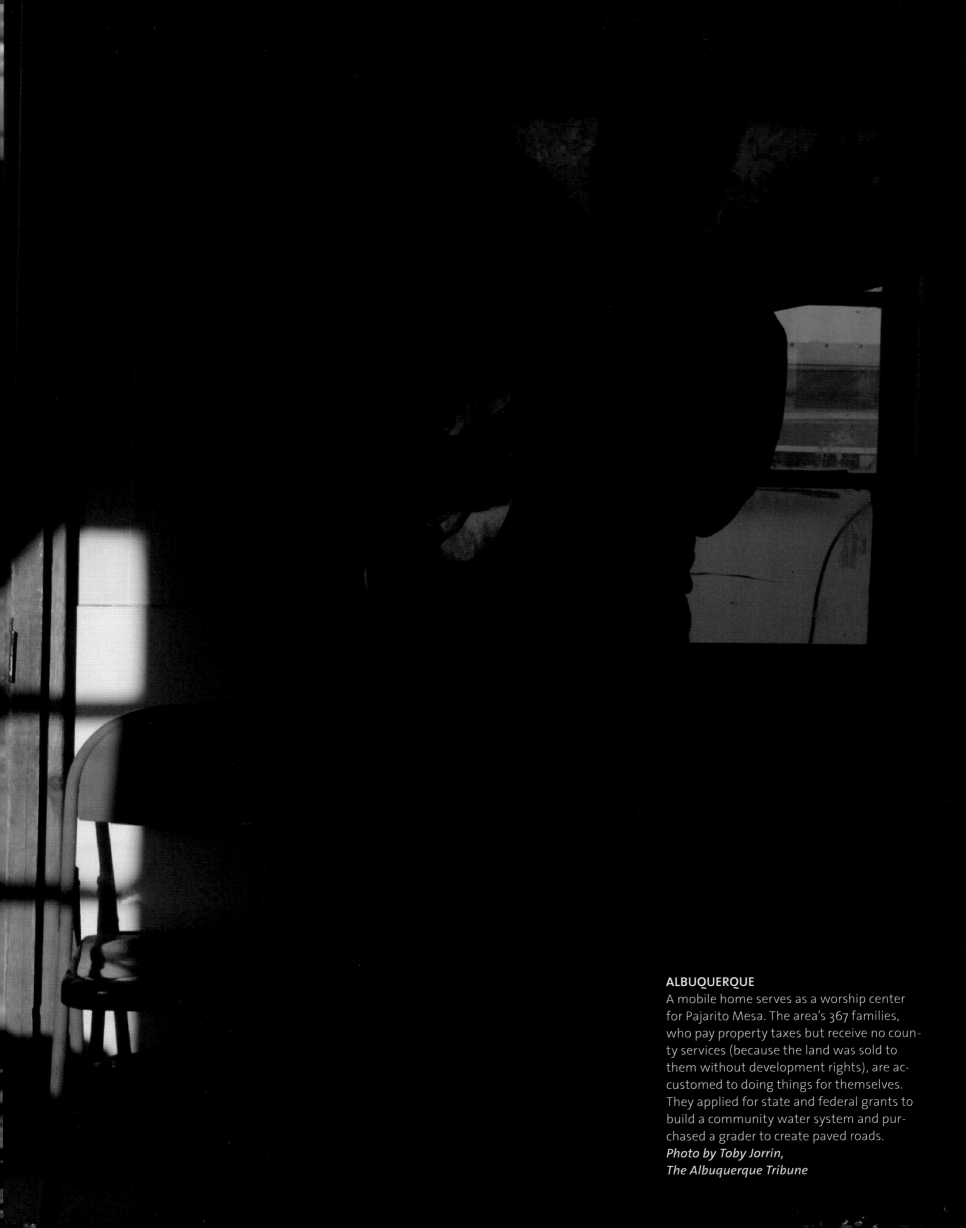

ALBUQUERQUE

A mobile home serves as a worship center for Pajarito Mesa. The area's 367 families, who pay property taxes but receive no county services (because the land was sold to them without development rights), are accustomed to doing things for themselves. They applied for state and federal grants to build a community water system and purchased a grader to create paved roads.
Photo by Toby Jorrin,
The Albuquerque Tribune

SANTA FE

Descansos memorialize two people who died in a car accident along I-25. An old European tradition, roadside crosses marked the spots where mourners stopped to rest while carrying a coffin from the home of a deceased person to the cemetery.
Photo by Douglas Kent Hall

SAN JUAN

The tradition of *descansos* is so popular in New Mexico that a group of Santa Fe researchers put together a traveling exhibit of photographs and personal histories to document them. This one sits along Highway 3.
Photo by Phillippe Diederich

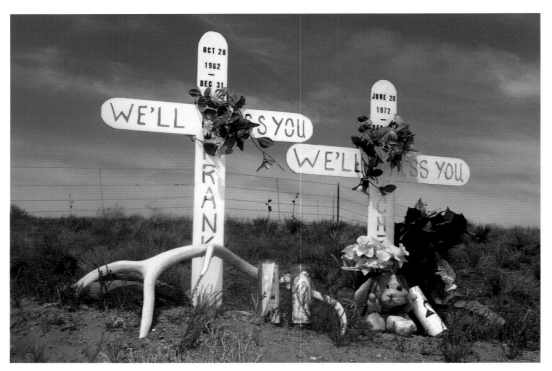

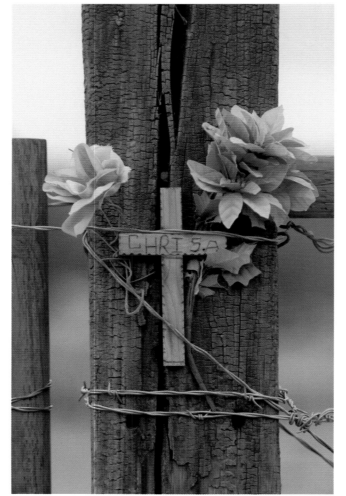

FARMINGTON

At the Sunrise Christian Reformed Church, members Carol Hollett, Nicole King, and King's sisters Kaitlyn and Kristin take down artificial flowers from an Easter display. The independent church promotes itself as a place for people who "want to check out Christianity without any pressure."

Photo by Brett Butterstein

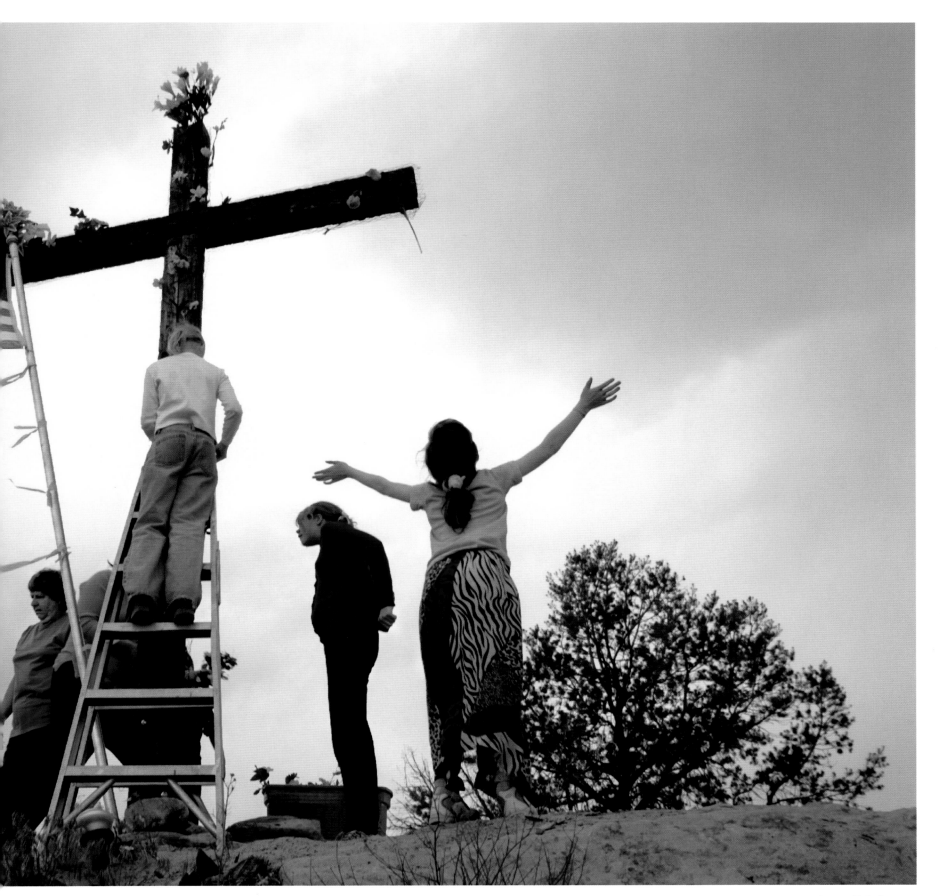

ZUNI PUEBLO
In 1970, when Alex Seowtewa agreed to repaint the ancient kachina spirit figures that had adorned the Zuni Mission (circa 1629) before its 1966 renovation, he had no idea that the work would become a lifelong endeavor. For his ongoing masterpiece, Seowtewa, who is known as the "Zuni Michelangelo," received the Governor's Award for Excellence in the Arts from Governor Bruce King in 1991.
Photo by Michael R. Stoklos

ALBUQUERQUE
More than two dozen Russian Orthodox saints
line 4th Street in front of the Holy Royal Martyrs
chapel. Father Symeon and Father Alexander
painted the mural over three months, completing
it in 2001.
Photos by Douglas Kent Hall

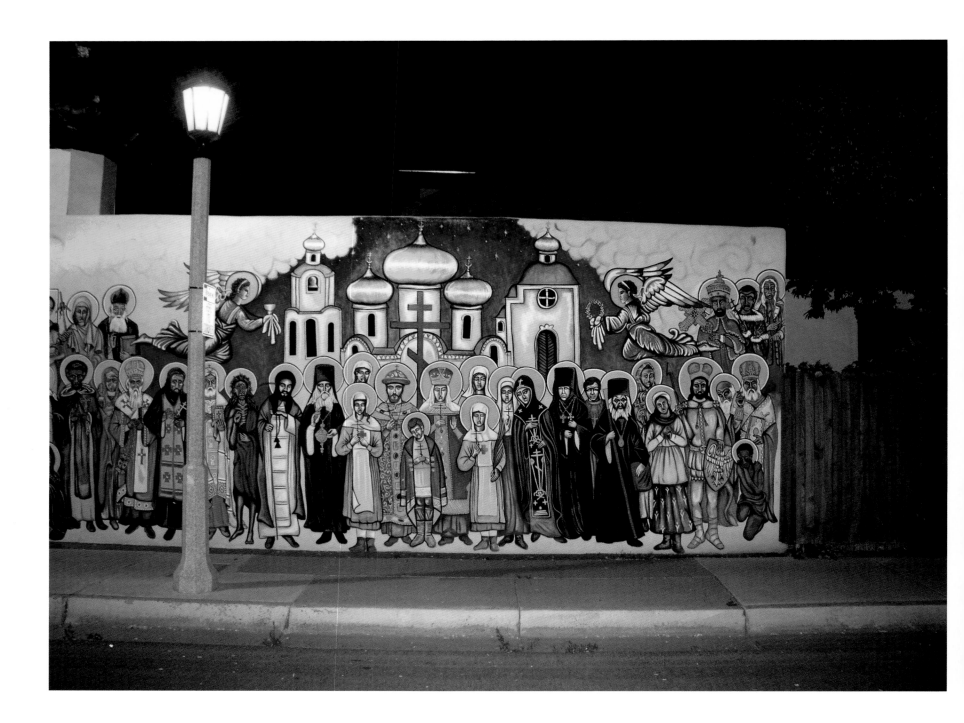

ALBUQUERQUE

Next door to the saints mural on 4th Street sits the 30-year-old Russian Orthodox Our Lady of Kazan monastery and convent, home to three monks and two nuns. Our Lady of Kazan is the patron of the mother chapel and monastery in Kazan, Russia.

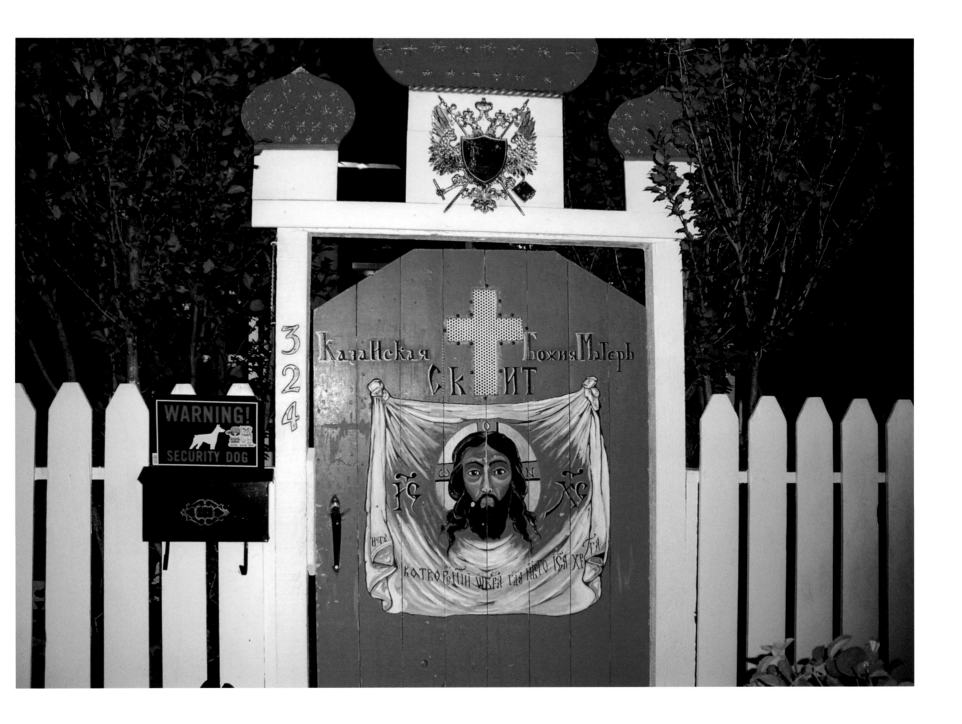

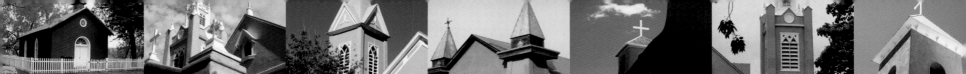

ALBUQUERQUE
For 210 years, the adobe gables and turrets of the San Felipe de Neri church have stood above the bustle of Old Town Plaza.
Photos by Douglas Kent Hall

RANCHOS DE TAOS
With its 4-foot-thick adobe walls, San Francisco de Asis Mission Church took 43 years to build. It was completed in 1815.

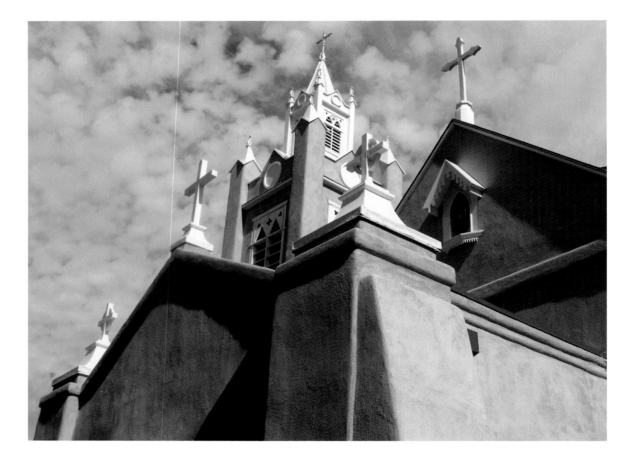

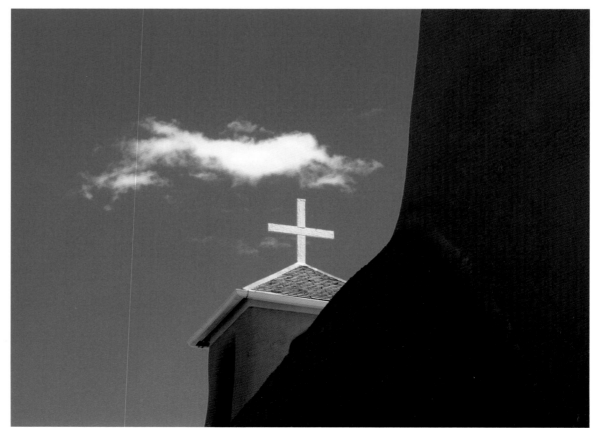

RANCHOS DE TAOS

The elegant symmetry of San Francisco de Asis Mission Church has inspired artists including painter Georgia O'Keeffe and photographer Ansel Adams.

TRAMPAS

The San Jose de Gracia mission was built in 1760 in a valley just south of Taos. The steeple was added to the adobe church during its restoration in the 1970s.

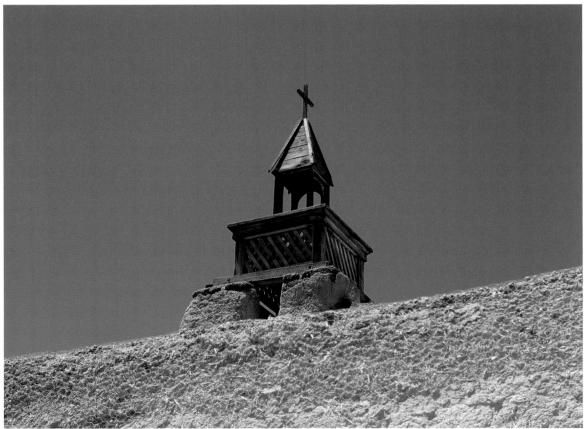

EMBUDO

David English and Marion Moore met at a café in Taos in 2001. While chatting, they discovered that 23 years earlier they had frequented the same nude beach at Lake Tahoe. Turns out Marion was the beautiful woman David had always admired from afar but was too shy to approach.
Photo by Jamey Stillings

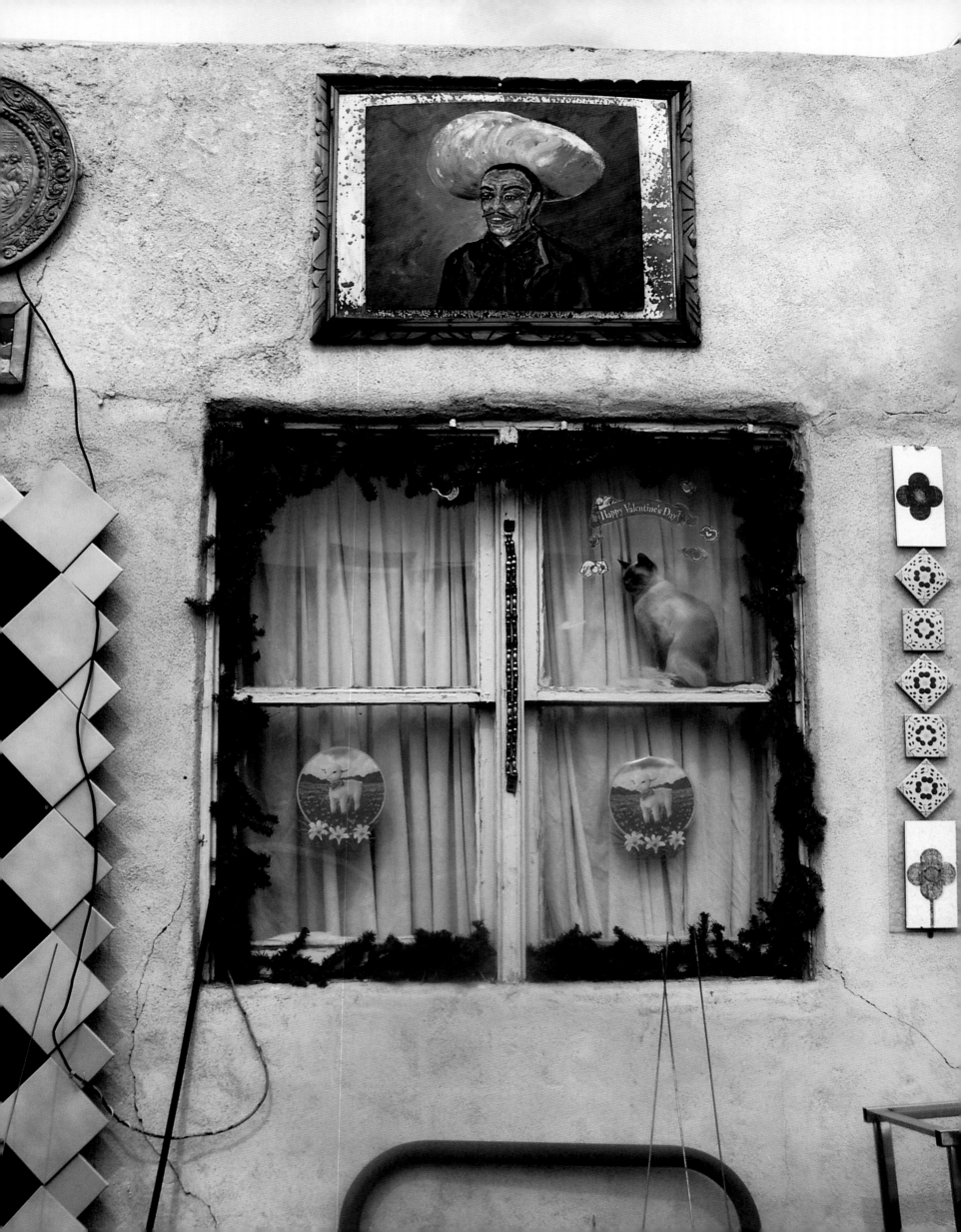

ALBUQUERQUE

Ten years ago, Phyllis Evans moved into the residential Aztec Motel and began decorating with thrift shop artwork. Her handiwork inspired her neighbors to get busy, too. On this wall, the painting is from a California garage sale Evans visited, and the tiles are from an Apache artist and former resident. The Siamese cat is courtesy of the room's current tenant.

Photo by Douglas Kent Hall

TRUTH OR CONSEQUENCES

Painted people adorn the doors of a secondhand shop on the corner of Main and Patton. Formerly called Hot Springs, the town adopted its current name in 1950 as a publicity stunt for the popular radio show.

Photo by Steve Northup

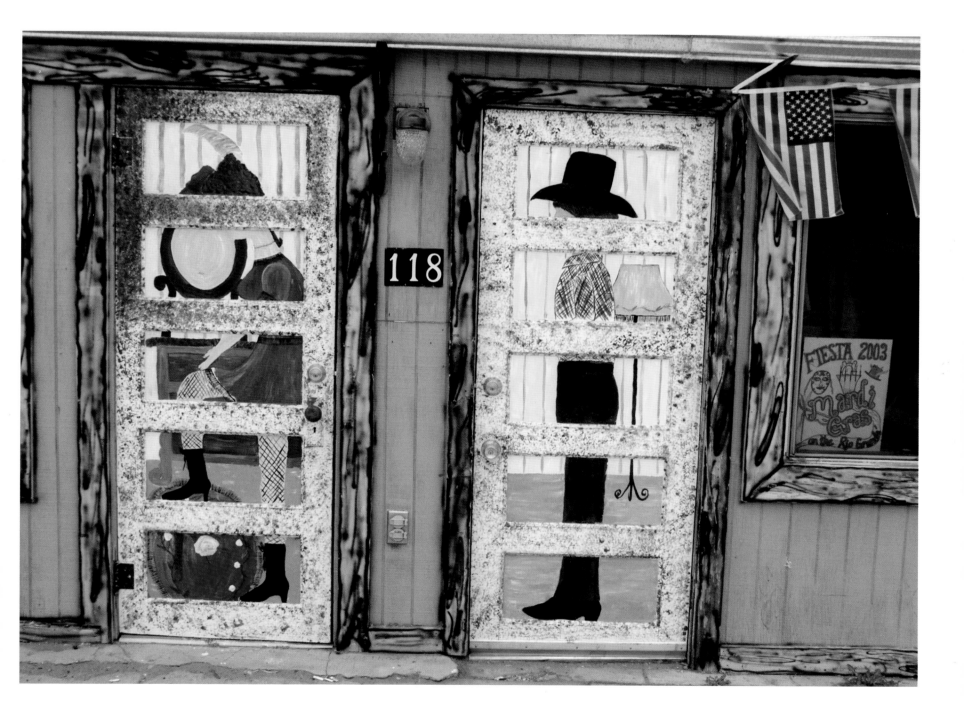

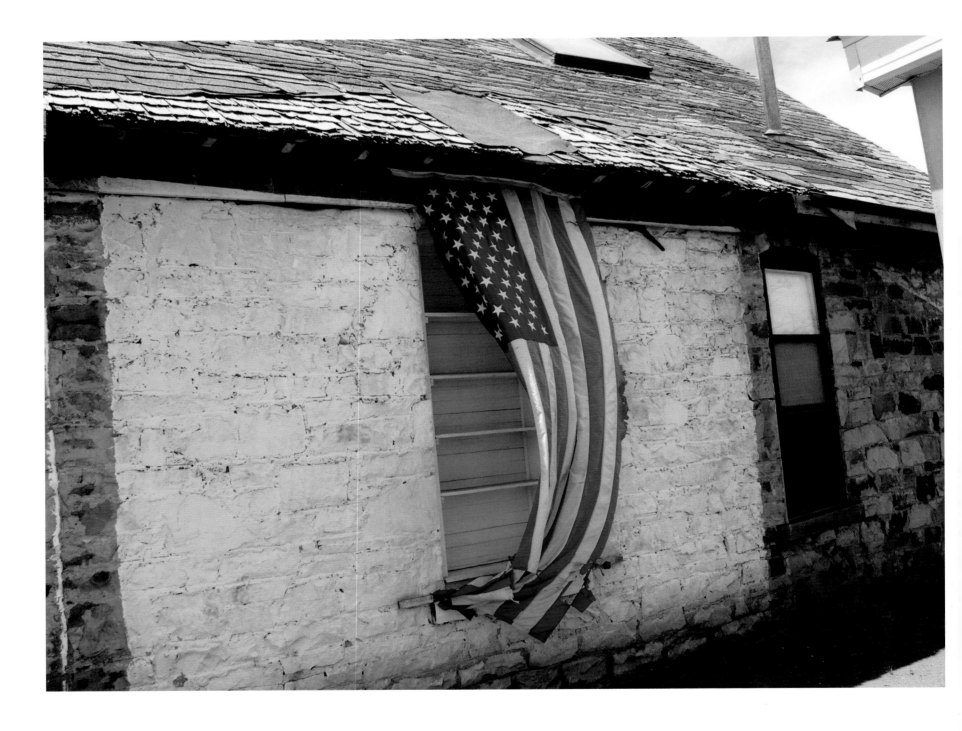

WATROUS

An adobe building wears its age, and pride, well. Two main branches of the 1821 Santa Fe Trail (the Cimarron Cutoff and the Mountain branch) joined up nearby for the trip into Santa Fe. Traffic on the trail grew scant with the coming of the Santa Fe Railroad in 1879.

Photo by Barbara Van Cleve

NAVAJO

John Brown, Jr. kept his role as a code talker in World War II secret for 30 years. One of the original 29 Navajo who devised the unbreakable code based on their native language, he was not allowed to talk about it until it was declassified in 1968. The code talkers were finally recognized in 2001 when they received the Congressional Gold Medal.

Photo by Jeffrey Aaronson, Network Aspen

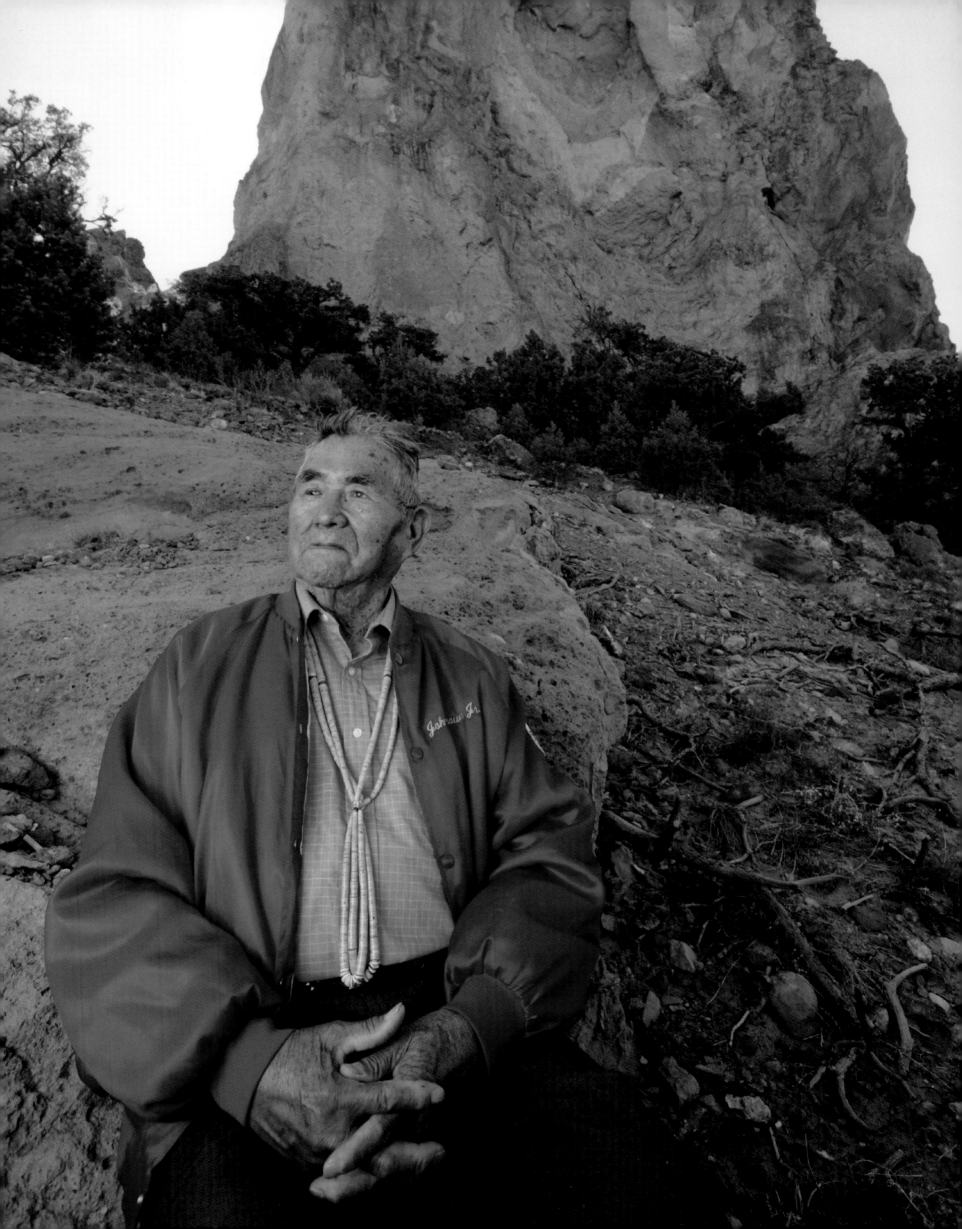

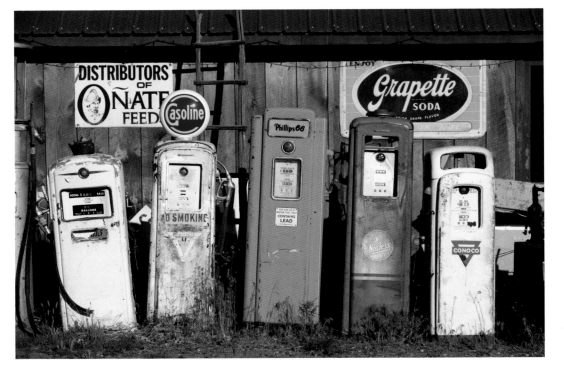

EMBUDO

These old-time gas pumps have caught the eye of many motorists traveling Highway 68, the two-lane road that snakes along the Rio Grande between Sante Fe and Taos. More often than not, the rusted relics will lure folks inside the Classical Gas Museum.

Photos by Jamey Stillings

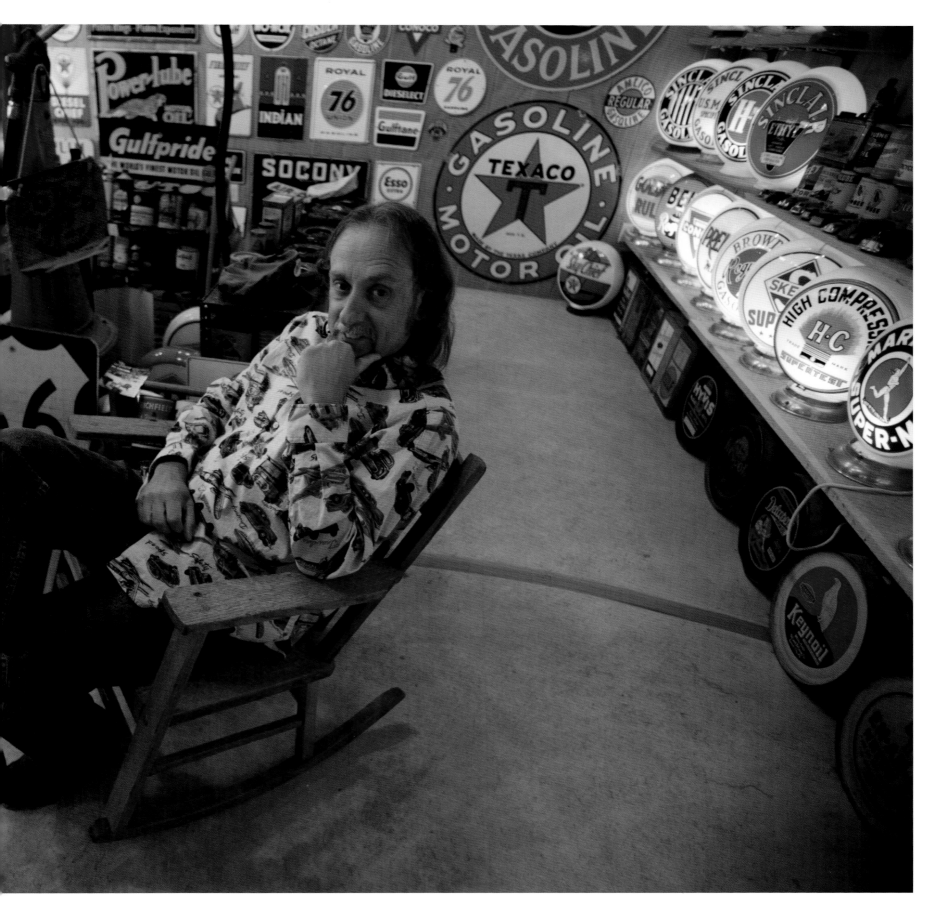

EMBUDO

Retired Los Alamos National Laboratory scientist Johnnie Meier has been collecting old gas pumps, oilcans, signs, and other petroliana for nearly 20 years. The self-proclaimed "ex–science geek" stored the stuff all over his house until 2000, when he opened the Classical Gas Museum. Meier is president of the New Mexico Route 66 Association.

SANTA FE

Lee Griggs, 14, and Lucas Screws, 11, keep it light while waiting for their events at the Sante Fe County 4-H Rodeo.

Photos by Preston Gannaway

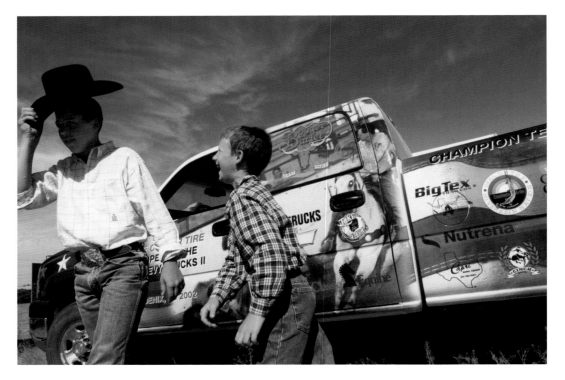

SANTA FE
With mom watching, first-year 4-H Rodeo partic-
ipant Quinton Ellis, 9, practices his dismount for
the goat tying event. "Ever since he could walk,
he's had a rope in his hand," says his mom
LeAnne.

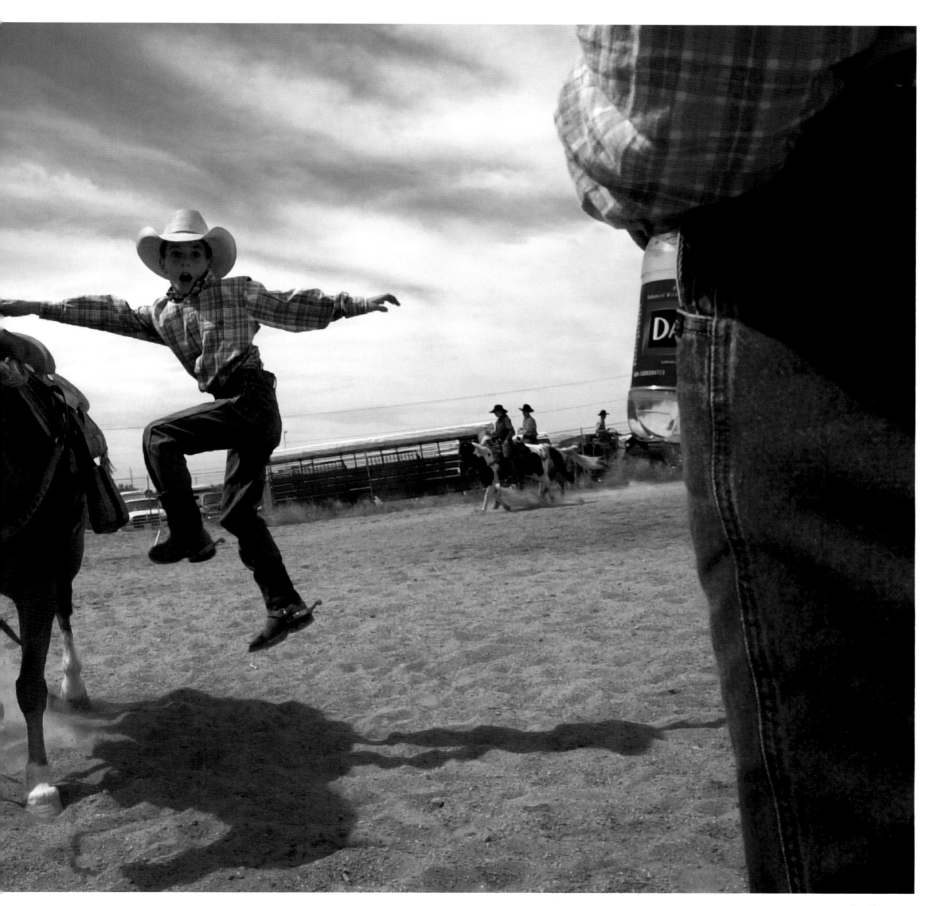

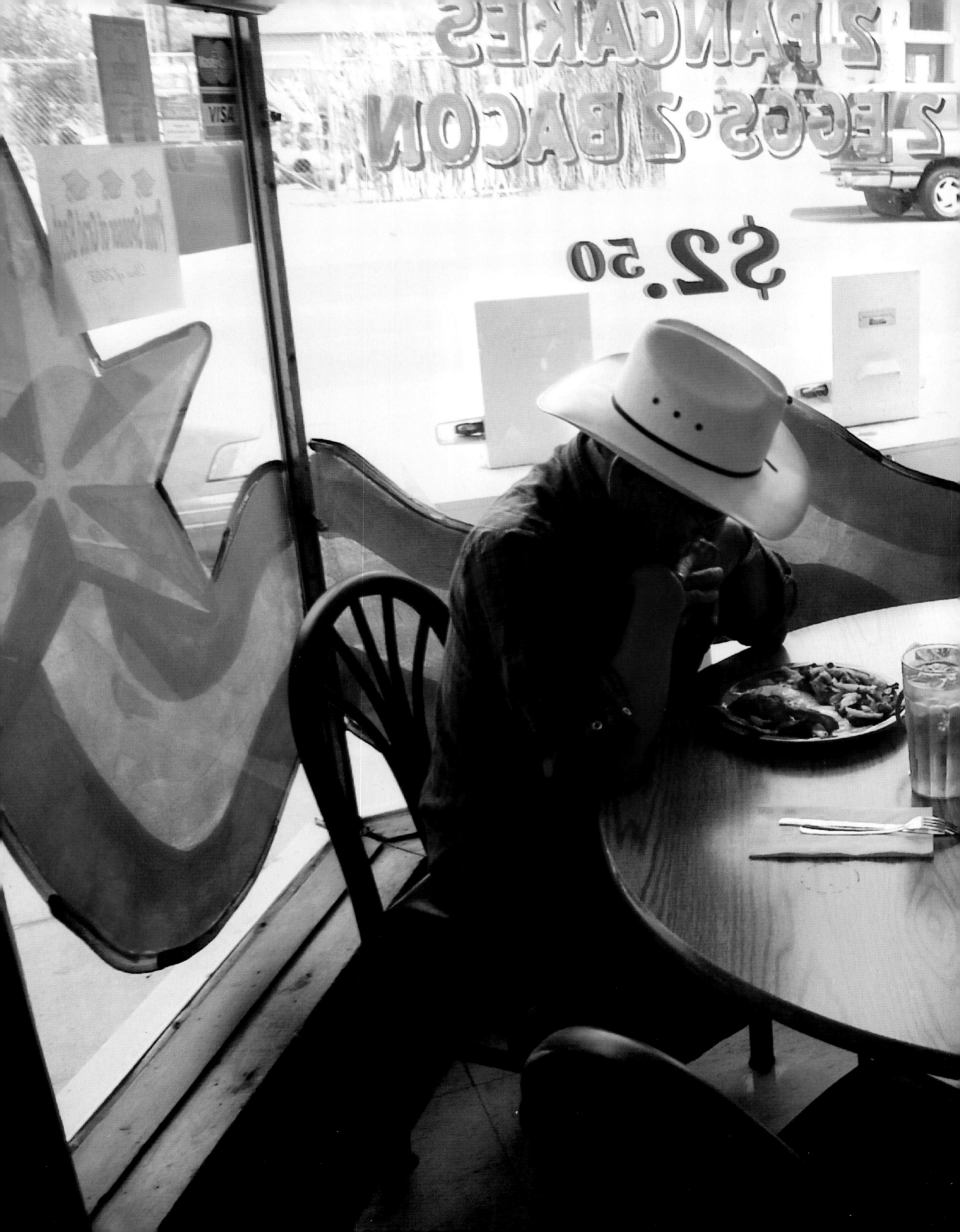

TRUTH OR CONSEQUENCES
Although prices at the Bar-B-Que on Broadway are circa 1980, the flag-waving is pure 2003. Bernardo Valenciano and Lawrence Bush say grace before digging in to their breakfast of pancakes, eggs, and bacon. According to local custom, it is not considered impolite to eat with one's hat on.
Photo by Steve Northup

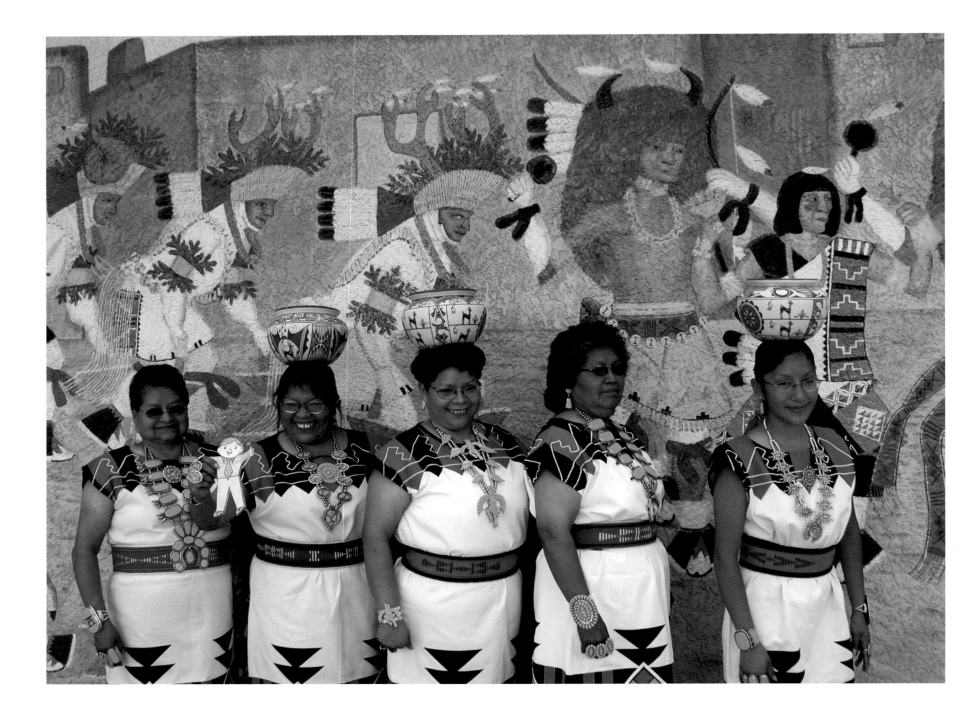

ALBUQUERQUE
Three generations of Zuni Olla Maidens, Cornelia Bowannie, daughters Juanita Edaakie and Loretta Beyuka, aunt Arliss Luna, and granddaughter Breana Yamutewa pose at the Pueblo Cultural Center. The Zuni Olla Maidens have been performing for 24 years, honoring their ancestors by singing while dancing with the ceramic olla pots used to carry water.
Photo by Marcia Keegan

SANTA FE

Esperanza Martinez, Jacqueline Lobato, Mariah Chavez, Denay Griego, and Zelyna Apodaca get ready to perform at Santa Fe's CommUNITY Days festival. The Baile Español troupe, which performs Mexican Folklorico–style dances, was founded in 1980 and includes dancers from 3 to 25 years old.

Photo by Carole Devillers

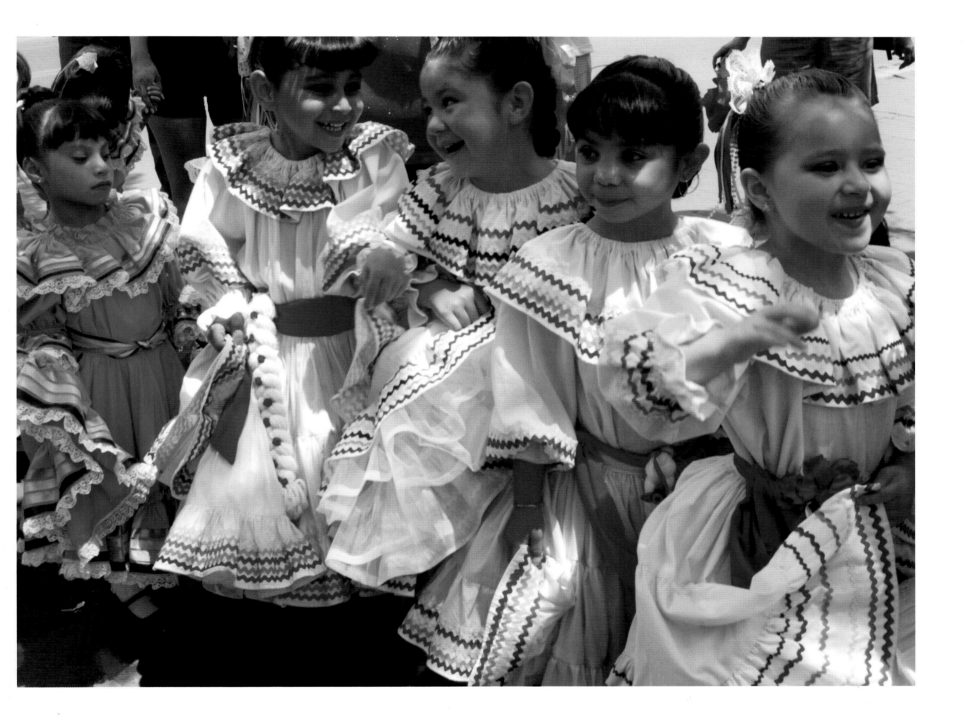

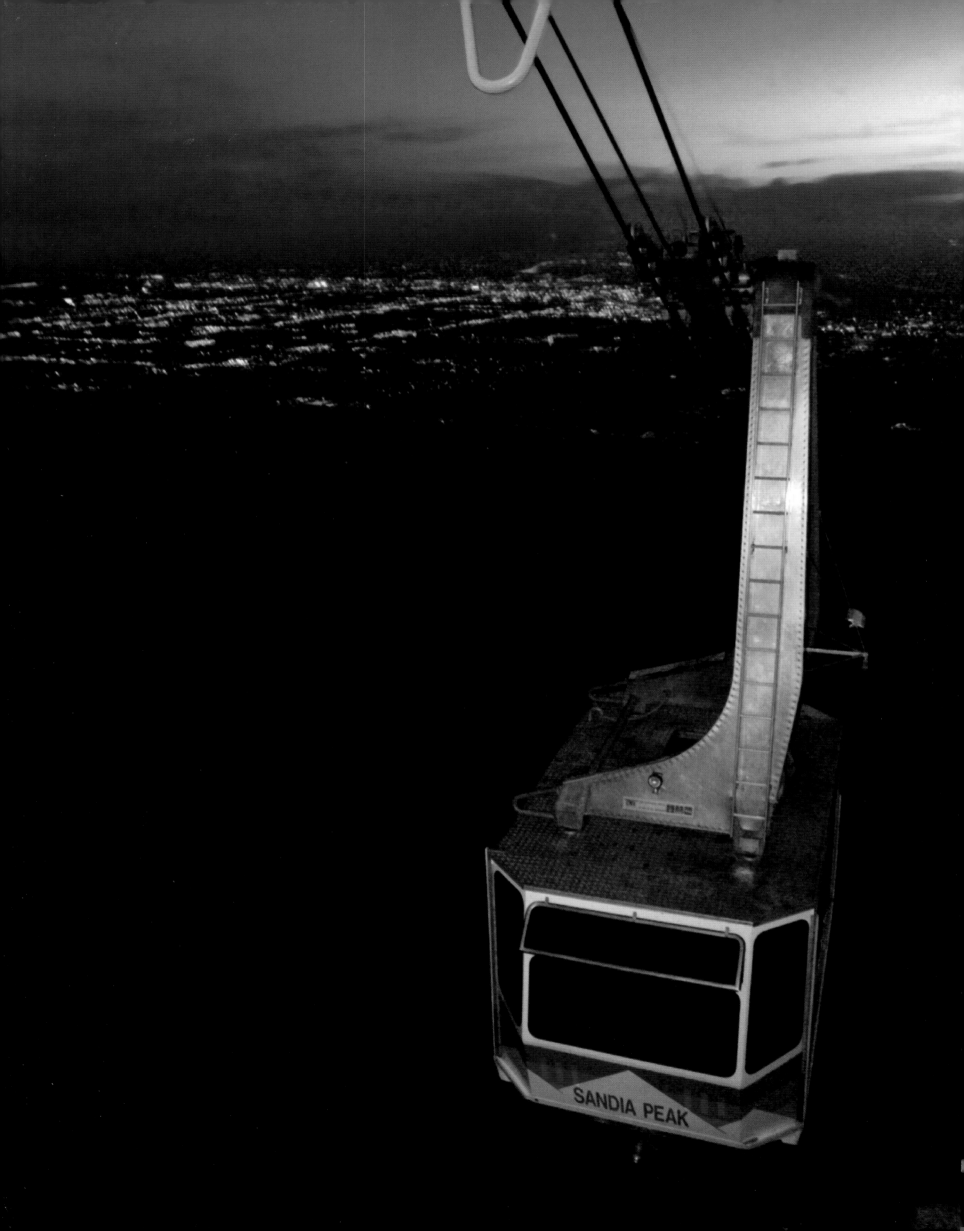

ALBUQUERQUE

The world's longest aerial tramway travels 2.7 miles from its base station in Albuquerque to 10,378-foot Sandia Peak in the Sandia Mountains.
Photo by Jake Schoellkopf

ALBUQUERQUE

Hey, daddy-o! Just blocks from historic Route 66, members of the Rumblers, a group of friends who've adopted the trappings of a 1950s lifestyle—from cars to clothes to slang to home appliances—hang out in the parking lot of the Heights Community Center.
Photo by Craig Fritz

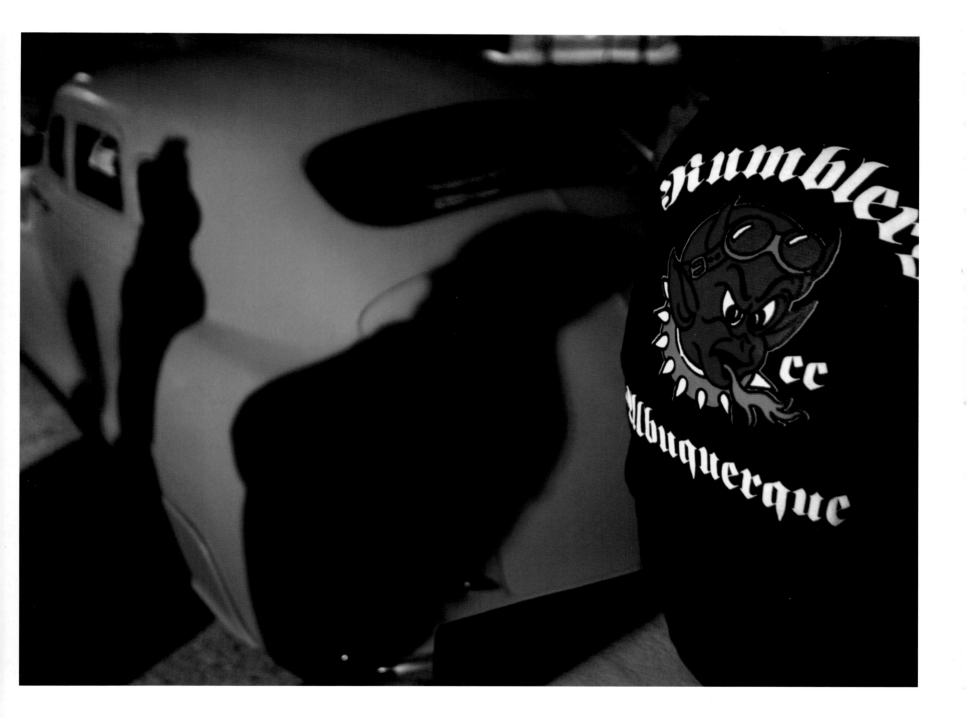

ALBUQUERQUE

Not only did the band Manzanares perform at the New Mexico Music Industry Association Awards, they took home four of the awards, including Album of the Year. *Nuevo Latino* is both the name of their winning CD and a description of their pulsating, high-energy sound. That's David Manzanares on guitar.

Photo by Eli Reed, Magnum Photos, Inc.

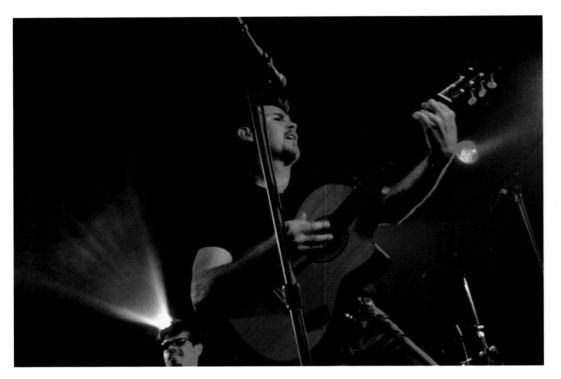

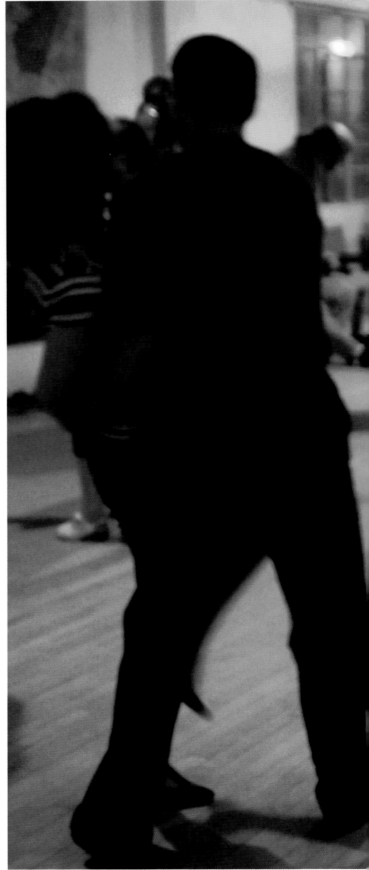

ALBUQUERQUE

During the weekly Tuesday night swing dance, Gina Alfieri reaches new depths at the Heights Community Center. The 61-year-old center, the first of its kind in Albuquerque, was built as a Depression-era National Youth Administration project.

Photo by Craig Fritz

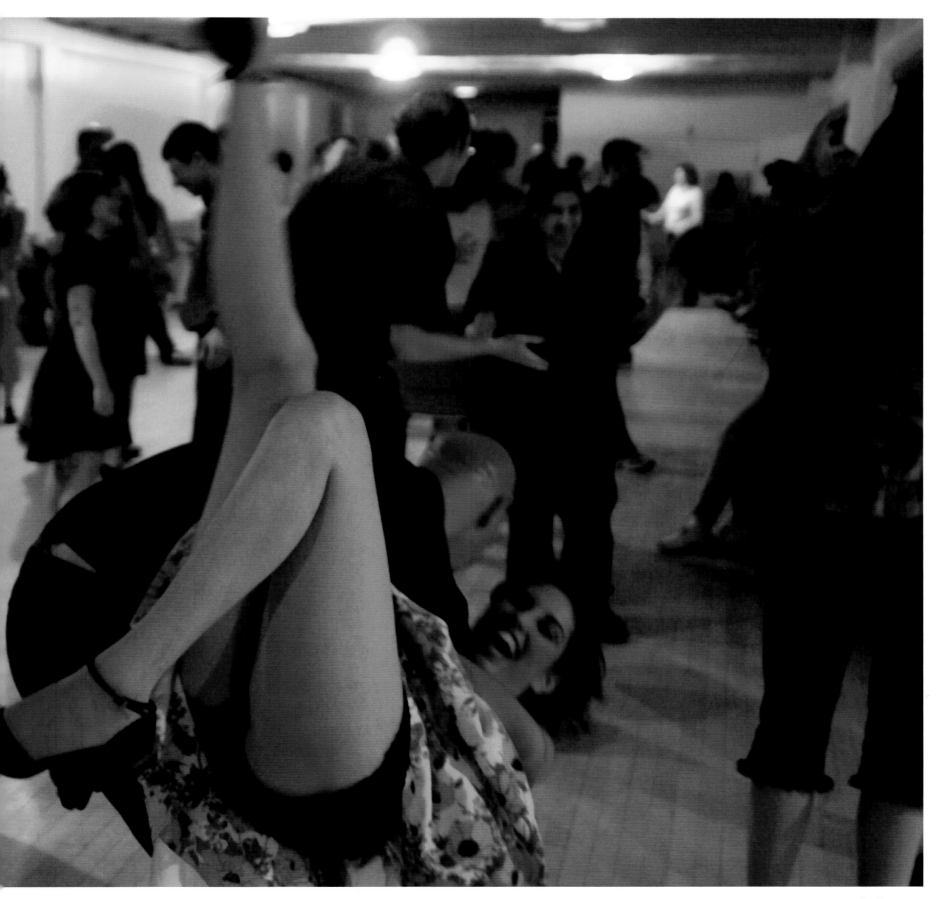

DOÑA ANA COUNTY
The San Andres Mountains silhouetted by
the approaching night sky in southern New
Mexico. The range's highest point is Salinas
Peak, at 9,000 feet.
Photo by Sterling Trantham,
New Mexico State University

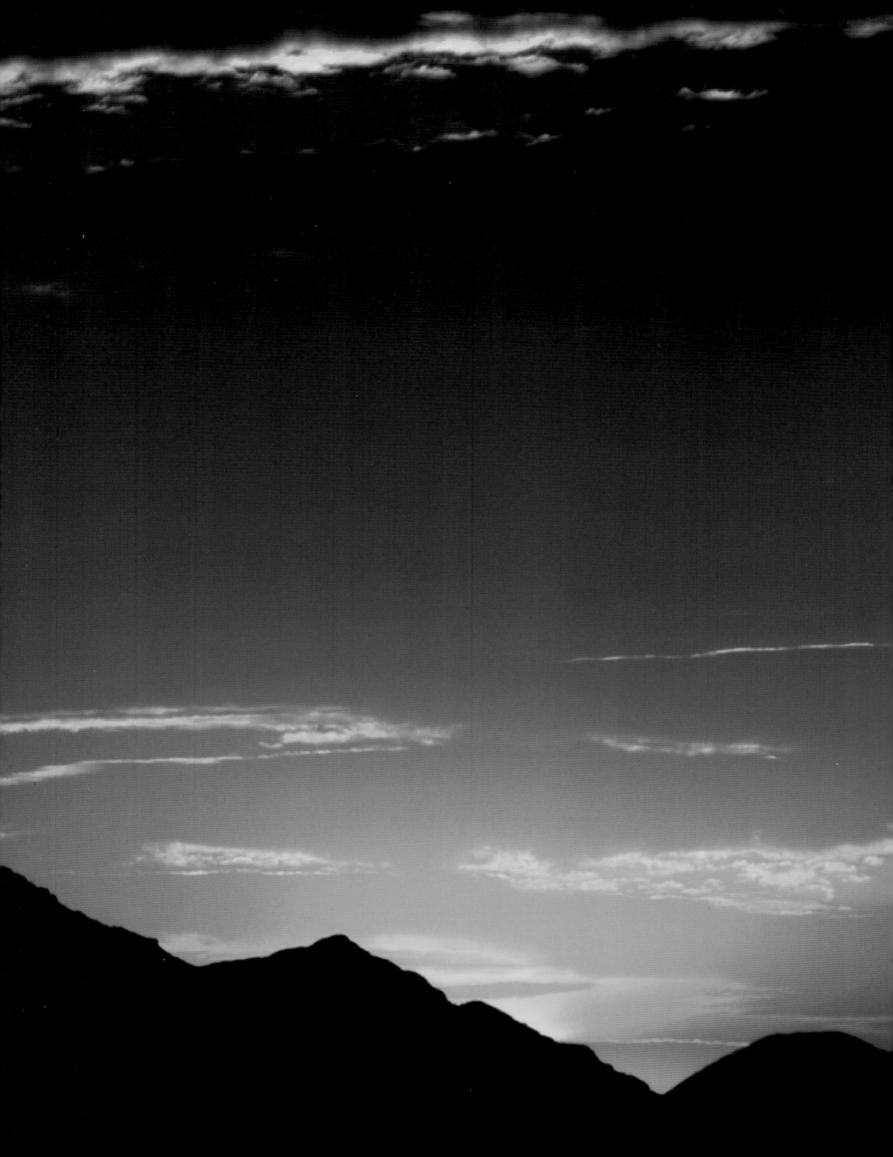

he week of May 12-18, 2003, more than 25,000
professional and amateur photographers spread out
ross the nation to shoot over a million digital photographs
h the goal of capturing the essence of daily life in America.
The professional photographers were equipped with
be Photoshop and Adobe Album software, Olympus
050 digital cameras, and Lexar Media's high-speed
mpact flash cards.

The 1,000 professional contract photographers plus
ther 5,000 stringers and students sent their images via
(file transfer protocol) directly to the *America 24/7*
bsite. Meanwhile, thousands of amateur photographers
baded their images to Snapfish's servers.

At *America 24/7*'s Mission Control headquarters, located
NET in San Francisco, dozens of picture editors from the
on's most prestigious publications culled the images
vn to 25,000 of the very best, using Photo Mechanic by
nera Bits. These photos were transferred into Webware's
veMedia Digital Asset Management (DAM) system,
ch served as a central image library and enabled the
gners to track, search, distribute, and reformat the images
he creation of the 51 books, foreign language editions,
and magazine syndication, posters, and exhibitions.
Once in the DAM, images were optimized (and in some
s resampled to increase image resolution) using Adobe
toshop. Adobe InDesign and Adobe InCopy were used to
gn and produce the 51 books, which were edited and
ewed in multiple locations around the world in the form
dobe Acrobat PDFs. Epson Stylus printers were used for
o proofing and to produce large-format images for
bitions. The companies providing support for the
rica 24/7 project offer many of the essential components
anyone building a digital darkroom. We encourage you to

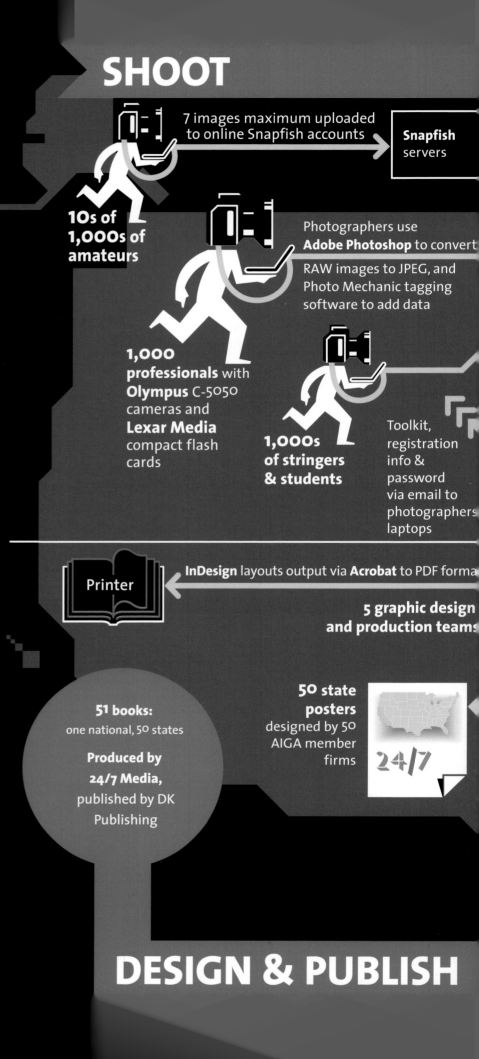

SHOOT

7 images maximum uploaded
to online Snapfish accounts

Snapfish
servers

**10s of
1,000s of
amateurs**

Photographers use
Adobe Photoshop to convert
RAW images to JPEG, and
Photo Mechanic tagging
software to add data

**1,000
professionals** with
Olympus C-5050
cameras and
Lexar Media
compact flash
cards

**1,000s
of stringers
& students**

Toolkit,
registration
info &
password
via email to
photographers
laptops

InDesign layouts output via **Acrobat** to PDF forma

Printer

**5 graphic design
and production teams**

51 books:
one national, 50 states

**Produced by
24/7 Media,**
published by DK
Publishing

**50 state
posters**
designed by 50
AIGA member
firms

24/7

DESIGN & PUBLISH

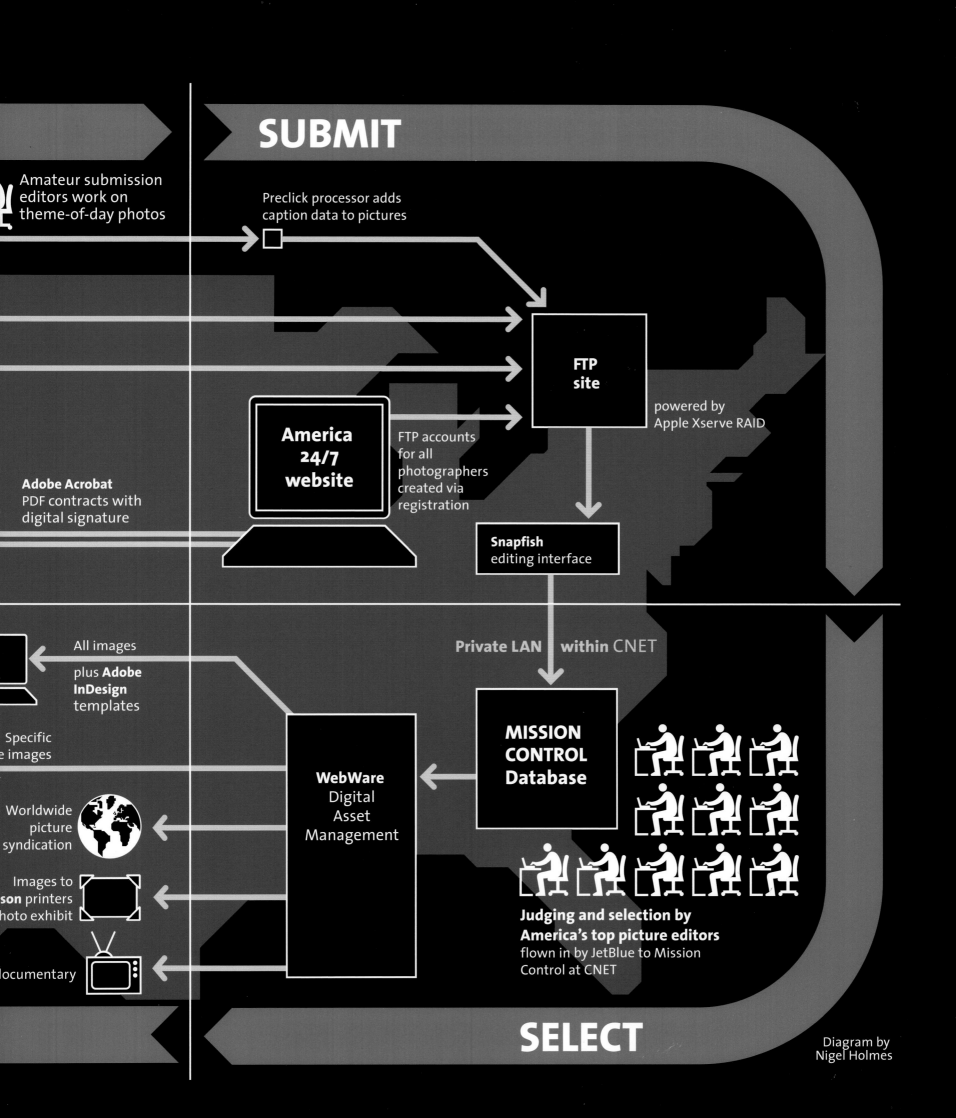

SUBMIT

Amateur submission
editors work on
theme-of-day photos

Preclick processor adds
caption data to pictures

**FTP
site**

powered by
Apple Xserve RAID

**America
24/7
website**

FTP accounts
for all
photographers
created via
registration

Adobe Acrobat
PDF contracts with
digital signature

Snapfish
editing interface

All images

plus **Adobe
InDesign**
templates

Private LAN within CNET

Specific
e images

**MISSION
CONTROL
Database**

Worldwide
picture
syndication

WebWare
Digital
Asset
Management

Images to
son printers
hoto exhibit

**Judging and selection by
America's top picture editors**
flown in by JetBlue to Mission
Control at CNET

ocumentary

SELECT

Diagram by
Nigel Holmes

About Our Sponsors

America 24/7 gave digital photographers of all levels the opportunity to share their visions of what it means to live in the United States. This project was made possible by a digital photography revolution that is dramatically changing and improving picture-taking for professionals and amateurs alike. And an Adobe product, Photoshop®, has been at the center of this sea change.

Adobe's products reflect our customers' passion for the creative process, be it the photographer, graphic designer, layout artist, or printer. Adobe is the Publishing and Imaging Software Partner for *America 24/7* and products such as Adobe InDesign®, Photoshop, Acrobat®, and Illustrator® were used to produce this stunning book in a matter of weeks. We hope that our software has helped do justice to the mythic images, contributed by well-known photographers and the inspired hobbyist.

Adobe is proud to be a lead sponsor of *America 24/7*, a project that celebrates the vibrancy of the American spirit: the same spirit that helped found Adobe and inspires our employees and customers to deliver the very best.

Bruce Chizen
President and CEO
Adobe Systems Incorporated

Olympus, a global technology leader in designing precision healthcare solutions and innovative consumer electronics, is proud to be the official digital camera sponsor of *America 24/7*. The opportunity to introduce Americans from coast to coast to the thrill, excitement, and possibility of digital photography makes the vision behind this book a perfect fit for Olympus, a leader in digital cameras since 1996.

For most people, the essence of digital photography is best grasped through firsthand experience with the technology, which is precisely what *America 24/7* is about. We understand that direct experience is the pathway to inspiration, and welcome opportunities like this sponsorship to bring the power of the digital experience into the lives of people everywhere. To Olympus, *America 24/7* offers a platform to help realize a core mission: to deliver and make accessible the power of the digital experience to millions of American photographers, amateurs, and professionals alike.

The 1,000 professional photographers contracted to shoot on the America 24/7 project were all equipped with Olympus C-5050 digital cameras. Like all Olympus products, the C-5050 is offered by a company well known for designing, manufacturing, and servicing products used by professionals to perform their work, every day. Olympus is a customer-centric company committed to working one-to-one with a diverse group of professionals. From biomedical researchers who use our clinical microscopes, to doctors who perform life-saving procedures with our endoscopes, to professional photographers who use cameras in their daily work, Olympus is a trusted brand.

The digital imaging technology involved with *America 24/7* has enabled the soul of America to be visually conveyed, not just by professional observers, but by the American public who participated in this project—the very people who collectively breath life into this country's existence each day.

We are proud to be enabling so many photographers to capture the pictures on these pages that tell the story of who we are as a nation. From sea to shining sea, digital imagery allows us to connect to one another in ways we never dreamed possible.

At Olympus, our ideas have proliferated as rapidly as technology has evolved. We have channeled these visions into breakthrough products and solutions to meet the demands of our changing world-products like microscopes, endoscopes, and digital voice recorders, supported by the highly regarded training, educational, and consulting services we offer our customers.

Today, 83 years after we introduced our first microscope, we remain as young, as curious, and as committed as ever.

Lexar Media has grown from the digital photography revolution, which is why we are proud to have supplied the digital memory cards used in the America 24/7 project. Lexar Media's high-performance memory cards utilize our unique and patented controller coupled with high-speed flash memory from Samsung, the world's largest flash memory supplier. This powerful combination brings out the ultimate performance of any digital camera.

Photographers who demand the most from their equipment choose our products for their advanced features like write speeds up to 40X, Write Acceleration technology for enabled cameras, and Image Rescue, which recovers previously deleted or lost images. Leading camera manufacturers bundle Lexar Media digital memory cards with their cameras because they value its performance and reliability.

Lexar Media is at the forefront of digital photography as it transforms picture-taking worldwide, and we will continue to be a leader with new and innovative solutions for professionals and amateurs alike.

Snapfish, which developed the technology behind the *America 24/7* amateur photo event, is a leading online photo service, with more than 5 million members and 100 million photos posted online. Snapfish enables both film and digital camera owners to share, print, and store their most important photo memories, at prices that cannot be equaled. Digital camera users upload photos into a password-protected online album for free. Users can also order film-quality prints on professional photographic paper for as low as 25¢. Film camera users get a full set of prints, plus online sharing and storage, for just $2.99 per roll.

Founded in 1995, eBay created a powerful platform for the sale of goods and services by a passionate community of individuals and businesses. On any given day, there are millions of items across thousands of categories for sale on eBay. eBay enables trade on a local, national and international basis with customized sites in markets around the world.

Through an array of services, such as its payment solution provider PayPal, eBay is enabling global e-commerce for an ever-growing online community.

JetBlue Airways is proud to be *America 24/7's* preferred carrier, flying photographers, photo editors, and organizers across the United States.

Winner of Condé Nast Traveler's Readers' Choice Awards for Best Domestic Airline 2002, JetBlue provides friendly service and low fares for travelers in 22 cities in nine states across America.

On behalf of JetBlue's 5,000 crew members, we're excited to be involved in this remarkable project, and for the opportunity to serve American travelers each and every day, coast to coast, 24/7.

DIGITAL POND

Digital Pond has been a leading creator of large graphic displays for museums, corporations, trade shows, retail environments and fine art since 1992.

We were proud to bring together our creative, print and display capabilities to produce signage and displays for mission control, critical retouching for numerous key images for the book, and art galleries for the New York Public Library and Bryant Park.

The Pond's team and SplashPic® Online service enabled us to nimbly design, produce and install over 200 large graphic panels in two NYC locations within the truly "24/7" production schedule of less than ten days.

WebWare Corporation is pleased to be a major sponsor of the America 24/7 project. We take pride in being part of a groundbreaking adventure that is stretching the boundaries—and the imagination—in digital photography, digital asset management, publishing, news, and global events.

Our ActiveMedia Enterprise™ digital asset management software is the "nerve center" of *America 24/7*, the central repository for managing, sharing, and collaborating on the project's photographs. From photo editors and book publishers to 24/7's media relations and marketing personnel, ActiveMedia provides the application support that links all facets of the project team to the content worldwide.

WebWare helps Global 2000 firms securely manage, reuse, and distribute media assets locally or globally. Its suite of ActiveMedia software products provide powerful media services platforms for integrating rich media into content management systems marketing and communication portals; web publishing systems; and e-commerce portals.

Google

Google's mission is to organize the world's information and make it universally accessible and useful.

With our focus on plucking just the right answer from an ocean of data, we were naturally drawn to the America 24/7 project. The book you hold is a compendium of images of American life distilled from thousands of photographs and infinite possibilities. Are you looking for emotion? Narrative? Shadows? Light? It's all here, thanks to a multitude of photographers and writers creating links between you, the reader, and a sea of wonderful stories. We celebrate the connections that constitute the human experience and are pleased to help engender them. And we're pleased to have been a small part of this project, which captures the results of that interaction so vividly, so dynamically, and so dramatically.

Special thanks to additional contributors: FileMaker, Apple, Camera Bits, LaCie, Now Software, Preclick, Outpost Digital, Xerox, Microsoft, WoodWing Software, net-linx Publishing Solutions, and Radical Media. The Savoy Hotel, San Francisco; The Pan Pacific, San Francisco; Four Seasons Hotel, San Francisco; and The Queen Anne Hotel. Photography editing facilities were generously hosted by CNET Networks, Inc.

Participating Photographers

New Mexico Coordinator: Mark Holm, Director of Photography, *The Albuquerque Tribune*

Jeffrey Aaronson, Network Aspen
S. Ray Acevedo
Brett Butterstein
Esha Chiocchio
Kitty Clark Fritz
Adam Conner
Carole Devillers
Phillippe Diederich
Teresa Espindola
Craig Fritz
Michael J. Gallegos, *The Albuquerque Tribune*
Miguel Gandert
Preston Gannaway
Douglas Kent Hall
Paul Jaeger
Toby Jorrin, *The Albuquerque Tribune*
Marcia Keegan
Karen Kuehn
Roger Levien

Kellie Lockhart
Maureen Mahoney-Barraclough
Steve Northup
Wes Pope, *The Santa Fe New Mexican*
Taralyn Quigley
Eli Reed, Magnum Photos, Inc.
David Reffalt
Jake Schoellkopf
Richard Scibelli, Jr.
Stacia Spragg, *The Albuquerque Tribune*
Steven St. John
Jamey Stillings
Michael R. Stoklos
Sterling Trantham, New Mexico State University
Barbara Van Cleve
Pat Vasquez-Cunningham
Jennah Ward
Rick Wiedenmann

Thumbnail Picture Credits

Credits for thumbnail photographs are listed by the page number and are in order from left to right.

20 Carole Devillers
Carmela Chavez
Phillippe Diederich
Douglas Kent Hall
Kitty Clark Fritz
Douglas Kent Hall
Douglas Kent Hall

21 Jamey Stillings
Jamey Stillings
Jamey Stillings
Jamey Stillings
Jamey Stillings
Jamey Stillings

22 Steve Northup
Phillippe Diederich
Jake Schoellkopf
Jake Schoellkopf
Jake Schoellkopf
Phillippe Diederich
Jake Schoellkopf

23 Kelly D. Gatlin, La Luz Photography
Phillippe Diederich
Jake Schoellkopf
Phillippe Diederich
Jamey Stillings
Jamey Stillings
Pat Vasquez-Cunningham

24 Toby Jorrin, *The Albuquerque Tribune*
Toby Jorrin, *The Albuquerque Tribune*
Brett Butterstein
Toby Jorrin, *The Albuquerque Tribune*
Brett Butterstein
Brett Butterstein
Brett Butterstein

25 Carole Devillers
Brett Butterstein
Craig Fritz
Brett Butterstein
Toby Jorrin, *The Albuquerque Tribune*
Brett Butterstein
Carole Devillers

26 Barbara Van Cleve
Barbara Van Cleve
Barbara Van Cleve

Barbara Van Cleve
Barbara Van Cleve
Barbara Van Cleve
Barbara Van Cleve

28 Brett Butterstein
Carole Devillers
Brett Butterstein
Barbara Van Cleve
Brett Butterstein
Carole Devillers
Carole Devillers

29 Carole Devillers
Pat Vasquez-Cunningham
Carole Devillers
Carole Devillers
Sterling Trantham, New Mexico State University
Carole Devillers
Steven St. John

30 Carmela Chavez
Esha Chiocchio
Richard Scibelli, Jr.
Stacia Spragg, *The Albuquerque Tribune*
Steve Northup
Ron Keller
Ron Keller

31 Steve Northup
Steven St. John
Steve Northup
Steven St. John
Steve Northup
Esha Chiocchio
Steven St. John

34 Karen Kuehn
Carole Devillers
Karen Kuehn
Carole Devillers
Karen Kuehn
Carole Devillers
Karen Kuehn

35 Karen Kuehn
Carole Devillers
Karen Kuehn
Carole Devillers

Karen Kuehn
Carole Devillers
Karen Kuehn

36 Luis Sanchez Saturno
Luis Sanchez Saturno
Esha Chiocchio
Luis Sanchez Saturno
Esha Chiocchio
Luis Sanchez Saturno
Esha Chiocchio

37 Brett Butterstein
Brett Butterstein
Craig Fritz
Eli Reed, Magnum Photos, Inc.
Shari Vialpando, New Mexico State University
Eli Reed, Magnum Photos, Inc.
Eli Reed, Magnum Photos, Inc.

38 Pat Vasquez-Cunningham
Pat Vasquez-Cunningham
Esha Chiocchio
Esha Chiocchio
Esha Chiocchio
Esha Chiocchio
Esha Chiocchio

39 Jennah Ward
Jennah Ward
Jennah Ward
Jennah Ward
Jennah Ward
Jennah Ward

40 Barbara Van Cleve
Barbara Van Cleve
Jennah Ward
Barbara Van Cleve
Jennah Ward
Barbara Van Cleve
Jennah Ward

41 Barbara Van Cleve
Jennah Ward
Jennah Ward
Barbara Van Cleve
Jennah Ward
Vaughn Morgan
Vaughn Morgan

48 Barbara Van Cleve
Barbara Van Cleve
Barbara Van Cleve
Barbara Van Cleve
Barbara Van Cleve
Barbara Van Cleve
Barbara Van Cleve

49 Barbara Van Cleve
Barbara Van Cleve
Barbara Van Cleve
Barbara Van Cleve
Barbara Van Cleve
Barbara Van Cleve
Barbara Van Cleve

52 Brett Butterstein
Brett Butterstein
Brett Butterstein
Jim Hunter
Stacia Spragg, *The Albuquerque Tribune*
Stacia Spragg, *The Albuquerque Tribune*
Stacia Spragg, *The Albuquerque Tribune*

53 Barbara Van Cleve
Sterling Trantham, New Mexico State University
Craig Fritz
Steven St. John
Phillippe Diederich
Phillippe Diederich
Steven St. John

54 Karen Kuehn
Karen Kuehn
Karen Kuehn
Karen Kuehn

Karen Kuehn
Carole Devillers
Karen Kuehn

55 Karen Kuehn
Karen Kuehn
Karen Kuehn
Karen Kuehn
Karen Kuehn
Karen Kuehn
Karen Kuehn

56 Sterling Trantham, New Mexico State University
Carole Devillers
Carole Devillers
Carole Devillers
Sterling Trantham, New Mexico State University
Carole Devillers
Carole Devillers

57 Carole Devillers
Carole Devillers
Carole Devillers
Carole Devillers
Steve Northup
Carole Devillers
Carole Devillers

60 Michael J. Gallegos, *The Albuquerque Tribune*
Esha Chiocchio
Michael J. Gallegos, *The Albuquerque Tribune*
Michael J. Gallegos, *The Albuquerque Tribune*
Esha Chiocchio
Michael J. Gallegos, *The Albuquerque Tribune*
Douglas Kent Hall

61 Esha Chiocchio
Pat Vasquez-Cunningham
Pat Vasquez-Cunningham
Pat Vasquez-Cunningham
Esha Chiocchio
Pat Vasquez-Cunningham
Pat Vasquez-Cunningham

64 Carole Devillers
Richard Scibelli, Jr.
Carole Devillers
Pat Vasquez-Cunningham
Carole Devillers
Douglas Kent Hall
Jim Hunter

65 Douglas Kent Hall
Wes Pope, *The Santa Fe New Mexican*
Steve Northup
Douglas Kent Hall
Douglas Kent Hall
Douglas Kent Hall
Richard Scibelli, Jr.

66 Douglas Kent Hall
Douglas Kent Hall
Douglas Kent Hall
Douglas Kent Hall
Douglas Kent Hall
Douglas Kent Hall
Douglas Kent Hall

67 Douglas Kent Hall
Jamey Stillings
Jennah Ward
Jamey Stillings
Douglas Kent Hall
Jennah Ward
Douglas Kent Hall

68 Miguel Gandert
Paul Jaeger
Miguel Gandert
Phillippe Diederich
Miguel Gandert
Miguel Gandert
Richard Scibelli, Jr.

69 David Reffalt
Sterling Trantham, New Mexico State University
S. Ray Acevedo

Steve Northup
S. Ray Acevedo
Steve Northup
S. Ray Acevedo

70 Douglas Kent Hall
Douglas Kent Hall
David Reffalt
Carole Devillers
Douglas Kent Hall
Douglas Kent Hall
Carole Devillers

71 Douglas Kent Hall
Douglas Kent Hall
Douglas Kent Hall
Jim Hunter
Douglas Kent Hall
Jamey Stillings
Jamey Stillings

72 Jamey Stillings
Jamey Stillings
Jamey Stillings
Jamey Stillings
Jamey Stillings
Jamey Stillings
Jamey Stillings

73 Jamey Stillings
Jamey Stillings
Jamey Stillings
Jamey Stillings
Jamey Stillings
Jamey Stillings
Jamey Stillings

74 Eli Reed, Magnum Photos, Inc.
Toby Jorrin, *The Albuquerque Tribune*
Eli Reed, Magnum Photos, Inc.
Eli Reed, Magnum Photos, Inc.
Toby Jorrin, *The Albuquerque Tribune*
Toby Jorrin, *The Albuquerque Tribune*
Eli Reed, Magnum Photos, Inc.

75 Sterling Trantham,
New Mexico State University
Toby Jorrin, *The Albuquerque Tribune*
Toby Jorrin, *The Albuquerque Tribune*
Toby Jorrin, *The Albuquerque Tribune*
Eli Reed, Magnum Photos, Inc.
Eli Reed, Magnum Photos, Inc.
Eli Reed, Magnum Photos, Inc.

80 Carole Devillers
Barbara Van Cleve
Carole Devillers
Barbara Van Cleve
Carole Devillers
Eli Reed, Magnum Photos, Inc.
Carole Devillers

81 Carole Devillers
Carole Devillers
Eli Reed, Magnum Photos, Inc.
Eli Reed, Magnum Photos, Inc.
Carole Devillers
Carole Devillers
Eli Reed, Magnum Photos, Inc.

82 Steve Bonner
David Reffalt
David Reffalt
Richard Scibelli, Jr.
David Reffalt
Douglas Kent Hall
David Reffalt

83 David Reffalt
S. Ray Acevedo
Brett Butterstein
David Reffalt
Steve Northup
Eli Reed, Magnum Photos, Inc.
David Reffalt

86 Phillippe Diederich
Craig Fritz
Phillippe Diederich
Craig Fritz

Phillippe Diederich
Craig Fritz
Phillippe Diederich

87 Craig Fritz
Wes Pope, *The Santa Fe New Mexican*
Wes Pope, *The Santa Fe New Mexican*
Wes Pope, *The Santa Fe New Mexican*
Wes Pope, *The Santa Fe New Mexican*
Wes Pope, *The Santa Fe New Mexican*
Wes Pope, *The Santa Fe New Mexican*

88 Craig Fritz
Karen Kuehn
Kitty Clark Fritz
Karen Kuehn
Craig Fritz
Karen Kuehn
Karen Kuehn

89 Kitty Clark Fritz
Kitty Clark Fritz
Karen Kuehn
Kitty Clark Fritz
Karen Kuehn
Karen Kuehn
Kitty Clark Fritz

92 Miguel Gandert
Craig Fritz
Toby Jorrin, *The Albuquerque Tribune*
Luis Sanchez Saturno
Kitty Clark Fritz
Craig Fritz
Miguel Gandert

93 Miguel Gandert
Kitty Clark Fritz
Miguel Gandert
Kitty Clark Fritz
Miguel Gandert
Kitty Clark Fritz
Brett Butterstein

98 Toby Jorrin, *The Albuquerque Tribune*
Toby Jorrin, *The Albuquerque Tribune*
Toby Jorrin, *The Albuquerque Tribune*
Toby Jorrin, *The Albuquerque Tribune*
Toby Jorrin, *The Albuquerque Tribune*
Sterling Trantham,
New Mexico State University
S. Ray Acevedo

99 Stacia Spragg, *The Albuquerque Tribune*
Sterling Trantham,
New Mexico State University
Sterling Trantham,
New Mexico State University
Stacy Kendrick
Toby Jorrin, *The Albuquerque Tribune*
Jamey Stillings
Sterling Trantham,
New Mexico State University

100 Sterling Trantham,
New Mexico State University
Douglas Kent Hall
Sterling Trantham,
New Mexico State University
Sterling Trantham,
New Mexico State University
Stacy Kendrick
Sterling Trantham,
New Mexico State University
Barbara Van Cleve

101 Steve Northup
Sterling Trantham,
New Mexico State University
Douglas Kent Hall
Sterling Trantham,
New Mexico State University
Stacy Kendrick
Sterling Trantham,
New Mexico State University
Sterling Trantham,
New Mexico State University

102 Esha Chiocchio
Esha Chiocchio
Esha Chiocchio

Esha Chiocchio
Esha Chiocchio
Esha Chiocchio
Esha Chiocchio

103 Esha Chiocchio
Esha Chiocchio
Esha Chiocchio
Esha Chiocchio
Esha Chiocchio
Esha Chiocchio
Esha Chiocchio

104 Marcia Keegan
Marcia Keegan
Marcia Keegan
Marcia Keegan
Marcia Keegan
Marcia Keegan
Marcia Keegan

105 Marcia Keegan
Marcia Keegan
Marcia Keegan
Marcia Keegan
Marcia Keegan
Sterling Trantham,
New Mexico State University
Marcia Keegan

106 Michael J. Gallegos,
The Albuquerque Tribune
Michael J. Gallegos, *The Albuquerque Tribune*
Michael J. Gallegos, *The Albuquerque Tribune*
Michael J. Gallegos, *The Albuquerque Tribune*
Douglas Kent Hall
Michael J. Gallegos, *The Albuquerque Tribune*
Michael J. Gallegos, *The Albuquerque Tribune*

110 Douglas Kent Hall
Douglas Kent Hall
Toby Jorrin, *The Albuquerque Tribune*
Toby Jorrin, *The Albuquerque Tribune*
Phillippe Diederich
Luis Sanchez Saturno
Toby Jorrin, *The Albuquerque Tribune*

111 Douglas Kent Hall
Toby Jorrin, *The Albuquerque Tribune*
Toby Jorrin, *The Albuquerque Tribune*
Brett Butterstein
Douglas Kent Hall
Toby Jorrin, *The Albuquerque Tribune*
Jamey Stillings

114 Michael R. Stoklos
Michael R. Stoklos
Toby Jorrin, *The Albuquerque Tribune*
Douglas Kent Hall
Craig Fritz
Douglas Kent Hall
Douglas Kent Hall

115 Sterling Trantham,
New Mexico State University
Douglas Kent Hall
Jamey Stillings
Douglas Kent Hall
S. Ray Acevedo
Miguel Gandert
Steve Northup

116 Barbara Van Cleve
Douglas Kent Hall
Douglas Kent Hall
David Reffalt
Douglas Kent Hall
David Reffalt
Douglas Kent Hall

117 Douglas Kent Hall
Douglas Kent Hall
Douglas Kent Hall
Douglas Kent Hall
Douglas Kent Hall
Douglas Kent Hall
Douglas Kent Hall

121 Douglas Kent Hall
Douglas Kent Hall
Steve Northup

Steve Northup
Steve Northup
Kelly D. Gatlin, La Luz Photography
Luis Sanchez Saturno

122 Pat Vasquez-Cunningham
Barbara Van Cleve
Kelly D. Gatlin, La Luz Photography
Jake Schoellkopf
Jeffrey Aaronson, Network Aspen
Kelly D. Gatlin, La Luz Photography
Khue Bui

124 Jamey Stillings
Jamey Stillings
Jamey Stillings
Jamey Stillings
Miguel Gandert
Jamey Stillings
Jamey Stillings

125 Jamey Stillings
Miguel Gandert
Jamey Stillings
Jamey Stillings
Jamey Stillings
Sterling Trantham,
New Mexico State University
Jamey Stillings

126 Miguel Gandert
Preston Gannaway
Miguel Gandert
Preston Gannaway
Steve Northup
Preston Gannaway
Steve Northup

127 Preston Gannaway
Miguel Gandert
Preston Gannaway
Miguel Gandert
Miguel Gandert
Miguel Gandert
Carmela Chavez

130 Carole Devillers
Carole Devillers
Marcia Keegan
Carole Devillers
Sterling Trantham,
New Mexico State University
Marcia Keegan
Carole Devillers

131 S. Ray Acevedo
Marcia Keegan
Carole Devillers
Sterling Trantham,
New Mexico State University
Sterling Trantham,
New Mexico State University
S. Ray Acevedo
Sterling Trantham,
New Mexico State University

133 Jake Schoellkopf
Jake Schoellkopf
Jake Schoellkopf
Craig Fritz
Craig Fritz
Jake Schoellkopf
Craig Fritz

134 Craig Fritz
Douglas Kent Hall
Eli Reed, Magnum Photos, Inc.
Douglas Kent Hall
Miguel Gandert
Eli Reed, Magnum Photos, Inc.
Eli Reed, Magnum Photos, Inc.

135 Eli Reed, Magnum Photos, Inc.
Eli Reed, Magnum Photos, Inc.
Steve Northup
Eli Reed, Magnum Photos, Inc.
Craig Fritz
Miguel Gandert
Steve Northup

Staff

The *America 24/7* series was imagined years ago by our friend Oscar Dystel, a publishing legend whose vision and enthusiasm have been a source of great inspiration.

We also wish to express our gratitude to our truly visionary publisher, DK.

Rick Smolan, Project Director
David Elliot Cohen, Project Director

Administrative
Katya Able, Operations Director
Gina Privitere, Communications Director
Chuck Gathard, Technology Director
Kim Shannon, Photographer Relations Director
Erin O'Connor, Photographer Relations Intern
Leslie Hunter, Partnership Director
Annie Polk, Publicity Manager
John McAlester, Website Manager
Alex Notides, Office Manager
C. Thomas Hardin, State Photography Coordinator

Design
Brad Zucroff, Creative Director
Karen Mullarkey, Photography Director
Judy Zimola, Production Manager
David Simoni, Production Designer
Mary Dias, Production Designer
Heidi Madison, Associate Picture Editor
Don McCartney, Production Designer
Diane Dempsey Murray, Production Designer
Jan Rogers, Associate Picture Editor
Bill Shore, Production Designer and Image Artist
Larry Nighswander, Senior Picture Editor
Bill Marr, Sarah Leen, Senior Picture Editors
Peter Truskier, Workflow Consultant
Jim Birkenseer, Workflow Consultant

Editorial
Maggie Canon, Managing Editor
Curt Sanburn, Senior Editor
Teresa L. Trego, Production Editor
Lea Aschkenas, Writer
Olivia Boler, Writer
Korey Capozza, Writer
Beverly Hanly, Writer
Bridgett Novak, Writer
Alison Owings, Writer
Fred Raker, Writer
Joe Wolff, Writer
Elise O'Keefe, Copy Chief
Daisy Hernández, Copy Editor
Jennifer Wolfe, Copy Editor

Infographic Design
Nigel Holmes

Literary Agent
Carol Mann, The Carol Mann Agency

Legal Counsel
Barry Reder, Coblentz, Patch, Duffy & Bass, LLP
Phil Feldman, Coblentz, Patch, Duffy & Bass, LLP
Gabe Perle, Ohlandt, Greeley, Ruggiero & Perle, LLP
Jon Hart, Dow, Lohnes & Albertson, PLLC
Mike Hays, Dow, Lohnes & Albertson, PLLC
Stephen Pollen, Warshaw Burstein, Cohen, Schlesinger & Kuh, LLP
Rick Pappas

Accounting and Finance
Rita Dulebohn, Accountant
Robert Powers, Calegari, Morris & Co. Accountants
Eugene Blumberg, Blumberg & Associates
Arthur Langhaus, KLS Professional Advisors Group, Inc.

Picture Editors
J. David Ake, Associated Press
Caren Alpert, formerly *Health* magazine
Simon Barnett, *Newsweek*
Caroline Couig, *San Jose Mercury News*
Mike Davis, formerly *National Geographic*
Michel duCille, *Washington Post*
Deborah Dragon, *Rolling Stone*
Victor Fisher, formerly Associated Press
Frank Folwell, *USA Today*
MaryAnne Golon, *Time*
Liz Grady, formerly *National Geographic*
Randall Greenwell, *San Francisco Chronicle*
C. Thomas Hardin, formerly *Louisville Courier-Journal*
Kathleen Hennessy, *San Francisco Chronicle*
Scot Jahn, *U.S. News & World Report*
Steve Jessmore, *Flint Journal*
John Kaplan, University of Florida
Kim Komenich, *San Francisco Chronicle*
Eliane Laffont, *Hachette Filipacchi Media*
Jean-Pierre Laffont, *Hachette Filipacchi Media*
Andrew Locke, MSNBC
Jose Lopez, *The New York Times*
Maria Mann, formerly AFP
Bill Marr, formerly *National Geographic*
Michele McNally, *Fortune*
James Merithew, *San Francisco Chronicle*
Eric Meskauskas, *New York Daily News*
Maddy Miller, *People* magazine
Michelle Molloy, *Newsweek*
Dolores Morrison, *New York Daily News*
Karen Mullarkey, formerly *Newsweek, Rolling Stone, Sports Illustrated*
Larry Nighswander, Ohio University School of Visual Communication
Jim Preston, *Baltimore Sun*
Sarah Rozen, formerly *Entertainment Weekly*
Mike Smith, *The New York Times*
Neal Ulevich, formerly Associated Press

Website and Digital Systems
Jeff Burchell, Applications Engineer

Television Documentary
Sandy Smolan, Producer/Director
Rick King, Producer/Director
Bill Medsker, Producer

Video News Release
Mike Cerre, Producer/Director

Digital Pond
Peter Hogg
Kris Knight
Roger Graham
Philip Bond
Frank De Pace
Lisa Li

Senior Advisors
Jennifer Erwitt, Strategic Advisor
Tom Walker, Creative Advisor
Megan Smith, Technology Advisor
Jon Kamen, Media and Partnership Advisor
Mark Greenberg, Partnership Advisor
Patti Richards, Publicity Advisor
Cotton Coulson, Mission Control Advisor

Executive Advisors
Sonia Land
George Craig
Carole Bidnick

Advisors
Chris Anderson
Samir Arora
Russell Brown
Craig Cline
Gayle Cline
Harlan Felt
George Fisher
Phillip Moffitt
Clement Mok
Laureen Seeger
Richard Saul Wurman

DK Publishing
Bill Barry
Joanna Bull
Therese Burke
Sarah Coltman
Christopher Davis
Todd Fries
Dick Heffernan
Jay Henry
Stuart Jackman
Stephanie Jackson
Chuck Lang
Sharon Lucas
Cathy Melnicki
Nicola Munro
Eunice Paterson
Andrew Welham

Colourscan
Jimmy Tsao
Eddie Chia
Richard Law
Josephine Yam
Paul Koh
Chee Cheng Yeong
Dan Kang

Chief Morale Officer
Goose, the dog